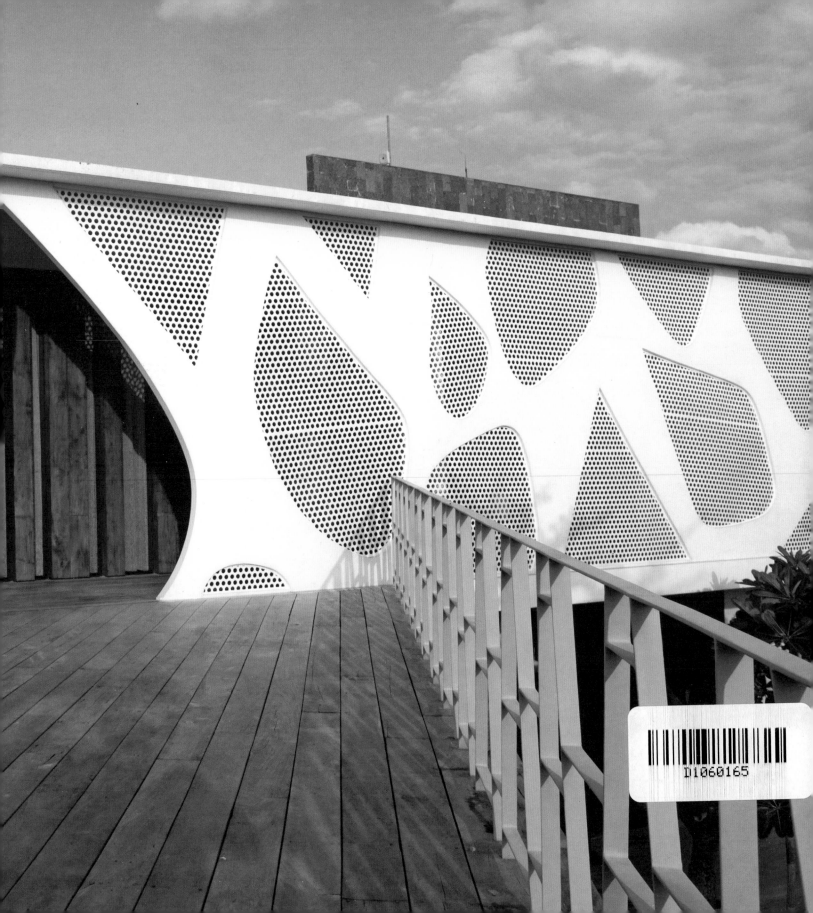

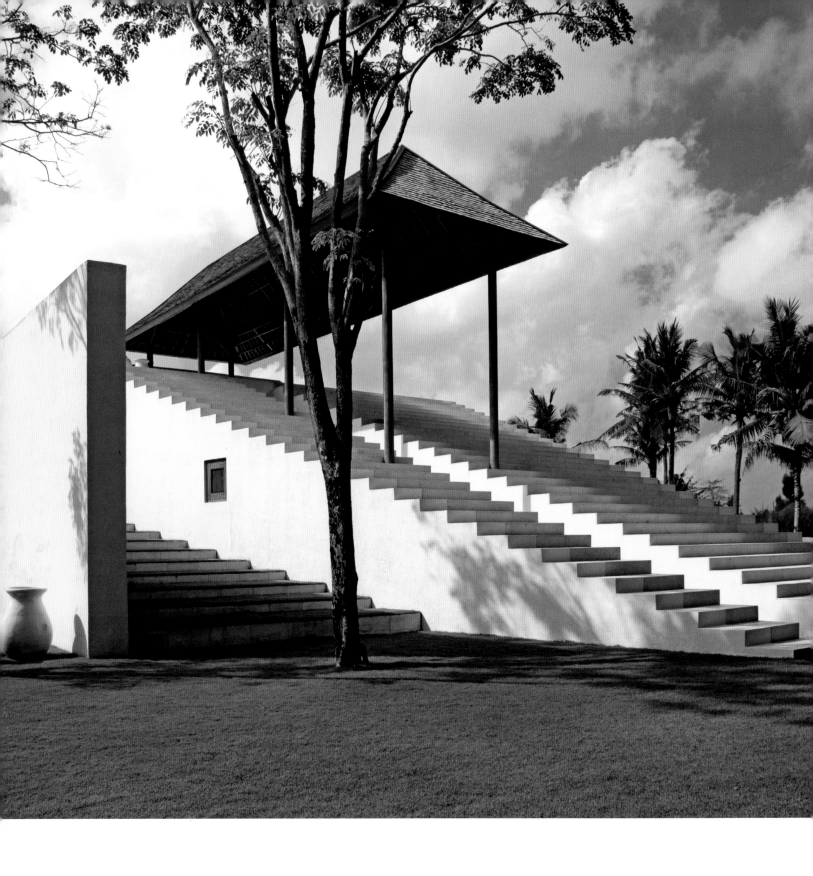

bali by design

25 CONTEMPORARY HOUSES

Kim Inglis

Photography by Jacob Termansen

TUTTLE Publishing

Tokyo | Rutland, Vermont | Singapore

Published by Tuttle Publishing, an imprint of Periplus
Editions (HK) Ltd

www.tuttlepublishing.com

ISBN: 978-0-8048-4233-4

Distributed by

North America, Latin America & Europe
Tuttle Publishing
364 Innovation Drive
North Clarendon, VT 05759-9436 U.S.A.
Tel: 1 (802) 773-8930
Fax: 1 (802) 773-6993
info@tuttlepublishing.com
www.tuttlepublishing.com

Japan
Tuttle Publishing
Yaekari Building, 3rd Floor
5-4-12 Osaki
Shinagawa-ku
Tokyo 141-0032
Tel: (81) 3 5437-0171
Fax: (81) 3 5437-0755
sales@tuttle.co.jp
www.tuttle.co.jp

Asia Pacific
Berkeley Books Pte. Ltd.
61 Tai Seng Avenue, #02-12
Singapore 534167
Tel: (65) 6280-1330
Fax: (65) 6280-6290
inquiries@periplus.com.sg
www.periplus.com

Indonesia
PT Java Books Indonesia
Kawasan Industri Pulogadung
Jl. Rawa Gelam IV No. 9
Jakarta 13930
Tel: (62) 21 4682-1088
Fax: (62) 21 461-0206
crm@periplus.co.id
www.periplus.co.id

15 14 13 12 10 9 8 7 6 5 4 3 2 1

Printed in Hong Kong 1206 EP

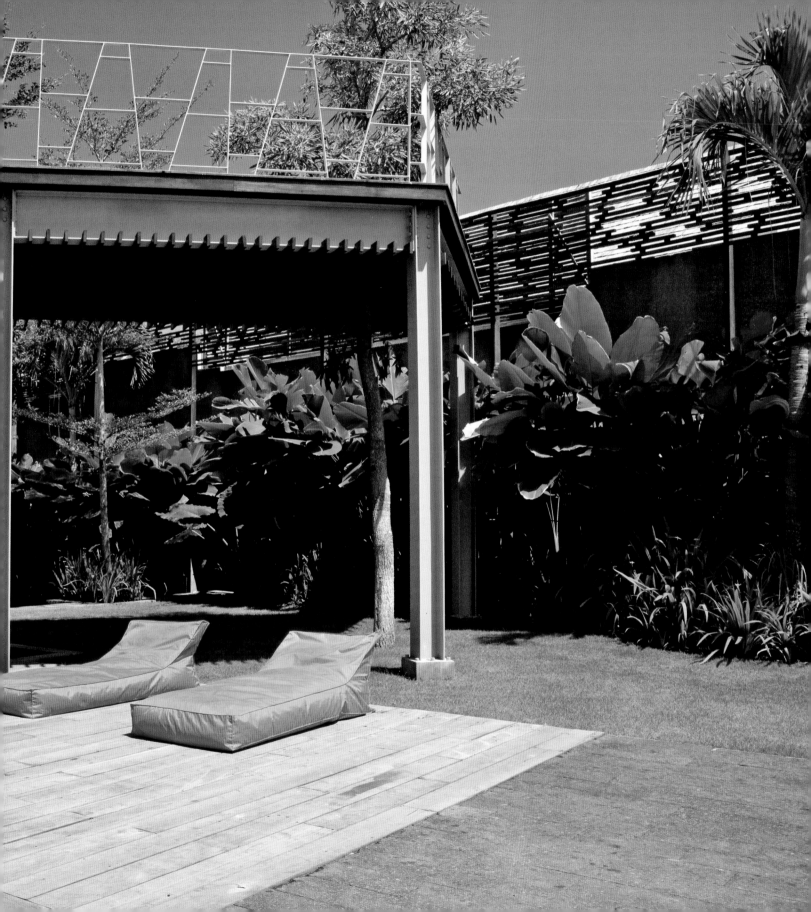

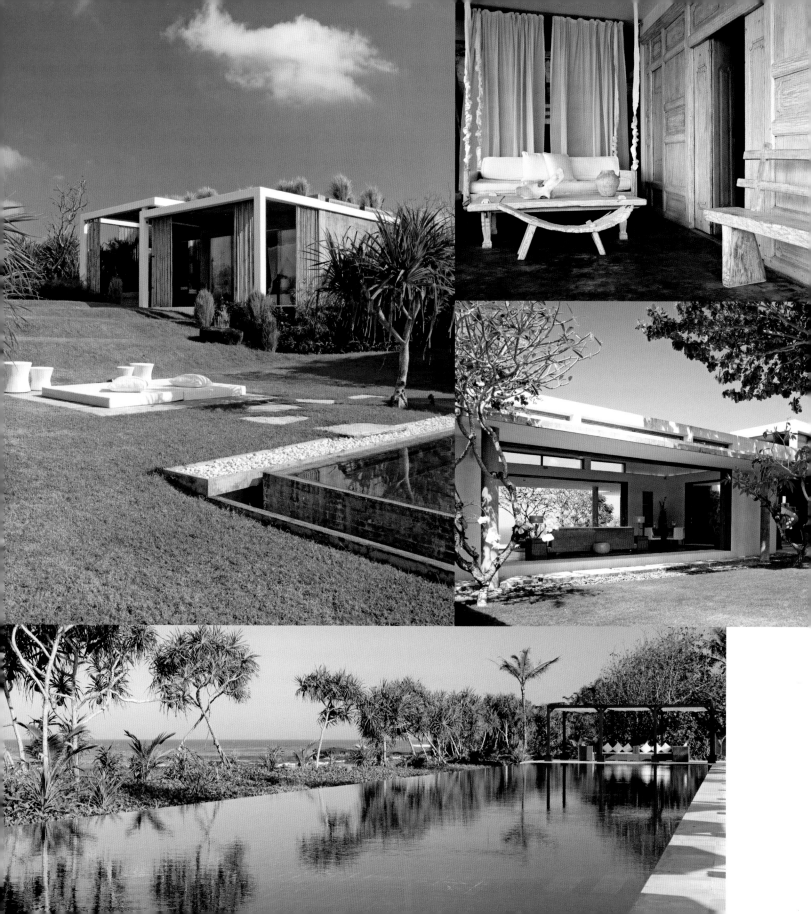

THE NEW BALI

For first time visitors, repeat guests, those that have made Bali their home, and the Balinese themselves, there is no denying the rapid changes that have taken place on the island in the past few years. What was once a romantic, cultural getaway with rice field and temple predominating has transformed into a thrusting metropolis, especially in the built-up southern areas. Bali's slow pace of life—in the main tourist and residential centers anyway—is a thing of the past.

As with all change, there are positives and negatives. Increased prosperity is certainly a plus point; traffic jams, pollution and unplanned development are sad reminders of the cost of "progress". Yet, amongst the mayhem, you can still find the rich landscape and culture that has beguiled visitors for centuries. It continues to draw outsiders—many of whom are building extraordinary homes.

After a year of research, we've come to the conclusion that the Bali brand is as strong as ever. Because the island is welcoming, the people some of the most beautiful on the planet, the climate salubrious, the economy buoyant—foreign investment continues, grows and multiplies. More and more outsiders—from Australia, other parts of Asia, Europe and even America—are making Bali their home, and many more are investing in villas suitable for the holiday rental market.

For the most part, this book concentrates on homes, although there are one or two rentals as well. Almost all are newly built residences. We consider them the cream of the crop,

representative of the exciting new architectural directions that Bali is witness to, yet by no means the norm.

We've left out the terraced villas, the cheek-by-jowl estates, the ribbon developments, the small condos; we're showcasing only extremely high-end, innovative properties. Some are in the countryside—by the sea, in the hills, overlooking rice paddies—but many are in built-up areas as is increasingly common. The homes may not have the picture postcard views of the past, in fact they're more than likely to be inward looking, but they are noteworthy nonetheless.

Each home has been chosen because of its excellent architecture, innovative design features, and cutting-edge interiors, but also because each is very different from the next. Variety is the key here; no cookie-cutter copies thank you very much. We want you to drool over their beauty in the same way we did, read about some of the new materials and methods used, maybe incorporate some of the ideas into your own homes. We're grateful to have been invited in—and we hope you'll find the houses as extraordinary as we have done.

Style, Substance and Sustainability

So what are the major changes in architecture and design in Bali? Firstly, an increased level of sophistication is increasingly sought—and supplied. Craftsmanship has always been one of Bali's strengths, but it has more often than not remained in the vernacular. Now, we see

BALI BY DESIGN

Below Nestling in a sculptural, yet lush, bamboo garden is a seemingly floating European-style, flat-roofed rectangular prism set on piles. Designed by i-LAB Architecture, it is part of a complex that also comprises recycled Javanese structures—a wonderful combo of new and old.

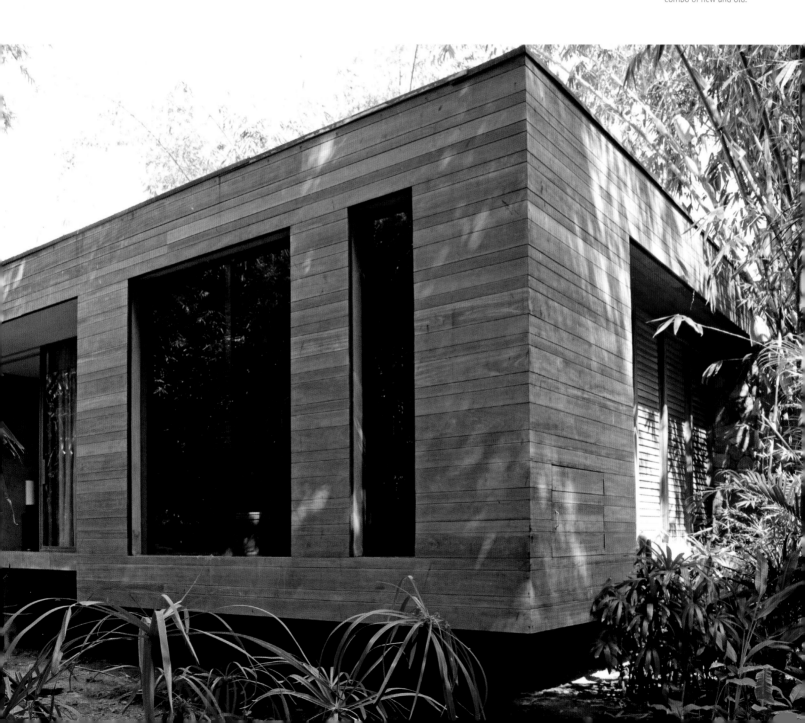

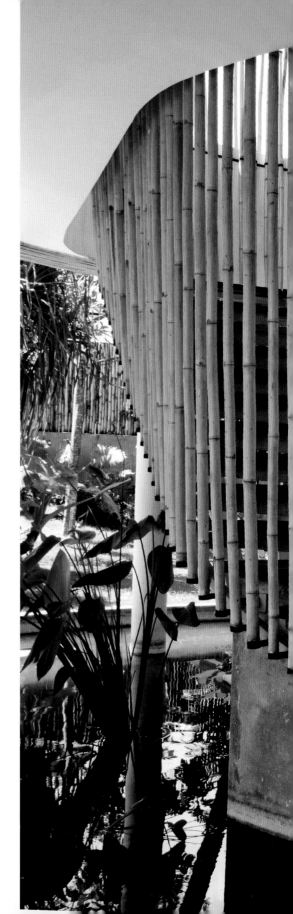

Right Designed by Balinese architect Yoka Sara, this home combines traditional materials with the ultra modern. This sculptural oval staircase rising up from a reflecting pool is a case in point: Made from concrete and steel with timber treads, it features a curving bamboo balustrade.

high-end finishing in furniture and artefacts, as well as surface embellishment and building materials. Modern imported kitchen equipment, technical know-how in lighting, plumbing and ventilation, high quality materials—all are becoming readily available in Bali.

The use of concrete has increased exponentially. Not only does concrete evoke a feeling of serenity and calm, it is cooling underfoot. Traditional building materials such as *alang-alang* for roofing are being replaced by wood shingles—and, more often, flat roofs. Often such roofs sport plantings or water features to help with natural cooling. Easily sourced local stones—andesite, *paras*, *palimanan*—are still widely used, but often the cut is more modern, the finishing more streamlined.

Sustainability is another factor. A lot of high-end clients want to impact as little as possible on the natural environment, so they often request a low-energy design that reduces the use of air-conditioning and returns to traditional natural ventilation techniques. Many of the architects featured in this book conduct an environmental impact assessment before they start a project and try to go as green as they can: Using non-toxic paints, solar energy, water catchment and recycling techniques, as well as trying to adhere as closely as possible to the natural contours of the land, are some of the methods they employ.

Many suggest that such practices are pure common sense. Gary Fell of Gfab, a firm that espouses a rigorous modernity in its aesthetic, believes passionately that buildings should be "married" to their environment going so far as to semi-bury buildings especially if they are on steeply sloping sites (see pages 174–179). Cutting down on air-con is simply practical, he says. "Why on earth wouldn't one exploit air flow through a planning mechanism?" he exclaims. "Why would one park a roof in that view for Pete's sake? (ipso facto use a roof garden, therefore flat roof)." Careful consideration of materials should be the job of every architect, but as he wryly notes: "How many full glass shop fronts in brilliant sunlight do you see?"

Valentina Audrito, an Italian architect with her own company Word of Mouth, echoes Gary's sentiments. In one recent project she placed landscaped boxes and reflecting lily pools on flat roofs to reduce air-con consumption and increase the cooling effect below. And because the house was three kilometers away from the nearest electricity source, she designed a power system based on a combination of solar panels and batteries supported by a generator. "Cutting air-con is a priority," Valentina states firmly.

Johnny Kember of KplusK Associates, a practice in Hong Kong, states that it is every architect's responsibility to explore sustainable and environmentally friendly building methods. After doing some research, he has been amazed at how many ways there are to produce low-carbon footprint buildings—and he has included a few in his iconic design on the Bukit (see pages 96–103). He sees many buildings that are almost entirely self sustaining in terms of their energy and water usage—and believes that this is the way forward for the future.

BALI BY DESIGN

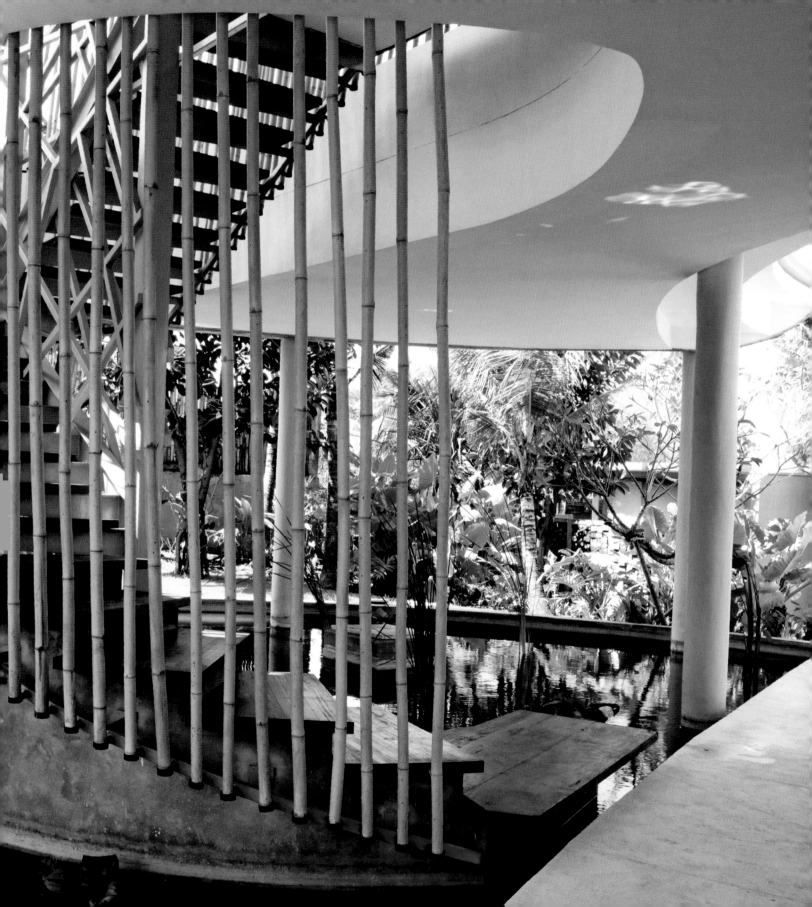

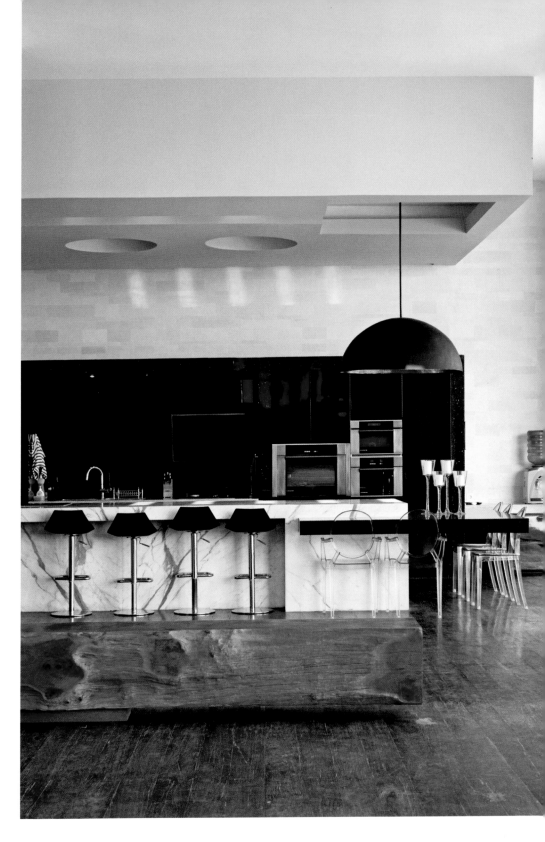

Right Large entertaining
spaces were a specific
request from the owner of
this spacious home. Ross
Peat of Seriously Designed
also made sure that
only the highest quality
materials were used, as
evidenced by this Statuario
marble show kitchen.

Naturally, this is not the norm. In Bali, there
are few building restrictions and the onus is
on clients and architects to try to do the "right
thing". Ross Peat of Seriously Designed laments
the over-crowding and the lack of infrastructure
planning, as well as the difficulty of acquiring
electricity and water, but notes: "All that being
said, there are some amazing buildings being
designed and built in Bali." Nevertheless, he
goes on to add: "It is clear that the building
regulations are far from conducive to people's
privacy as you do see structures being built too
close to their boundaries and often overlooking
other properties."

As such, Ross often turns houses in on themselves,
replacing external viewpoints with internal
courts and secluded gardens. "You can't count
on the view for ever," he maintains, "so in most
cases I design to have the view internally. I also
try to have generous open spaces both in and
outdoor, giving a feeling of a seamless transition
between the outdoor and indoor areas." See his
own home on pages 138–143, a fine example
of easeful tropical living.

This idea of blurring boundaries between indoor
and outdoor harks back to earlier pavilion-style
living in wall-less or semi-walled structures, a
type of style that we have come to term "Bali-
style". In fact, this type of structure should
really be named "resort-style" or something to
that effect, as it was pioneered by early resort
architects such as Peter Muller at the Kayu Aya
Hotel (now the Oberoi) and Amandari. He,
in turn, was influenced by tropical maestro,
Geoffrey Bawa. The style bears little relation

to indigenous Balinese building traditions—with the exception perhaps of the open-sided *wantilan* and *balé*.

Today's villas have eschewed the dark wood and pitched roofs for something very different to these earlier prototypes: The new wave of architecture is more lightweight, open-plan, more streamlined, definitely more Western in form. There may be a sense of place, an interpretation of Balinese courtyard living, but visually these new residences are nothing like their older counterparts. Balinese architect Yoka Sara says there may be some reference to Balinese roots and culture in house design, but you have to really look to see the parallels. The days of having a rice granary or *lumbung* as a spare room are well and truly over, he believes.

Instead, he tends to immerse himself in the landscape to try to "improve and emphasize natural elements and surroundings" within a modern architectural vocabulary. Only by imagining the movement and sequence of spaces on a site, can he "build up the emotion and set the living spaces". As with Gary Fell and Johnny Kember, he uses the natural contours of the land, the way that the breeze blows, the direction of natural light to articulate the spaces—and these elements usually result in a reduction in air-con and power. One of his recent designs, Kayu Aga (see pages 74–79) is a case in point.

Another reason that architects are looking inward is that plots are becoming smaller. What were once small settlements or villages are turning into towns and areas of rice field are

being erased. For example, in Seminyak land is very expensive nowadays, so architects are increasingly looking for innovative ways to counteract the limitations. In one of Gary Fell's new projects, he "effectively stands the villa on its head" placing the utilities and bedrooms at the front of the house, ie on the lower levels, and putting the living areas and pool on the roof to access views.

In another project, Swiss designer Renato Guillermo de Pola incorporates a central atrium, complete with glass pyramid roof and internal plantings, in the center of his house. For all practical purposes, this is his "garden", with open-plan spaces clustering around (see pages 50–55). Built along the lines of a New York loft with semi-industrial materials and an urban aesthetic, it is the exact opposite of the trad Bali villa with rice field view.

Nevertheless, we do showcase plenty of homes in remote, rural areas where the houses work consciously with their tropical environment, be they overtly modern or vernacular in inspiration. The use of water features (often nowadays found on roofs), the melding of timber and stone, and the idea of bringing the landscape to bear on the interior are all perfected in different ways. Many of the houses sport clean lines, sculpted shapes and are modernist in style, but there is some conservation and re-use of existing architecture and materials, mostly observed in the recycling of wood and the use of entire wooden structures. The residence featured on pages 56–65, comprising a number of *joglos* and *gladags*, traditional wooden

structures from Java, as well as a Sumatran house, counters vernacular architecture with fashion-forward interiors that would not be out of place in a chic Parisian apartment or a London townhouse.

A New Wave of Interior Design

Bali has long been renowned as a center of creativity, with a profound artistic tradition that has inspired a proliferation of cottage industries all over the island. Every village has an artist, a sculptor, a carver—often scores of them. As such, it has long been a magnet for talented creatives from abroad.

Yet the last few years has seen a change in emphasis and scale. The small ateliers and individual artists of the 20th century have burgeoned into 21st-century export-driven factories with large showrooms and expansive designer collections. Yesterday's hippies have either grown up and grown out, or have been superseded by younger, hungrier replacements. The main difference in the items produced today with those from even a decade ago is in the quality.

Now any number of conglomerates design, manufacture and export any number of high-end furniture pieces, fabrics, lighting products, and accessories. When mixed with recycled panels in carved wood, old dyeing vats, birdcages transformed into sexy lights, masks and canvases, you have the perfect East meets West combo. It's no wonder that many people specifically visit Bali with a view to furnishing

their new apartment back home. Recent years have seen a proliferation of businesses that specifically source art, furniture, fabrics and artifacts on a buyer's behalf.

One area that reflects this eclectic theatricality is to be found in some of south Bali's newer commercial outlets—restaurants, cafés, clubs and hotels that are making design waves quite out of proportion to their size or standing. Take a look at the outstanding lighting design in Café Bali, for example, or the pared-down post-modernity at The Junction (see pages 207, 211 and 219). Potato Head Beach Club's futuristic façade, composed of over 1,000 vintage wooden shutters salvaged from across the archipelago, is both a lesson in sustainable material re-use and a flight of architectural imagination (see pages 220–221). And for those who love to see reinterpretations of cultural concerns, but in a contemporary context, look no further than the funky W hotel, the latest outpost from this über-chic brand (pages 184, 202–205).

In our collection of houses, interiors are extremely varied. Because most are lived in by their owners, each sports an individual style that differs greatly one from the next. We have family homes with practical arrangements for teens, funky bedrooms for kids, family AV rooms for home entertainment. There are homes with private yoga rooms, attached offices, bars and studios. Some sport priceless art and artefacts, others are more down to earth.

Where they are unified, however, is in the care given to selection of furniture and furnishings, and in the quality. We're seeing a lot less Asian style; Euro flair is on the rise. Along with Christian Laigre lookalikes—think sleek sofas with ottomans in cream and dark wood—there are iconic pieces from Italy and the Americas. These may be accented by some Asian decorative pieces, but that is what they are: accents.

One of the most notable changes is in the field of kitchen design. In the past, kitchens were tucked away in the back of the villa and equipment was rudimentary at best. Even high-end rental villas often didn't have an oven, relying on a gas cylinder and hob for cooking. All that has changed with easy access to imported, high-end brands such as Bosch, Miele and Boretti, and the plethora of talented cabinet makers now resident on the island.

Detlev Hauth is one such artisan. After stints at Boffi, Poliform, Artemide and other big contemporary manufacturing companies, he moved to Bali nine years ago and set up a studio called Casa Moderno to manufacture products aimed at the German market. "Germany needs quality," he notes, "and all my people here in Bali have the necessary skills." Combining German technology with Italian sophistication, as well as Bali's natural materials and craft skills, his kitchens are both sleek and functional (see pages 176–177).

Methods and technical know-how are European, materials and craftsmanship totally Balinese. For cabinets, he uses what he considers the best rail system in the world—a German one—to ensure that drawers and cupboards slide very smoothly and don't slam shut, while other pieces are locally made but equally sleekly finished. "We also produce furniture for villas, shops and offices —all contemporary," he says, adding that problems start once the style is set in the modernist idiom. "Clean lines need higher quality. If you produce a traditional Indonesian table or you build a traditional Balinese house you can hide all the mistakes; this is not so in contemporary— with contemporary, all is exposed."

Detlav is but one of many such craftsmen based in Bali today. As competition grows, the demand for sophisticated products that really work, expands. Nobuyuki Narabayashi, or Nara-san, of Desain9 agrees. Having worked for many years at Japanese design supremo, Super Potato, he is now at the helm of an extremely individual design firm in Bali. As an interior designer of both commercial spaces (check out his refined craftsmanship at The Junction in Seminyak—page 219) and residential, he is well placed to comment on the scene in Bali.

Desain9 is, however, a little different to many of the design ateliers on the island, in that its specific aim is to use recycled materials as much as possible and transform them into new, timeless products. "As you know, Bali has an extremely particular culture and regional tradition," explains Nara-san, "but that originality is disappearing because of today's design homogeneity. My challenge is to re-compose true Balinese items, re-make the old culture, and transform it into new products."

It's certainly encouraging to see that companies like Desain9 have such an ethos and they stick with their ethics. They put their money where their mouth is, as it were. Their products and

Left Indonesian architect Budi Pradono's roof form at Villa Issi was purposely angled so as to obtain shifting patterns of light on the rigorous volcanic rock wall in the stairwell.

interior finishes look very slick and very contemporary—but at their heart lies a reinterpretation of Bali.

Another company that takes its sustainability credentials seriously is Ibuku, under the creative direction of Elora Hardy. Currently gaining publicity for its entirely built-in-bamboo Green Village residential project near Ubud, it uses several different species of bamboo to build in ways that are "in integrity with nature". In the hands of Ibuku, bamboo is beginning to cast off its somewhat old-fashioned reputation, as designers manipulate bamboo's versatility in furniture, flooring and wall materials.

"Quite often we cut splits of bamboo, then laminate them together under pressure," explains Elora. "And if we want a graphic element, we slice *duri* bamboo lengthwise to reveal the nodes and internodes." Then, instead of using the material to make an entire table or door, Ibuku may incorporate bamboo detailing within individual pieces. The end result is something sophisticated, something modern, yet something that retains a connection with Bali's natural beauty. See the doors and kitchen counter on pages 84–85 for more of an idea of Elora's work.

In contrast to Desain9 and Ibuku, some designers have begun experimenting with more industrial materials, moving away from Bali's natural resources. As the island matures and expands, so does the availability of higher-tech methods and materials. Ateliers specializing in synthetic rattans, all-weather wicker, acrylic and polyurethane are proliferating. Heat and

Left The wow factor in this 33-m swimming pool is a glass bottom in the shallow end. It allows for sneaky peeking from the games room below. Designed by KplusK Associates, the pool is surrounded by a number of discrete modern pavilions set aside, above and below.

humidity, not to mention sea breezes and pollution, all take their toll, so many home owners are making more practical choices in their choice of décor items.

Some of the quirky furniture pieces designed and manufactured by Valentina Audrito and Abhishake Kumbha at Word of Mouth combine such modern materials with witty, tongue-in-cheek expressions that are sold both overseas and on the island (see pages 212–215). Their inspiration comes from their lives, they say, but even though they're Bali based, there's not much in the way of tropicality in their work. Benches, chairs and loungers may be made in Bali, but they stand outside the vernacular in terms of style.

In addition to such locally made pieces with a European slant, home owners also have the choice of buying items made overseas. Each year, Mario Gierotto sources at the Salone Internazionale del Mobile in Milan to select items for his trendy home wares and furniture shop, simplekoncepstore: he believes that the increased population of expats has led to the demand for European pieces. In his own home (see pages 170–173) he mixes quality imports with some custom-crafted items and artworks that he has picked up locally. He is by no means alone in this.

Overall, as with the architecture, it is variety, quality and a certain individuality that we celebrate in this book. Most home owners have worked full-time on sourcing, designing, and incorporating their personalities into their homes—and because of the plethora of choices

Below In one of the guest bedrooms at the home of architect Ross Peat is a self-portrait by well-known Melbourne artist Jody Candy.

they now have on the island, they've been able to weave together highly covetable looks. We also invite you to look at some of the websites of designers, shops and manufacturers listed at the back of the book.

Conclusion

One thing that became very evident during that process of compiling this book is that Bali has a unique ability to keep re-inventing itself. Even though there is a more mercantile outlook nowadays, the island still retains its rich culture steeped in tradition and ritual, its welcoming people, and the beauty of its landscape. This is the Bali that attracted people in the first place. The fact that architects and designers, home owners and even the Balinese themselves are reinterpreting the island's culture in a more international way doesn't undermine the original essence of Bali.

We believe that the designs in this book are simply one facet, one "layer", one stage of the journey in Bali's development; in the future, different spaces, different interpretations, different structures will evolve. Perhaps that is why the island continues to beguile visitors and residents alike. It may not be Tropical Paradise any more, but it certainly isn't Paradise Lost.

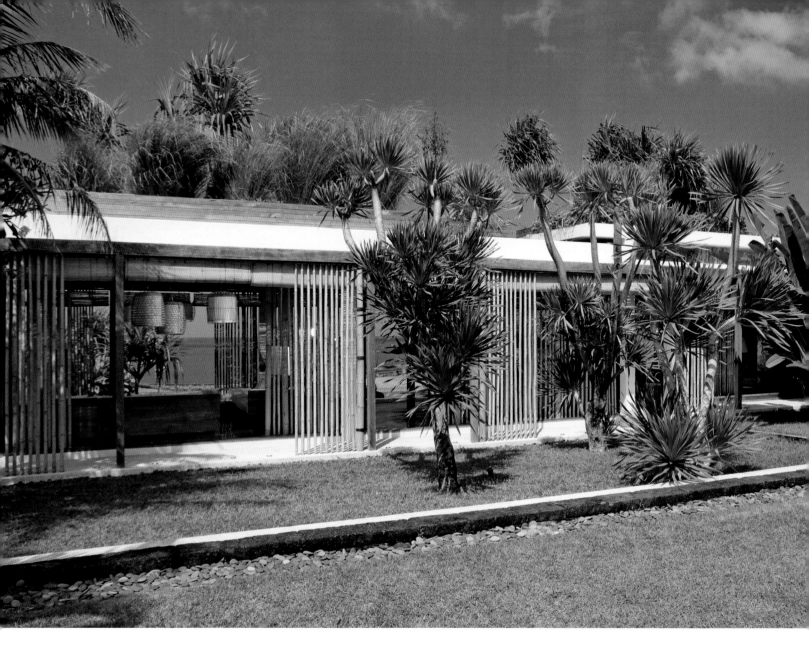

Above Partial view of the core of the home, the central courtyard, looking towards the main living/dining pavilion. The grassy court is surrounded by semi-transparent, flat-roofed buildings and a variety of plants and trees. Because of the "see-through" nature of many of the pavilions, the property feels spacious yet there is still a certain intimacy about it.

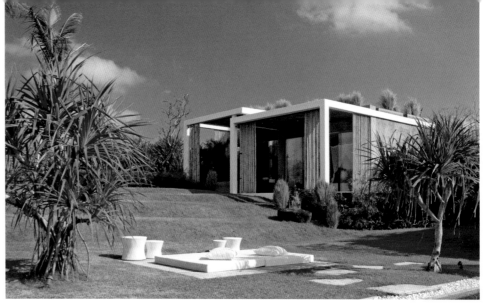

VILLA TANTANGAN

Finding Design in Nature

Architect **Valentina Audrito, Word of Mouth**
Location **Nyanyi Beach**
Date Of Completion **2011**

Built on an isolated piece of gently sloping land overlooking a secluded beach, this holiday home is a wonderful example of how architecture can truly be integrated with landscape. Comprising a series of "boxes" that sit on different levels, the home is light and airy, open and spacious, but intimate and inter-connected nevertheless. There is also an overriding organic aspect to both house and site that makes one feel that the buildings completely "fit" into their environment.

Italian architect, Valentina Audrito of Word of Mouth, explains that she oriented the various buildings around a central courtyard so they had "a more inward feeling towards the inside and a more open one towards the outside". Furthermore, by treating them like "big planter boxes with landscaped roofs"—some have plants, others sport ponds above—she ended up with a type of "landscaped architecture where the boundaries between garden and buildings are very blurred, allowing the architecture not only to sit on the land, but to be part of it".

The orientation and interaction of spaces is key in this project. There are two main views—one overlooking the ocean at the front and one to the side as the land slopes down towards a river and jungle. Each of the strictly rectilinear boxes (there's even a box within a box in the central living space!) overlooks one or the other or over the central courtyard, and all are joined by paths and walkways—some open, others covered—that dissect the site at right angles.

The integration of house and land is furthered by the use of natural local materials—semi-transparent lines of bamboo, creamy *silakarang*

stone, handmade chick blinds, recycled teak and ironwood, and a bespoke all-wood furniture collection. Similarly, the palette in this house is as organic as its materials: grey, cream, off white, café au lait, biscuit, with touches of color in the bathrooms and upholstery.

The owners, a Belgian couple who live in Tokyo, were keen to build as sustainably as possible. Even though the design was left up to Valentina, they did specify a desire for contemporary style, "something simple but elegant, a combination of geometric and organic" and something that impacted on the environment only minimally. "I wanted to have as much 'green' as possible incorporated in the architecture," explains the owner, "See the tree in between the study and guest bathroom, for example. Also, I liked the idea of the planted roofs—we were inspired by some houses in Japan and the planted walls of the Quai Branly Museum in Paris."

Because the house is three kilometers away from the nearest electricity source, it runs on a combination of solar panels and batteries supported by a generator. The planted roofs insulate rooms and keep them cool, reducing the need for excessive air-conditioning, and lighting was designed by Reginald Worthington of NuQu, an alternative energy company that specializes in low energy and LED lighting design. As such, this is possibly one of the most energy-efficient houses in this book.

Below and far right All the furniture, made to designs by London-based Josette Plismy from Gong, was made in Bali. The impeccable, manual techniques and hand-crafted workmanship of George Nakashima are admired by the owners and his influence can be seen in some of the natural-grained wood lamps, for example. Similarly, the palette is intentionally organic with cream and/or grey upholstery with some splashes of pale sea blue..

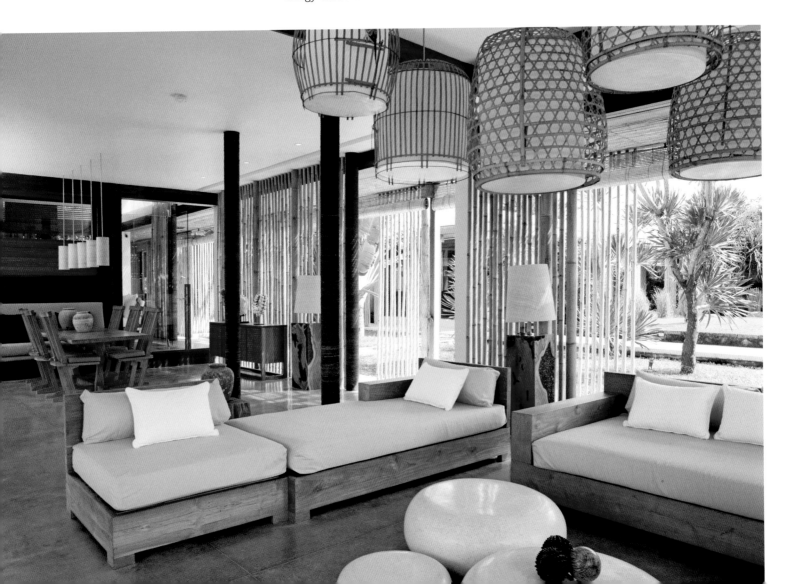

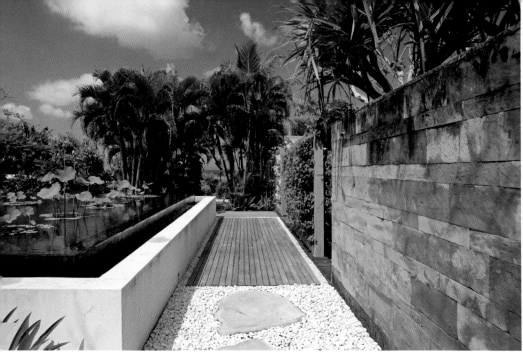

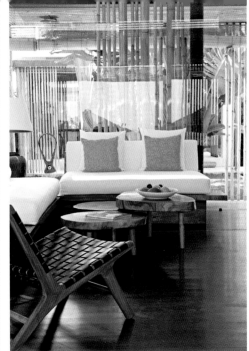

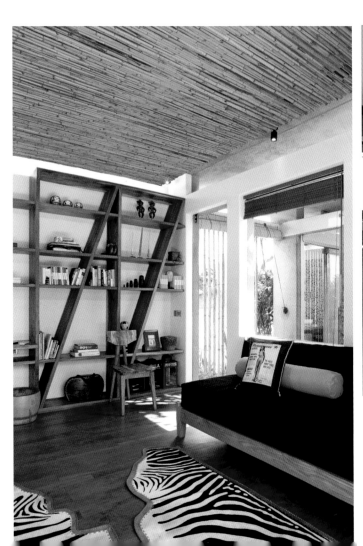

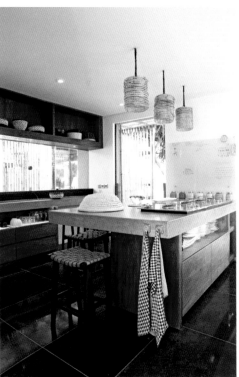

Above At the entrance to the compound, the house reveals itself in stages. Water on roofs is a cooling feature, while the garden was designed by Irish horticulturalist, John Pettigrew of Design in Nature, one of Bali's leading landscape designers.

Right The office is a practical room with two sofas that can be converted into beds if further accommodation is required. A custom-crafted shelving unit adds visual appeal with diagonal struts.

Far right The kitchen sports teak cupboards and drawers with terrazzo counter tops and enough stainless steel to give a modern vibe.

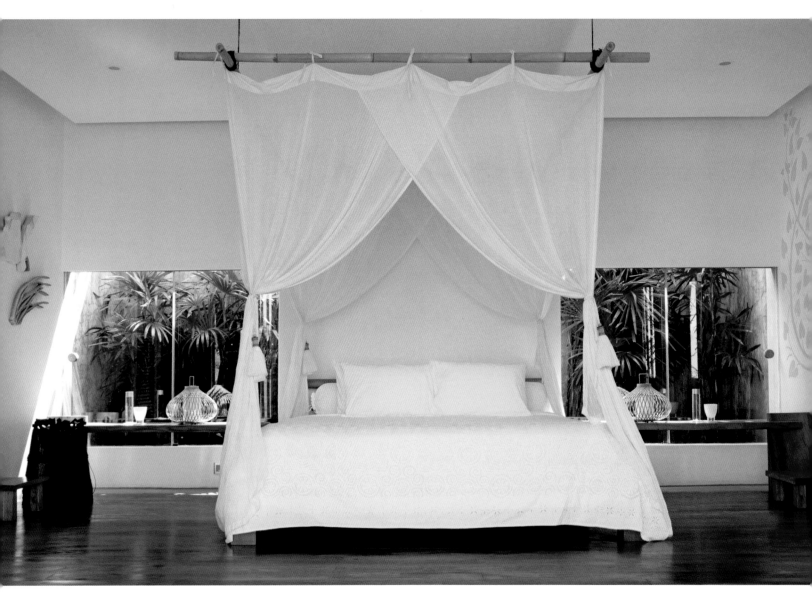

Above The Beach View bedroom is clean and spare with a white-on-white palette and a tree of life stencil in yellow on the walls. A planted light well behind the bed brings nature and light into the room.

Opposite, left below and right top The Sea View bedroom features in interesting starburst picture window and ceramic artworks by the well-known Japanese artist Fujiwo Ishimoto. Ishimoto, surprisingly, lives in Finland and is the face behind many designs at Marimekko.

Opposite, top left Departing from the style of the other bathrooms, this bathroom features colonial inspired colored tiles made by a supplier from Java. They contrast with the waxed black polished concrete of the centerpiece box and shower room.

Opposite, right below Japanese *washi* paper, traditional paper hand crafted from the bark of trees, makes an attractive artwork on a wall in the Sea View bedroom.

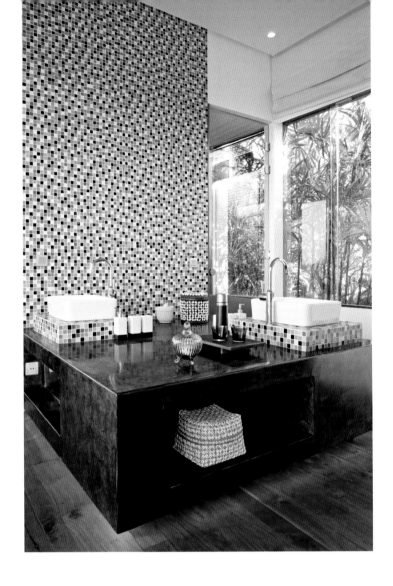

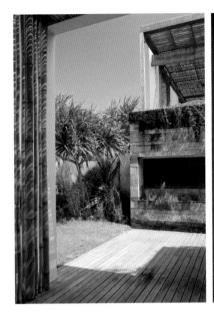
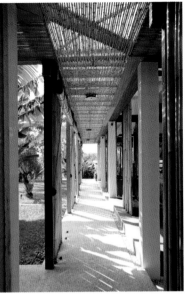
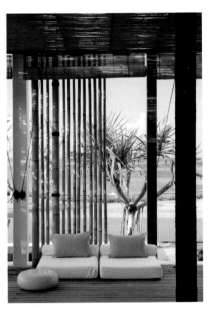

Left to right The complex reveals itself in stages with a low key entrance pathway finished with loose pebbles and large slabs of *kebumen* stone. To begin with one sees a wall, then a roof with reflecting pond (see page 21), a gradual opening, a glimpse of a building, a clever boxy hedge, then interconnecting pathways—before the full extent of the house, pool and sea is fully revealed.

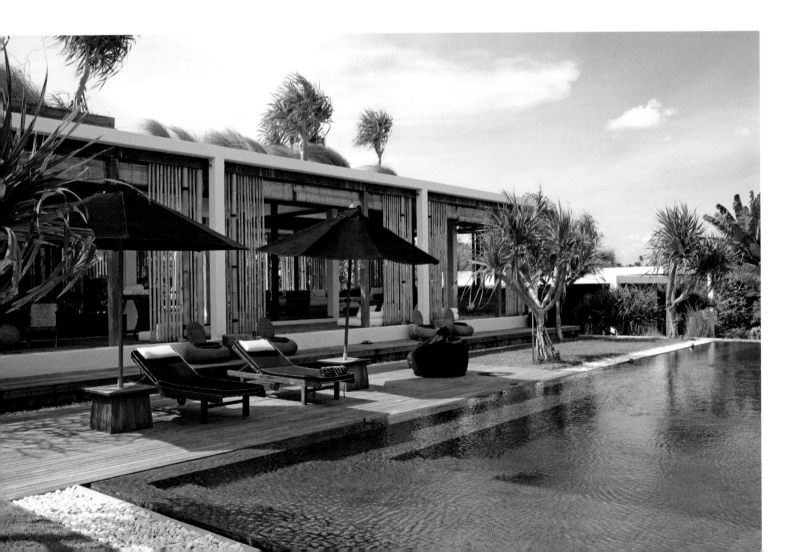

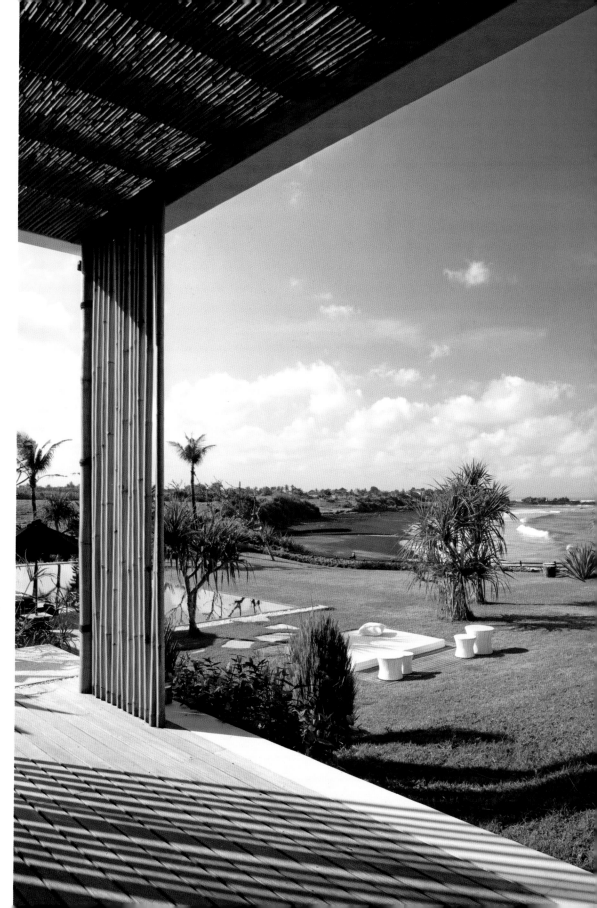

Opposite, below Fronting a simple rectangular pool clad in *batu candi* and green stones and the deserted Nyanyi beach beyond, the main reception room sports glass doors, custom made in Java, with imported tracking. They ensure sea views are a constant, when open or closed.

Right The terrace in front of the Sea View bedroom is set at a slightly elevated position, so offers the best views of Nyanyi beach and the Indian ocean beyond.

In the words of the owners, Villa Tantangan is: "A place to relax, a place to enjoy the beauty of nature. A place to get together with your family and friends or on your own away from the crowd. A place to watch sunrises and sunsets. A place to watch the cows grazing, or the fishermen coming back with their catch. A place to watch the time passing by."

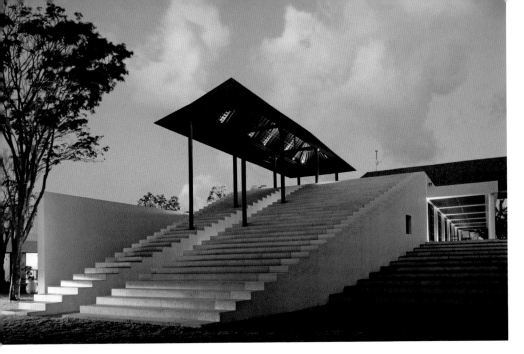

VILLA TANGGA

Stepping up in Style

Architect Ali Reda, ar + d
Location Canggu
Date Of Completion Remodeled in 2010

Above and right Super dramatic by day or night, the villa is accessed by parallel flights of steps, either in creamy Jerusalem stone or covered with a thin layer of grass. A "half-way stop" is protected by a Bali-style roof clad with wood shingles.

According to the architect Ali Reda of Singapore-based ar + d, there are two types of structures that suit the tropics—ones that hover above a site and ones that are anchored to it. At Villa Tangga, a residence he originally designed in 2002-03 but remodeled and updated in 2010, Ali has anchored the villa firmly to its locale.

That's not to say there isn't a bit of "hovering" going on also—as you access the villa up a series of steps (tangga), enter into a long, low volume, then climb more stairs to a second-storey party room that juts out at right angles from its base, you enter the hover realm. Up here, you really are on top of things: there are ocean views ahead, a small temple complex

glittering beneath the sun to the left, and the garden and pool below. And with sliding glass doors on three sides, there's a liberating feeling of being outside *and* above it all.

Owned by a Dutch-Indonesian businessman who wanted to get away from the "whole dark wood Balinese thing", the villa is a clever combination of East and West. There are nods to Asian culture—the steps are inspired by temple approaches or rice terraces or both, there are lotus shaped columns inside, the party room and steps are protected by a wood-shingled, Bali-style pitched roof, and some of the decorative details are Eastern —but the architecture displays a thoroughly contemporary Western language.

The main flat-roofed rectilinear volume sports rooms on the right side with access to terrace and pool, a central corridor and utilities on the left. It also connects with the parking lot here. First up is an entertainment room tucked beneath the steps, then comes a large living/dining room, followed by the bedrooms. A corridor with skylights connects all and separates the living areas from the kitchen and bathrooms and stairs to the second volume on the left. Almost processional in nature, the overall effect is cool and calm—creamy Jerusalem stone, pre-cast elements in the ceiling mimicking Roman or Spanish styles, a few figurines in niches—otherwise little in the way of ornamentation.

On closer inspection, you begin to notice the extraordinary attention to small details. The terrace is etched with a subtle pattern that is barely visible; the screens that protect the sliding doors are made from a bronze mesh that is used in the oil industry (they are super strong so have a security element as well as a

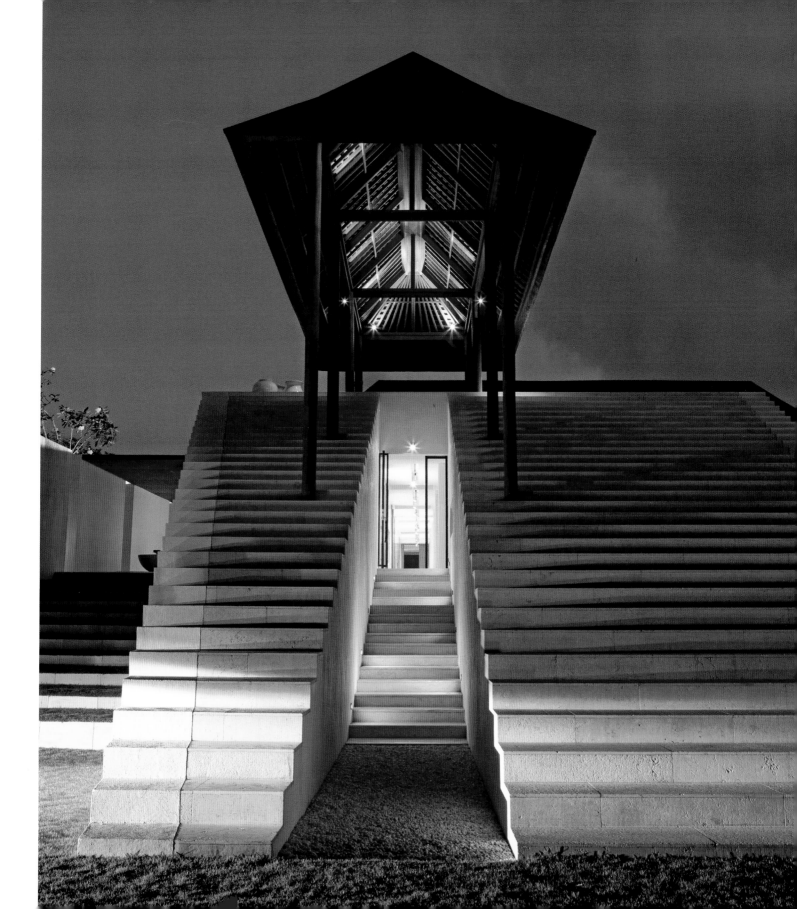

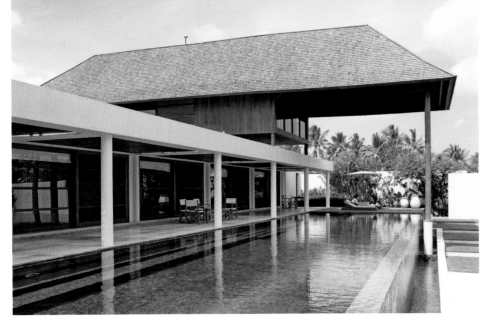

decorative one); the pool is lined with handmade tiles from Surabaya that are fired at a very high temperature so they are all a little different; cool, creamy storage jars, custom-made to a design from Ho Chi Min, replace traditional statuary; the garden is enclosed by a boundary "wall" that resembles a bar code so you can see through to the landscape beyond, yet remain enclosed.

Inside, spare decoration is melded with sophisticated appliances and custom-crafted furniture, including baths and basins carved from single blocks of stone. The overall ambience is peaceful and cool—a true retreat beneath the hot Balinese sun.

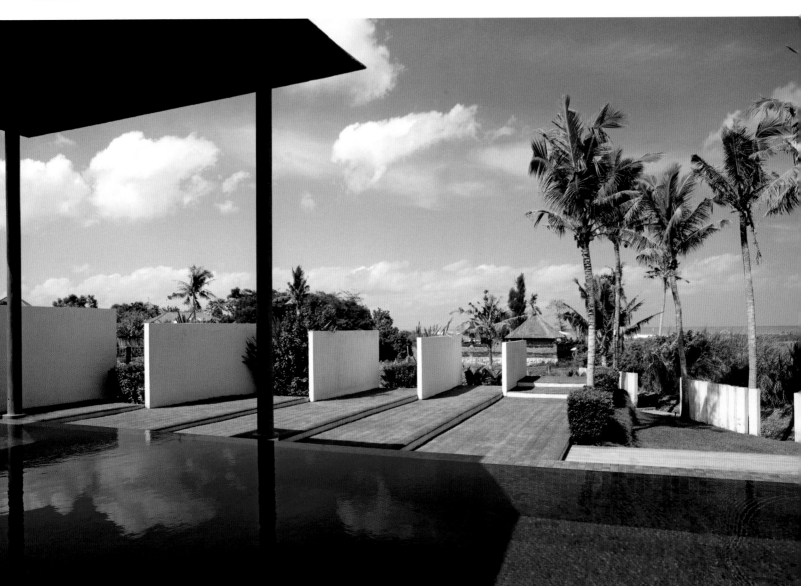

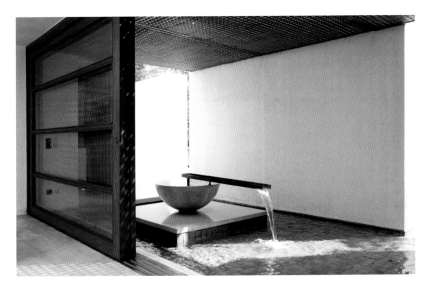

Opposite, top The second storey party room juts out over the pool, giving stuning views across the Balinese countryside on three sides.

Opposite, bottom The property is bounded by a stream, in front of which is a barcode style fence. Each individual stone slab was cast in different sizes, then the slabs were set at random intervals and sizes. It was built this way to separate the site but also connect it with what is beyond.

Left A reflecting pool near the entrance (and terrace adjacent the swimming pool, unseen) is shaded by a slatted wooden screen. The depth and width of the slats were carefully selected to optimize shadow (except when the sun is directly overhead).

Below The palette throughout is creamy-colored, both indoor and out. Dark teak and cream terrazzo with white wall finishes give homogeneity to the entire design scheme.

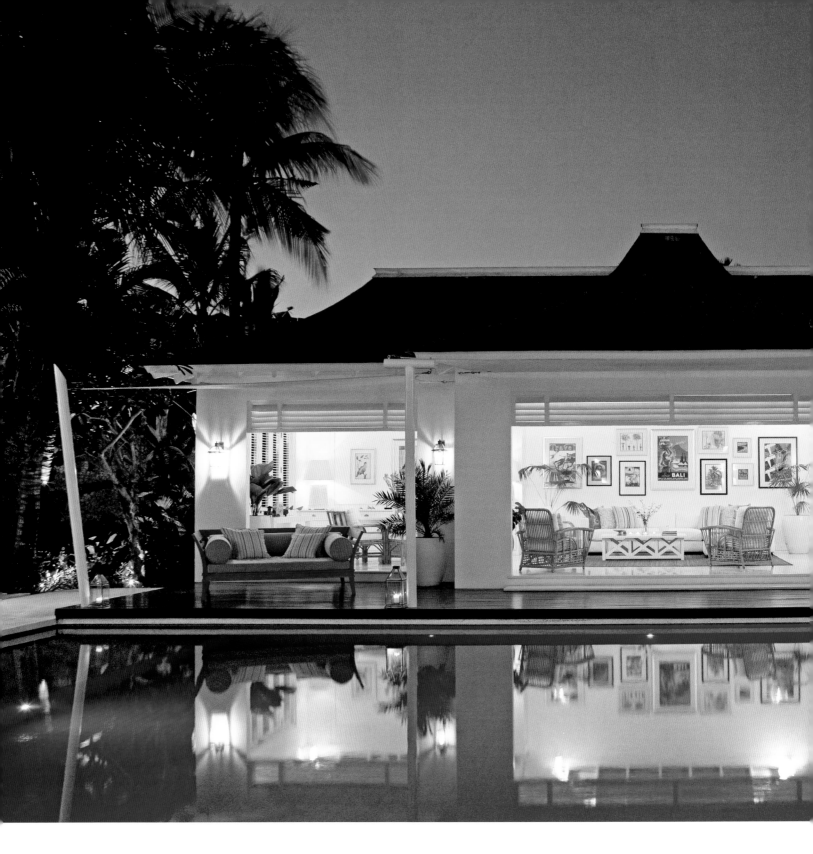

BALI BY DESIGN

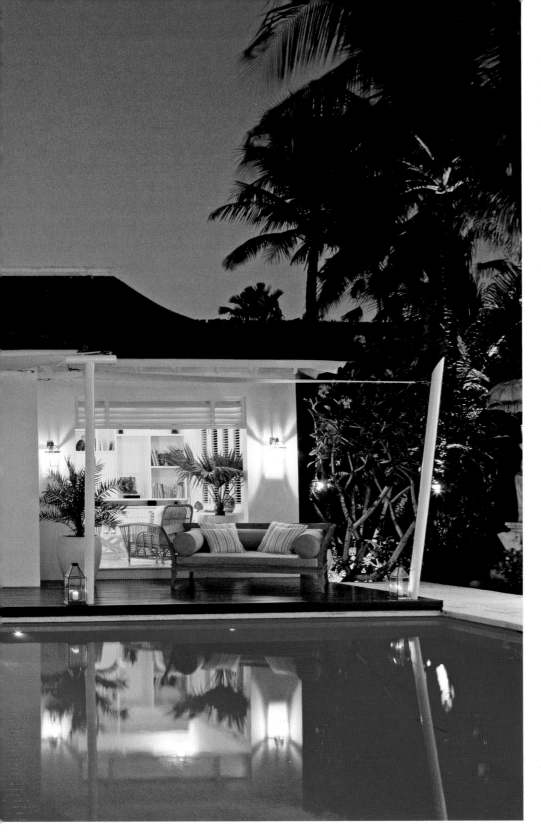

Left Shipshape: Fronted with ironwood decking that is shielded by huge sail-like shades, the open-air living pavilion is a dreamy mix of colonial and cool.

VILLA LULITO

Island Glamour

Architect **Stuart Membery**
Location **Petitenget**
Date Of Completion **2011**

Set in the heart of the prestigious Petitenget area, this plantation-style villa brings to mind languid days in the Caribbean or cool cocktail parties in the Hamptons. The overall effect is one of island glamour from days gone by; where are the grand dames lounging on chaise longues with elegant cigarette holders and long iced drinks, I ask myself?

On second thoughts, I realize they aren't necessary. After all, this white-on-white gem oozes glamour and glitz already. Props would simply be superfluous.

Designed by Stuart Membery, an Australian who relocated to Bali some ten years ago, the home combines retro island chic with an undeniable modernity. Because there are no views to speak of, the spatial orientation of the compound is inward looking, comprising a

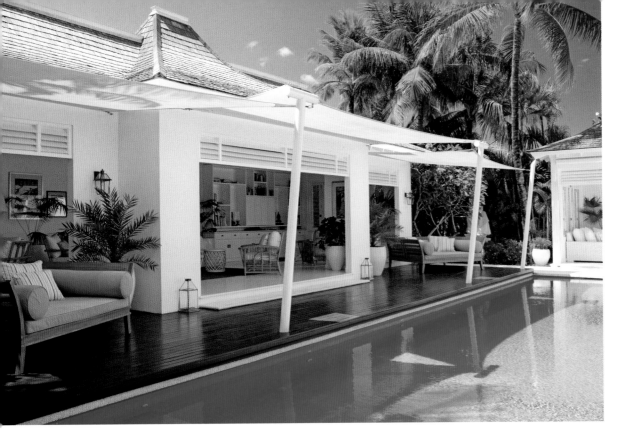

"With Ralph Lauren as our inspiration, we wanted singular island elegance, woven rattan furniture, all upholstery in white on white with the cushions, pool and a pretty garden giving the necessary splashes of color that would enhance the beauty of the villa, along with hurricane lamps set around to give out a lovely soft ambiance." Philly Gebbie, owner

number of stand-alone stone-and-wood pavilions set around a bright blue, decent-sized rectangular pool that makes more than a splash at its center.

Philly Gebbie who owns the property with her husband Tim, has this to say about the creative processes behind the villa: "The design was entirely Stuart's vision, with our brief being 'Ralph Lauren with Indonesian influences'. I guess we envisaged rattan furniture, white mosquito nets, slow moving tropical ceiling fans, dark wooden flooring along with terrazzo splashes everywhere …". She has nothing but praise for Membery, who she describes as an "extremely talented designer in both interiors and architecture", and she couldn't be happier with the end result.

A slightly nautical front entrance gives out into a modern open-plan kitchen pavilion on the left, living quarters ahead, *balé* beyond and a two-storey building housing bedrooms on the right. All overlook the pool. The atmosphere is light, airy, summery, pristine and pure. In fact, as a study in purity, the home has some important lessons to impart: Everything looks super casual and thrown together, but, because of the palette, is far from it—corners cannot be cut and nothing can be hidden in such a clean-cut environment.

The results of meticulous craftsmanship are evident all around: Tongue-and-groove paneling and second-storey balustrades in *benkerai* give a boathouse feel; classical columns set around deep verandahs with overhanging eaves add

European elements; and ground-floor terrazzo laid in situ creates a surface shimmer that contrasts with warm wooden decking and teak floors above. Much of the furniture was sourced from Membery's Home Collection, in particular the bunk beds in the children's room and the mahogany-colored four-posters, with other prints and pieces sourced from Bali-based interior designer, Charles Orchard.

Philly is particularly happy with the plantings in the garden, all of which were overseen by the "very passionate garden designer, Bruce Johnson". She sees the outdoors as more than an adjunct to her villa—rather it is part of the whole. As such, a pretty colorful garden with more than a few ornamentals was a must.

Below An open-plan area in front of the kitchen gives a good view of the *balé* on the opposite side of the pool. According to Philly, the family had always wanted a clean-lined open kitchen feeling: "We believe it suits and enhances family living," she says.

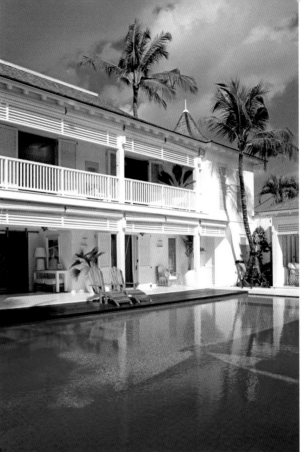

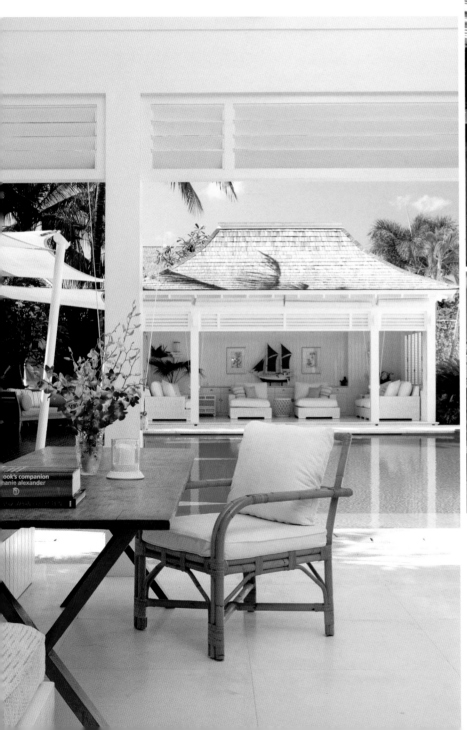

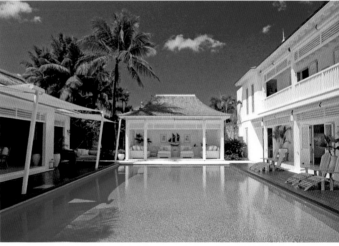

Above and top The living pavilion and bedroom building (on right, above) are fronted by *ulin* wood decking. It's hoped that over time the decks will turn a soft grey to match the grey ironwood shingle roofing.

Above and opposite, top left
The front entrance with its blue doors and wooden awning has a jaunty, boathouse feel. "We adore Ralph Lauren's boathouse in Jamaica and, being so near the sea ourselves, we wanted Villa Lulito to express a nautical element," explains Philly, the owner.

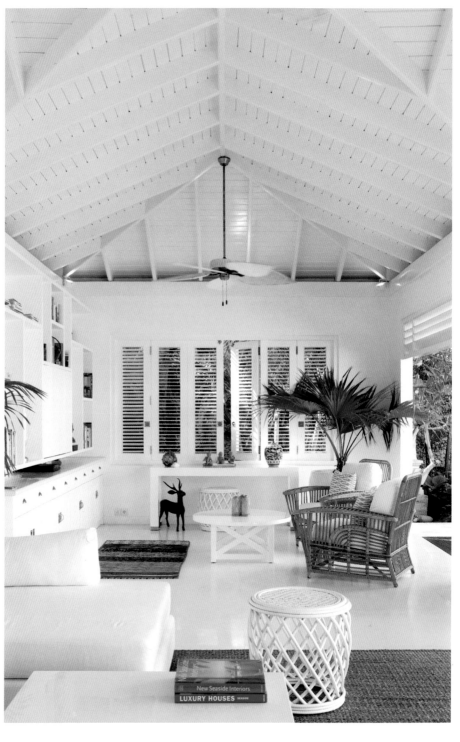

Right, below and opposite, right Comfortable, yet chic, the living pavilion features a pitched roof and creamy stone floors. Many of the tropical prints sourced from Charles Orchard have a Bali theme; mixed with potted palms, they keep the atmosphere light and bright.

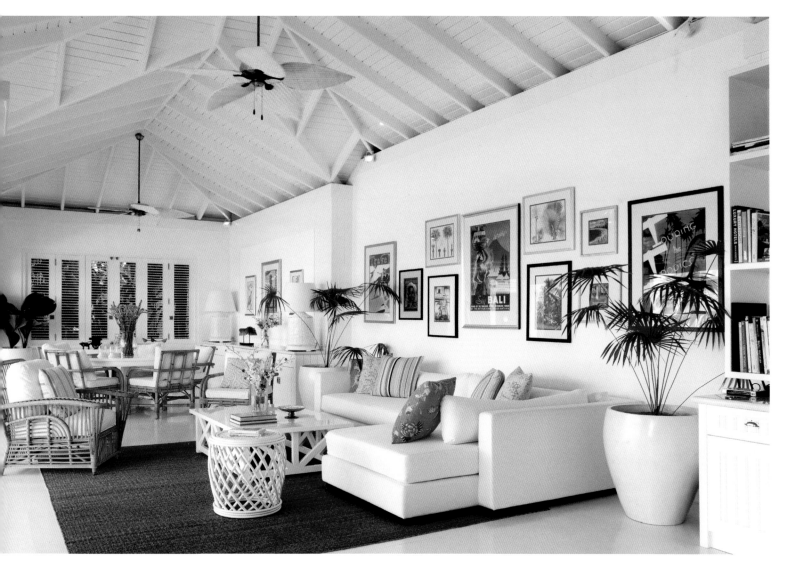

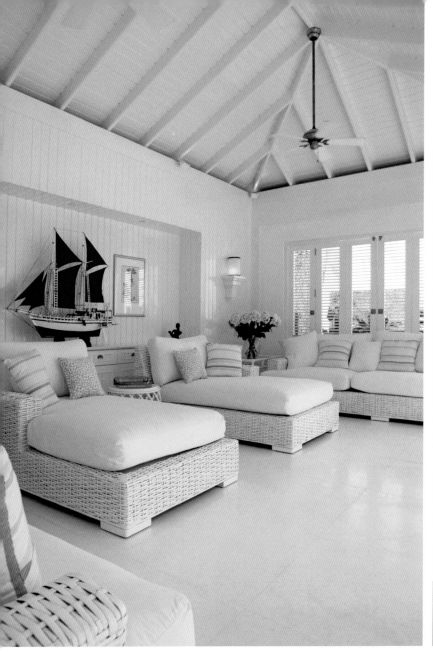

While owners, Philly and Tim, appreciate the traditional Bali style of villa architecture, they wanted their island home to be a bit different. For inspiration they looked at some of the remaining Dutch plantation-style homes in Singaraja, the island's former colonial capital, and in the coffee-growing hills around the town of Munduk.

Above left Splashes of color in the scatter cushions as well as the deep blue sails on the model boat enliven the cool, white-on-white décor in the *balé*.

Above Inbuilt bunk beds in the sweet children's room are from the Stuart Membery Home Collection; practical and stylish, they make for great fun sleepovers. Unlike the other structures, the bedroom building is fully closable, ensuring total security at night.

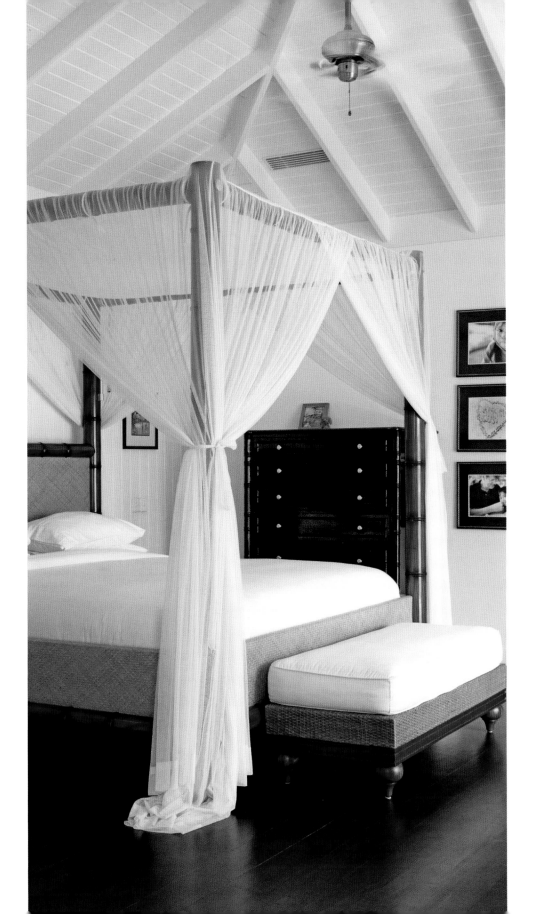

Left and above One of the master suites features a dark glossy bamboo four poster bed with elegant mosquito netting. Antique style drawers, side tables, Indonesian art and illustrations complete the romantic feel. Photos of family are displayed in the up-market adjoining bathroom

BUMBAK 3

Merging House and Landscape

Architect **GM Architects**
Location **Umalas**
Date Of Completion **2011**

The architectural partnership of Gianni Francione and Mauro Garavoglia is well known in Bali for producing a type of tropical villa that is instantly recognizable as a GM Architects building. The duo always tries to minimize the impact of buildings on the landscape, and often combines two different architectural elements together—namely curved ironwood shingled roofs and flat volumes clad in stone.

This home is no exception, lying as it does amidst the rice fields of Umalas. On previous visits to Bali, the two Italian owners rented a GM Architect villa, so when it came to building their own home it was a logical step to employ the duo. "We like their work, we find the homes livable, so we discussed a few options, then chose the one we thought was best for the site."

The house, which took nearly two years from conception to completion, was finished in early 2011. GM signature touches are to be seen everywhere: over-arching articulated roof forms, severe angles, partial walls, picture views of garden, pool and rice terrace, and a built form that fully integrates with the swells of the land. Built on a gently sloping site, there is a detached guest pavilion at the highest point, the main house in the middle and a garden and pool at the lowest level.

"We try to build homes with a variety of spaces —some more open and airy, others more cocooned," explains Mauro. The main living room is of the former variety: With views through the eaves out along a crazy paving path inset with pebbles to the pool and garden, it features stand-alone "walls" in grey Indian stone, a beautifully grained teak floor and several pieces of comfy furniture. "The interiors developed step by step during the building process," explain the owners. "We wanted them to match the style of the house, the materials used, and our tastes, of course." With help from one of the owners' sister, an interior designer, the overall effect is subtle, yet refined, with ethnic Indonesian furniture predominating.

The raised entertainment niche, on the left of the house and accessed by a staircase of black Indian stone inset with teak treads, nestles beneath the open roof. An example of one of GM's "cocooned spaces", it houses a lowslung comfy sofa facing a large DVD screen on a Nakashima-esque table. There's also an adjacent small upstairs terrace with picture postcard views over the surrounding landscape.

Below Most of the furniture was sourced in Bali and often "upgraded" by a local carpenter. A large sofa with batik cushions fills the slightly odd-shaped area on the left.

Right Just above the sofas in the living room is the partially seen so-called eagle's nest: An eerie on the mezzanine level, it contains the television den. Set well away from the main action, it is bordered by a sculptural balustrade on one side and a small roof terrace (seen with green) on the other.

Opposite, below An overall picture of the curving roofs, and stone-clad volumes below can be seen from the far side of the pool.

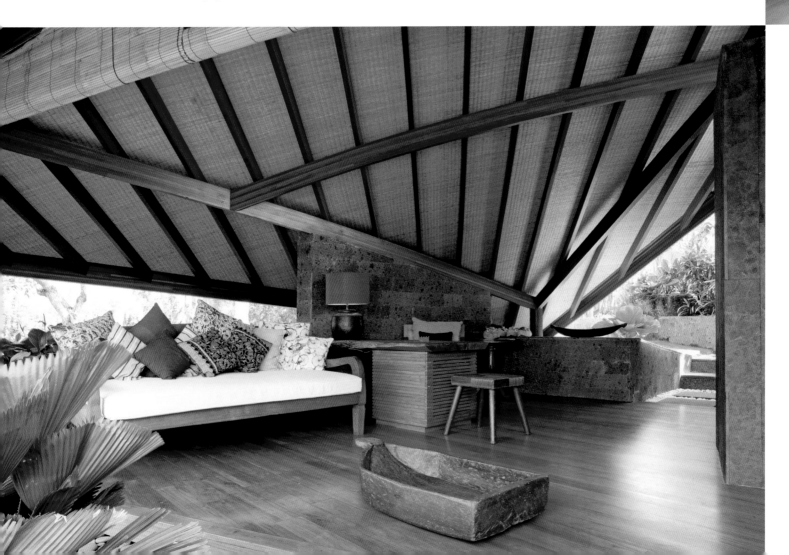

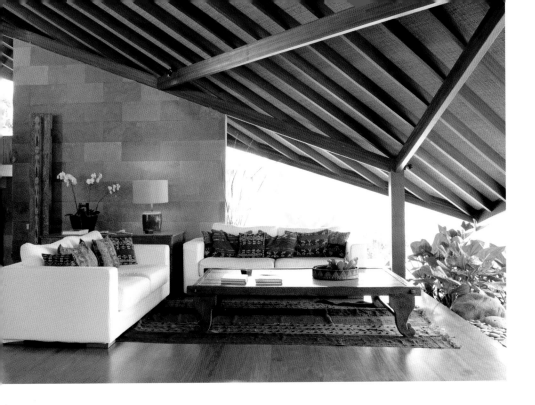

A potentially dangerous drop is masked by a wonderful piece of curving driftwood that is bolted to the floor: part balustrade, part artwork, it is both practical and beautiful.

The three bedrooms each sport a different color theme and are individually styled with much of the furniture sourced in Bali from a variety of local shops. Of particular note are the one-of-a-kind bathrooms with teak sinks and, in one instance, a spectacular teak tub. As one of the owners notes: "The wooden pieces in the bathrooms are really a gift from the island. Where else could you get such craftsmanship and such beautiful teakwood—and in such quantity?"

Where else, indeed?

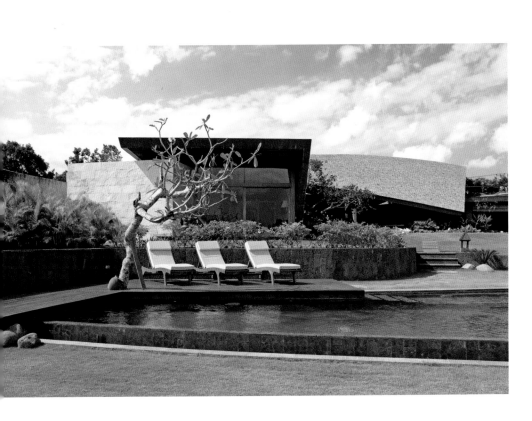

Eclectic artefacts, such as a piggy bank pig donated as a housewarming gift and antique hand-carved shoe lasts set on a bedroom wall, give this home a highly personal atmosphere.

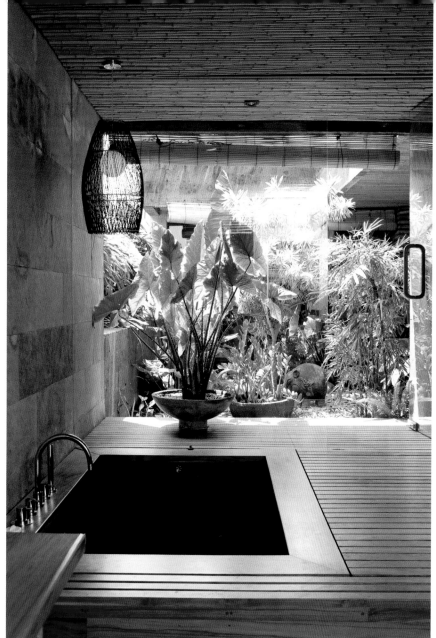

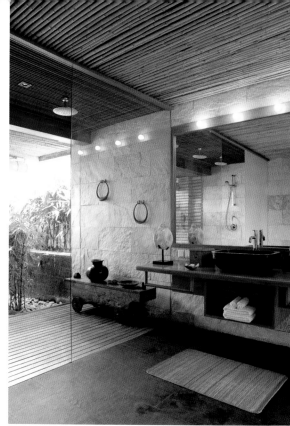

Sited over many levels on a gently sloping site, this home by GM Architects merges into the landscape. All aspects—pool, terraces and buildings—are sited on different levels depending on the contours of the existing topography. Inside is no different, with small garden courts adjoining bathrooms and different levels forming different interior spaces.

Left and right Bedrooms and bathrooms are all styled slightly differently depending on the individual inhabitant's tastes. One sports a classic style with a gorgeous antique panel from Madura serving as a headboard, while another bedroom has an orange theme where the owner's love of Chinese furniture predominates.

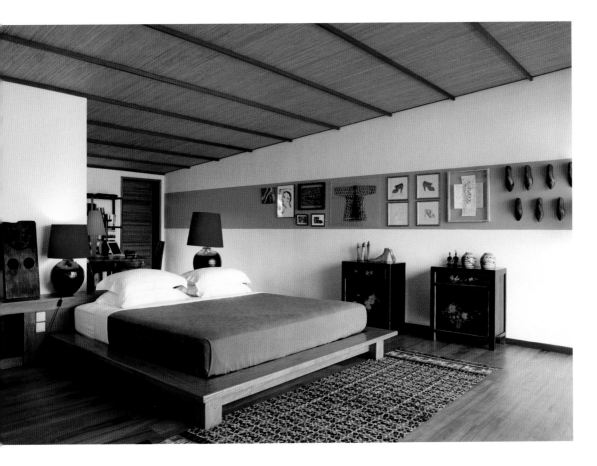

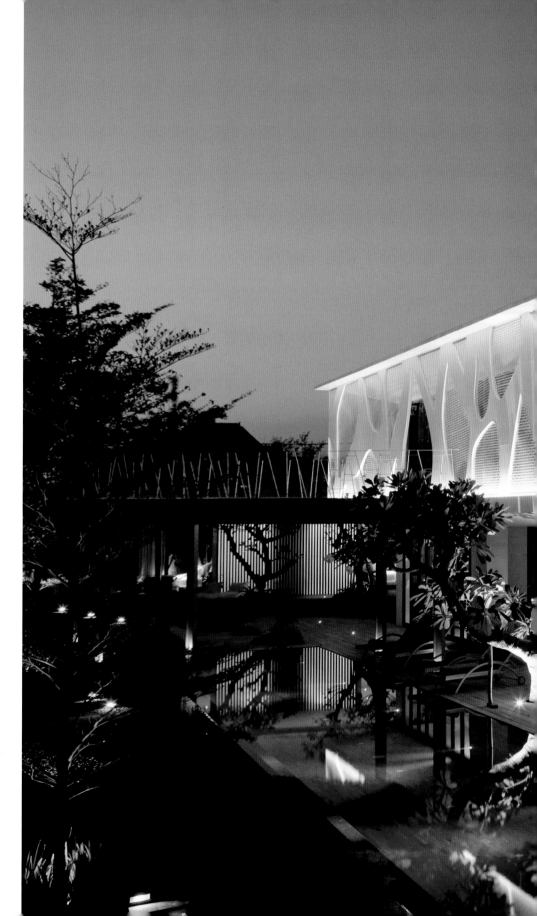

Right The so-called blue hour shows Villa Issi in particularly dramatic mode. It also illustrates the talent of Hadi Komara, a lighting specialist based in Jakarta. His main priority was to make sure that the source of lights was not exposed, thereby keeping a flow of mood and ambience from inside to outside.

VILLA ISSI

Reinterpreting Tradition

Architect Budo Pradono,
Budipradono Architects
Location Seminyak
Date Of Completion 2011

Designed by talented Indonesian architect, Budi Pradono, this home is a stunning combination of modern Western architectural elements and ancient Balinese principles. As such, it met the owner's brief of being minimal and contemporary, all the while retaining a connection to the land on which it sits.

In general, Balinese architecture consists of separate pavilions situated around a courtyard, often with the plot divided into nine areas. Based on a set of cosmological orientations and ritual considerations that influence most aspects of life called *sanga mandala*, the kitchen is generally found at the front of the site, the private quarters at the back. Budi employs this organizational principle at Villa Issi, using the swimming pool as the central

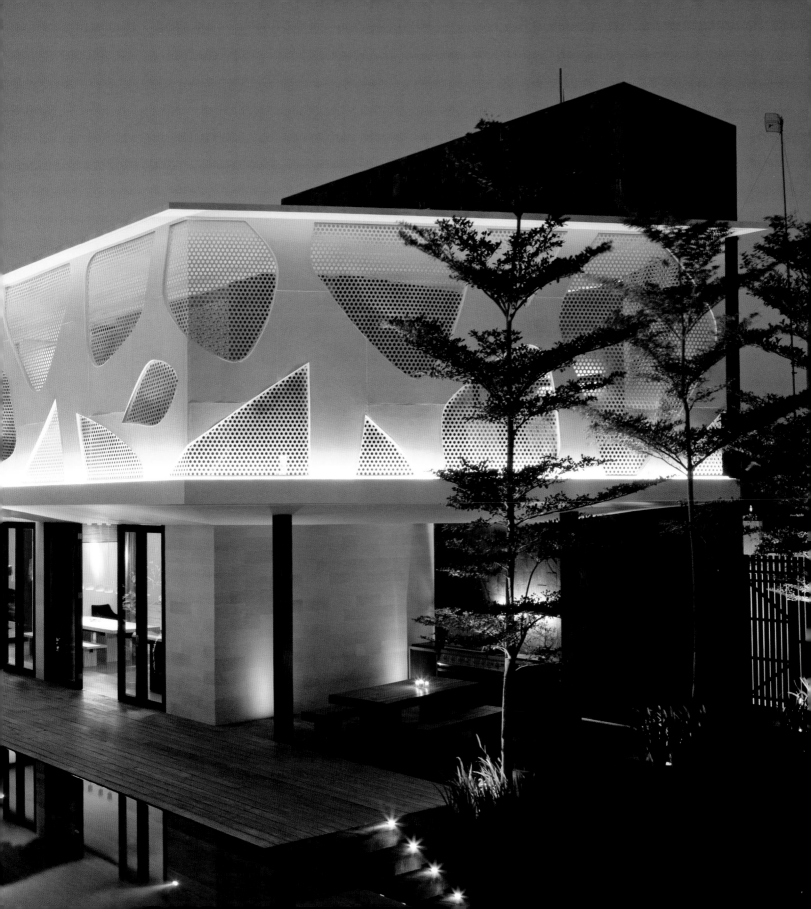

A connection with nature is paramount in this modern house in the center of Seminyak: organic tree graphics on the light-filtering outer "skin", an indoor-outdoor connection with all rooms, a cool pool, plenty of deck space, and sea almond trees planted in a sea of green lawn.

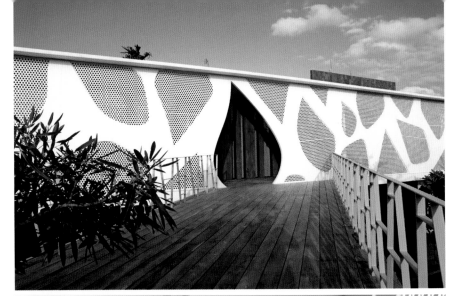

datum from which all the buildings radiate. There's the main two-storey house, a smaller structure housing a gym and deck, and a single storey structure housing bedrooms at the back.

The wow factor the clients wanted comes in the form of a singular secondary "skin" that hugs the upper storey and connects with the pool and courtyard in the form of a bridge. Made from GRC (glass fiber reinforced cement) and perforated metal sheeting, it is white and bright, yet also subtle and secretive, as it provides privacy at the upper level. Rendered with an organic tree graphic, it plays with the light on the west side of the plot, producing different shadows according to the time of day.

Texture, light and space, as well as comfort and balance, were important to the clients, an Australian business couple who fell in love with Bali ten years ago and are delighted to have finally realized their dream home. They wanted

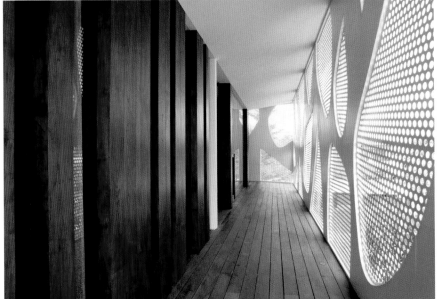

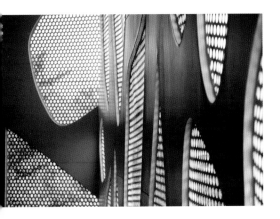

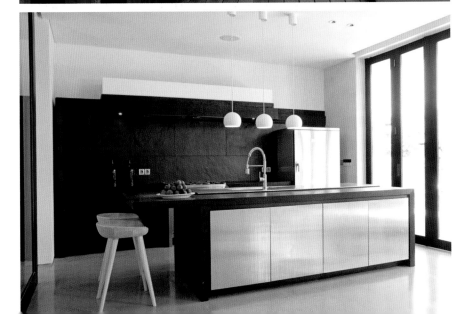

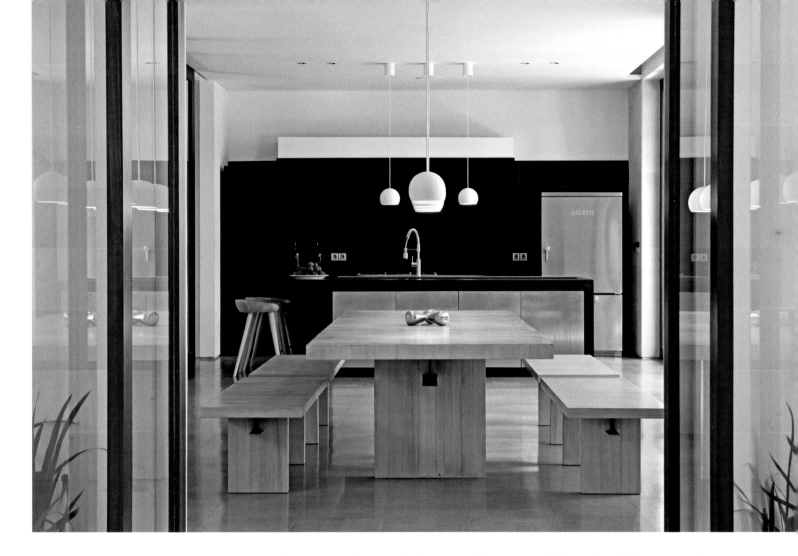

Opposite, top, middle and far left Various views of the bridge and "skin" illustrate the imaginative powers of the architect.

Opposite, bottom A combo of raw timber, stainless steel and black terrazzo gives the kitchen a textural quality. Realized by Jacques Hugen of C+R Creation, it was integral to the owners' vision.

Above The oversized dining table in blonde wood with steel supports was custom made to give a floating feeling, yet also has stability and integrity. Its light color matches the stools, benches and side credenza.

the spaces to flow, one to the next, and boundaries between inside and out to blur. This is more than adequately achieved by Budi, as most rooms have attendant decks, and light and air are invited in from all sides.

The connection to Bali is furthered through the use of local materials—volcanic stone, andesite, sandstone as well as recycled ironwood and teak—all easily obtained on the island. Further cultural reference comes in the form of the entrance: masked by a series of walls with a water feature, visitors have to follow a set route from the road into the compound, with different parts of the villa revealing themselves in stages. Budi explains the reasoning behind this: "I wanted to interpret various community

activities, such as Balinese processions, as a way of appreciating the space. In Bali, religious ceremonies always go through stages of change, so I wanted to bring people into the building as if in a procession. The last stop is the dynamic upper floor."

Interiors wise, Villa Issi is very easy on the eye. "I am always looking for balance," explains one of the owners, "and usually I find it within opposites—black and white, calm and chaos, drama and serenity." Here, a rigorous mono-chrome scheme, enlivened by bright cushions designed and printed by the owners and the odd colorful artwork, predominates, while high quality custom-made furniture is clean-lined and well finished.

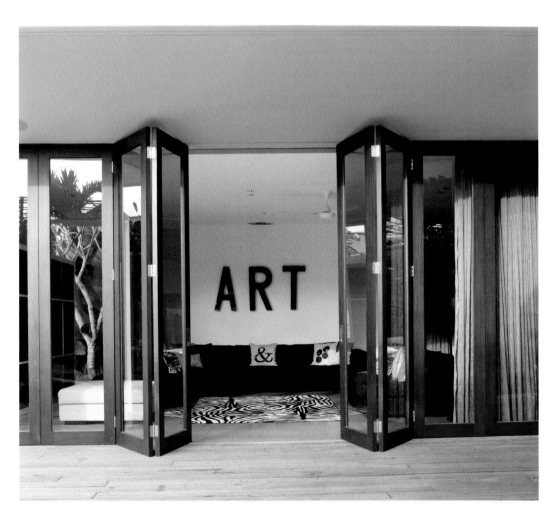

Left and opposite, top
The owners have a shop in Seminyak called Platform 18/27, where Australian designs are manufactured and sold in Bali. Adding a splash of color to the monochrome decorative scheme in the living room is a number of throw cushions, printed in Bali and available at the shop. The custom made sofas and ottomans were based on an Italian design, but were tweaked with dimensions and fabrics provided by the owners.

Opposite, bottom left Again, a black-and-white color palette predominates in the super-luxurious, generously proportioned bedrooms, all with walk in closets. Whimsical charcoal artworks were realized by a Balinese artist from the owners' brief.

Above Quirky, yet cool, no?

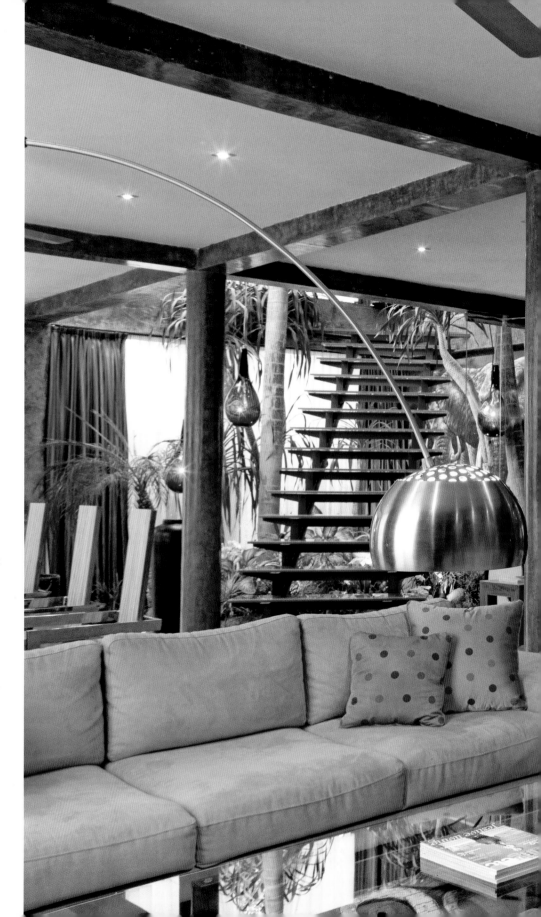

MAISON BERABAN

Luxury Loft

Architect Renato Guillermo de Pola
Location Seminyak
Date Of Completion 2010

This house is representative of a new breed of urban housing that is springing up in and around Seminyak—although its over-the-top decorative details may be more extravagant than those found in "normal" homes! It's built on a small plot of land, there's no garden to speak of, its focus is inwards (as opposed to out over rice field views), and it has a distinctly city feel. Its owner calls it the Bali equivalent of New York loft living.

A bit of a hybrid, the home was originally the restaurant of the small resort that lies adjacent. The owner, René Wilhelm or Renato Guillermo de Pola as he is known in design circles, bought it in 2008 with a view to converting it into a studio; later he turned it into his own residence. After designing numerous homes for the European jet set in Ibiza, René relocated to Bali determined to plan and build a home that incorporated all the grandiose interior design

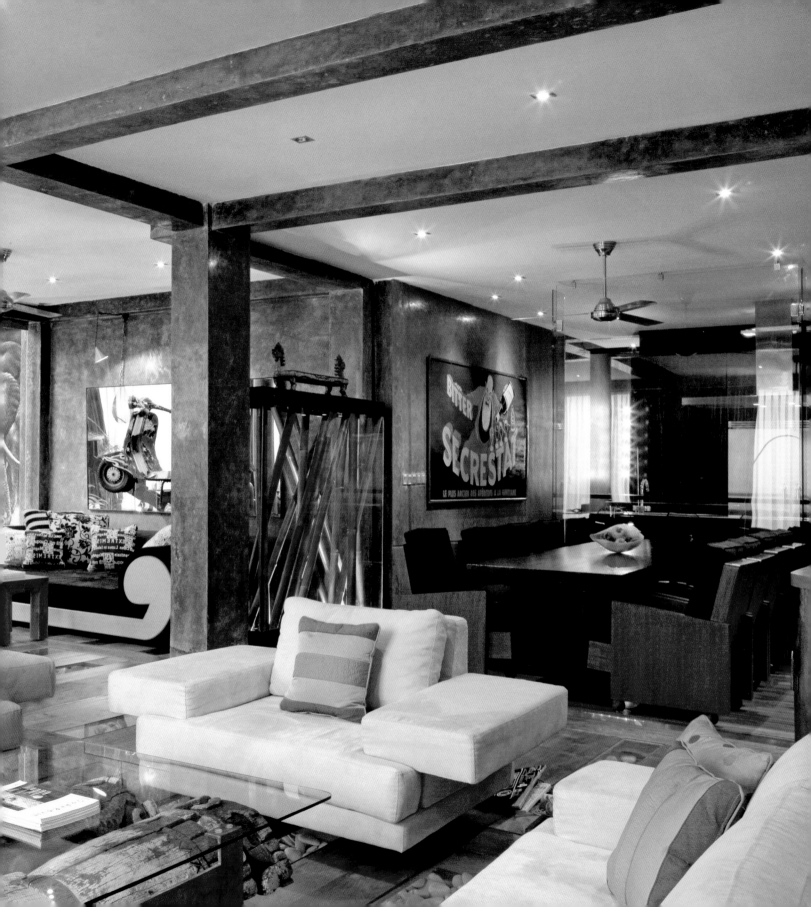

schemes he had not been able to put together —for one reason or another—in clients' houses and apartments in the past.

The result is an emporium dedicated to experimentation, with layout, furniture, detailing and materials combining fine craftsmanship with a bold audacity. From the atrium staircase topped by a glass pyramid to the first-floor entertainment room, there's a surprise at every turn. Nonconformity is the name of the game here. How to transform a simple *lumbung*-style structure into party central? Take a lesson from René.

The first thing the designer did was gut the interior, then work on the exterior. "I decided to leave the *alang-alang* style at the back where the house looks onto the trad-style resort," explains René "but I wanted the façade to look modern." To this end, he put in huge glass windows, clad the walls in concrete, and planted rushes and grasses in planter boxes. From the street, the home looks like a custom-crafted modernist cube.

Inside, the ground floor comprises one open-plan office-kitchen-dining-foyer with areas demarcated by furniture placement rather than walls. There's a workstation with a bespoke glass-and-steel table, a lounge area, an integrated daybed, and an inviting kitchen-cum-dining room. Wonderfully masculine, the kitchen is decked out in black terrazzo and stainless steel with a Boretti fridge/wine cellar taking pride of place. It overlooks a custom-

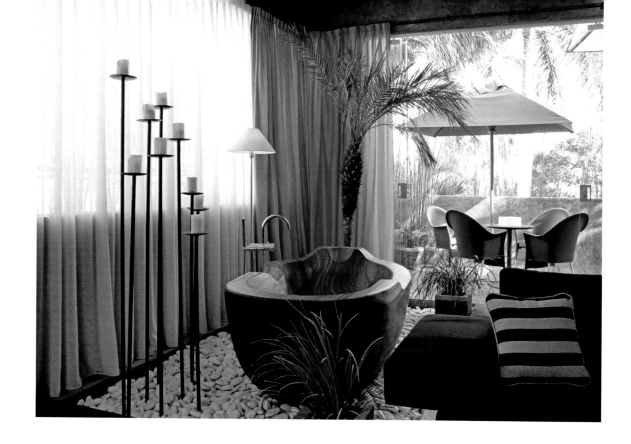

Opposite, left A view of the staircase loking down from the first floor. A small terrace gives some outdoor space.

Opposite, right Aluminum cladding and black terrazzo are the order of the day in the sexy masculine kitchen.

Left An upstairs terrace is located adjacent the party room, where pride of place is given to a custom-crafted wooden bath.

Below A giant chill-out day bed sits beneath an artwork realized by René's team. The other half of the Vespa is still awaiting customization in the designer's Bali studio.

crafted, dark stained table in *suar* wood lined with over-sized comfy chairs. "Nowadays we all want to eat, drink, cook, and socialize together," explains René.

The upstairs lounge is accessed via a glass staircase that sits beneath a huge chandelier and winds through what René calls his "tropical winter garden". Full-size palm trees, yuccas and pendant glass orbs make this the sexiest indoor garden in Bali. "The idea upstairs was to create a chill-out space," explains René, "There's a small terrace for cocktails, two state-of the-art bedrooms with adjoining mezzanine closets, and plenty of party and lounging space." So, what else do on-trend guests require here?

A centrally sited bathtub made from a single piece of wood and floating on a sea of pebbles? Indeed, why not.

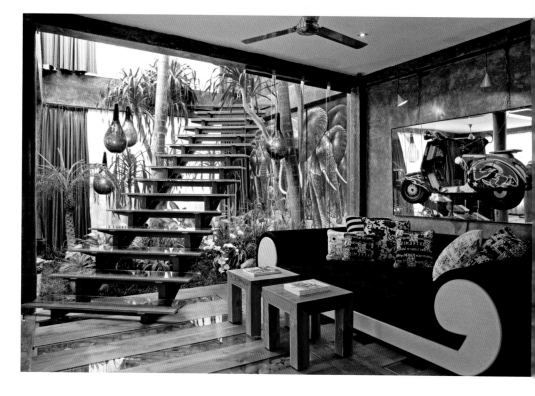

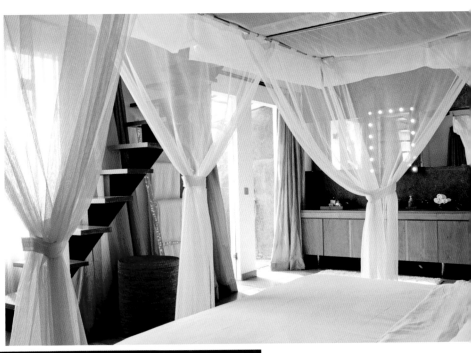

Above far left The highlight of the dining area is this lively painting, a copy of a French poster advertizing an aperitif, realized in oils. The table itself (just seen) uses a glass divider for support; as such, it only has one leg at the far end—a highly practical solution for diners.

Above middle Attention to detail is paramount, as evidenced by the superior workmanship of these stairs and balustrade.

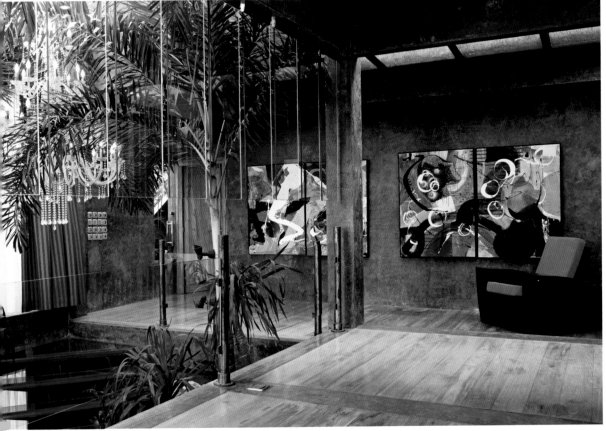

Left Upstairs, two paintings by Pascale Doumeng—"Cool Brain" on left and "Windy Thoughts" on right add color to a sleek space. The teakwood floors work well with polished plaster and black sand walls. The chandelier is from Lightcom, a lighting store in Kuta.

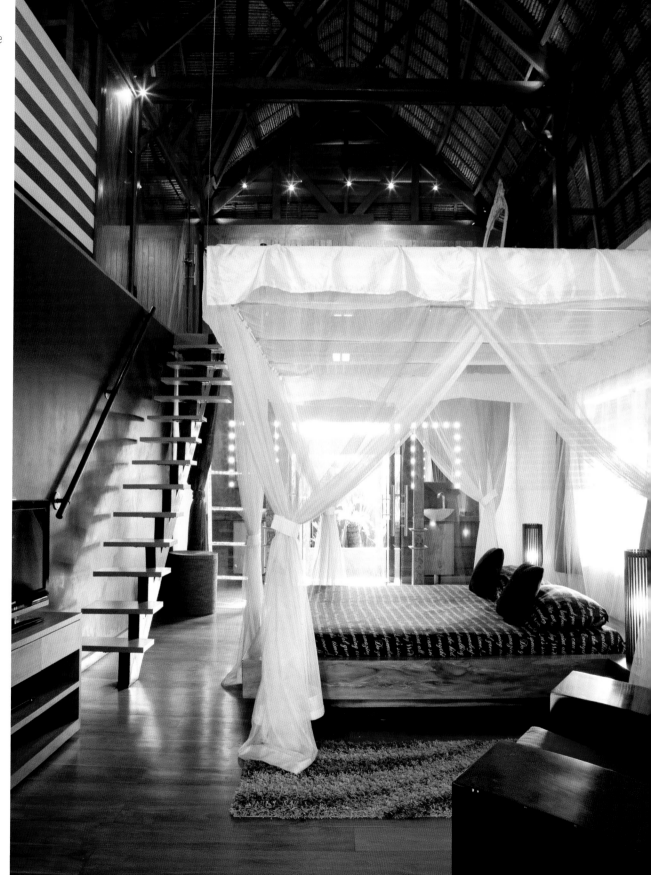

Urban in vibe, style and materials, this loft-style home is one of the first of its kind in Bali. In the old days, homes were oriented towards the outside; now, as space becomes a premium, people are building with an inward focus. At René's home it looks as though the drapes are never opened, as the view is out to a busy traffic-laden Seminyak street.

Above and right The two bedrooms are joined in the loft by a shared mezzanine wardrobe level accessed by somewhat scary steps. A slightly Japanese feeling predominates here.

VILLA ASLI
Purity of Vision

Location Kerobokan
Date Of Completion 2011

According to this villa's owner, the word *asli* translates from the Indonesian as "pure" or "authentic". As such, it is a fitting name for a residence that uses a number of traditional Indonesian structures at its core. The fact that it then dresses them flamboyantly with a modernist European sensibility ensures its inclusion in this book.

Comprising a number of *joglo* roofed homes and *gladags*, traditional wooden structures from Java, as well as a Sumatran house, all set around a swimming pool and ornamental lily pond, the home is positioned in pristine rice terrace country. Designed by a French publisher and her art collector hotelier husband, it is not the first home the two have collaborated on: Previous projects include a Savoyard chalet in the Haute Savoie and a Provençale residence in St Tropez. In the owner's words: "A common point between all our creations is that they incorporate their environment and appear as if they have always existed; hence the authenticity from our Balinese villa's name."

Having said that, despite the vernacular inspiration, Villa Asli's ambience is undeniably contemporary with all interior furnishings

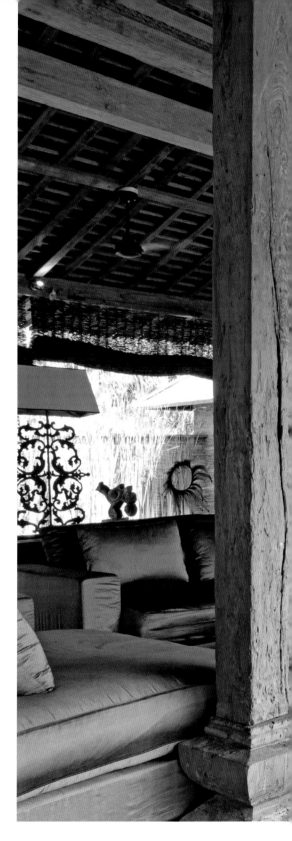

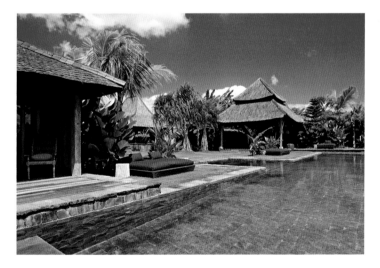

Right Too avoid the décor becoming too rustic in the main living pavilion, the owner incorporated modern sofas upholstered in decadent silk along with painted furniture she found in China. Torajan panels transform into carved coffee tables, tribal totems stand sentinel as ornaments, and lamps are made by the studio of Stephane Sensey, a French designer based in Bali.

Left A generously proportioned pool acts as the anchor in the middle of the complex.

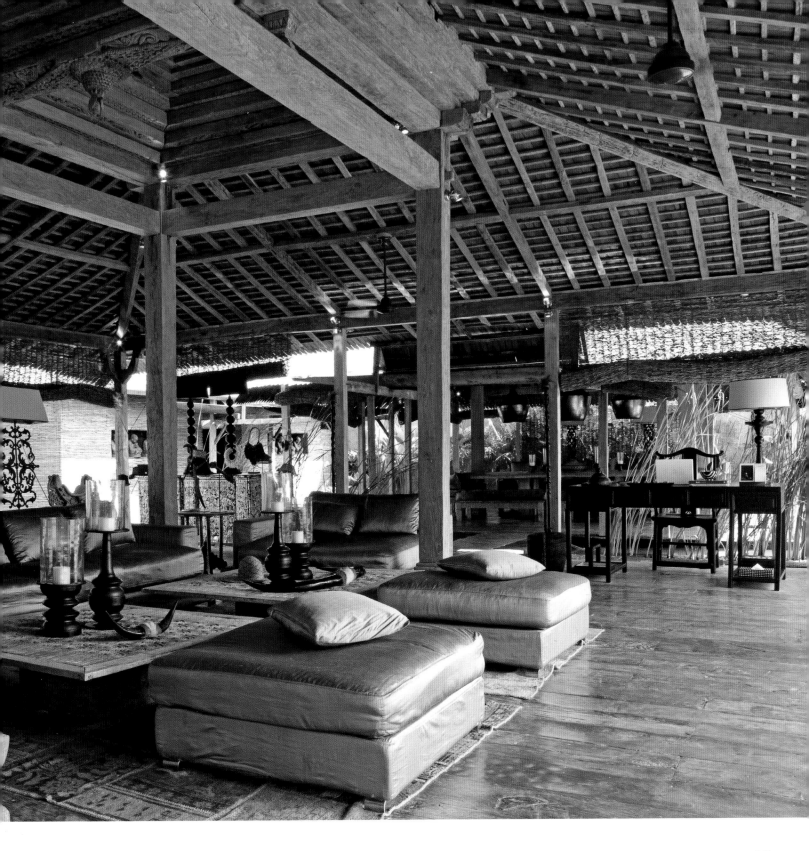

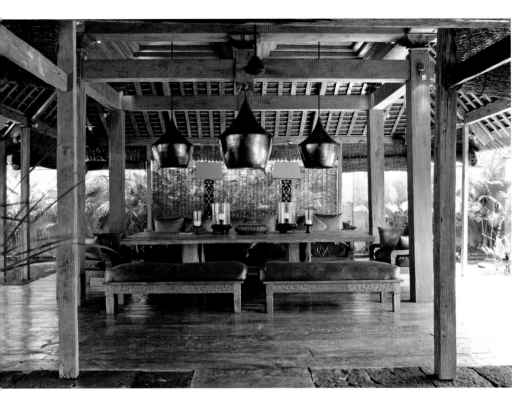

sporting a high-style, almost urban aesthetic. Along with teak and ironwood, traditional statues, carvings, and artworks are sleekly styled, custom-crafted furniture pieces upholstered in crisp, luxuriant Chinese silks. All are the result of the couple's unique vision.

Three main pavilions—the living, dining and bar areas—are placed so that they seemingly float above a lily pond at the uppermost part of the site. The main living pavilion is particularly impressive: Its elaborately carved beams soar up towards a steeply pitched pyramidal roof form supported by a system of interconnected pillars. Beneath is a sumptuous seating area positioned round two coffee tables made from panels from Toraja and backed by a custom-crafted console scattered with artifacts from all over the archipelago—necklaces, shields, musical instruments, spears, combs, statues, totems from "Sumatra, Toraja, Papua New Guinea, China, the four corners of the 17,000 islands of Indonesia that I finally found time to discover …".

Below and adjacent a tranquil swimming pool are seven more stand-alone buildings set around ornamental water gardens and accessed by wooden walkways. They house a pool house and massage *balé*, along with five double bedrooms, each furnished slightly differently. There's a *gelebeg* or rice storage barn with an open living room at ground level and a cosy bedroom above. My personal favorite is the Sumatra house: here, luxe lacquer combines with silk finishes for a Chinese-themed interior that wouldn't look out of place in a retro-modern loft in Shanghai.

And for outdoor bathing fans—the bathrooms are quite simply spectacular: Decorated with petrified wood, super-sized shells, lanterns, stones, and statues, each has a garden court element and truly sensational showers and tubs. They bring to mind baroque bathing, sybaritic spas, five-star pampering—inviting guests to truly indulge.

Opposite, top The owner searched for a long time to find a piece of wood for her dining area, but eventually she found two pieces of teak that could be joined to accommodate up to 14 people comfortably. The benches are custom-crafted from old teak, while the suspended lamps were also built to order. "I wanted an antique look without sacrificing practicality and contemporary comfort," she explains.

Opposite, bottom Antiques of an exceptionaly high quality are the norm.

Right The large kitchen, a combination of practicality and style, is ideal for both eating and cooking. A black terrazzo counter, dressed with antique wood from Toraja, sits before a selection of stainless steel restaurant-quality cooking equipment. Tin boxes, that double up as lanterns in the garden, add a cheerful accent. All the furniture was built to the owner's design by the studio of Stephane Sensey.

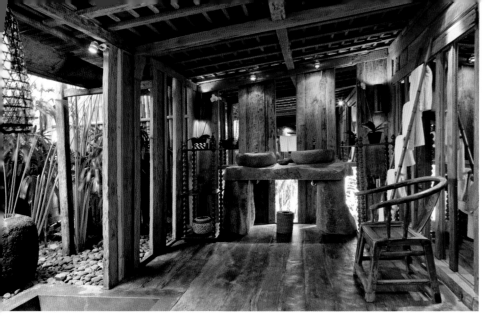

The owner, a famous designer and collector from France, traveled quite extensively throughout the Indonesian archipelago and further afield, to acquire the furniture, furnishings and artefacts in Villa Asli. Beautifully polished teak and ironwood are utilized—from floors to ceilings to roofs. Exterior porches provide serene views of the expansive gardens, bedrooms are extravagantly luxurious, and ensuite bathrooms all have private garden courts.

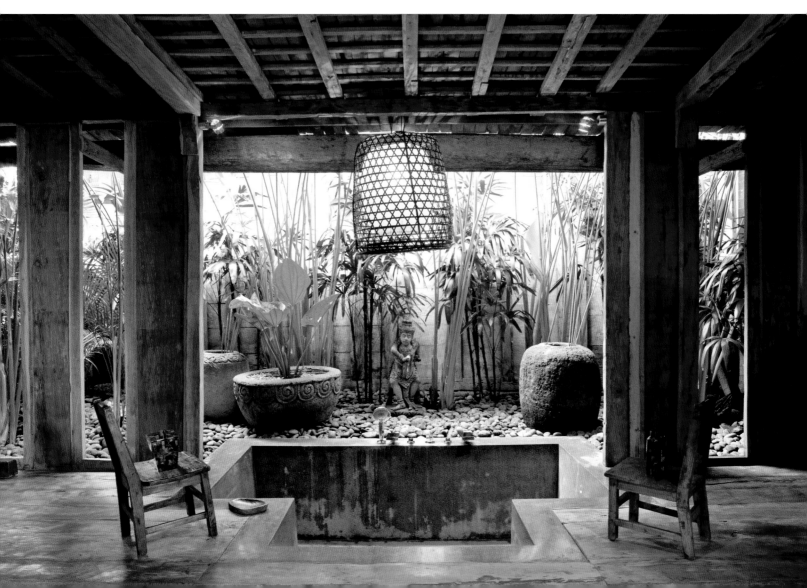

Opposite Bathrooms are a sensuous mix of indoor and outdoor, with over-sized tubs, roughly-hewn sinks, statuary and petrified wood for ornamentation, and exotic plantings.

This page Bedrooms all feature private porches and seating areas, as well as sumptuous beds. In the bedroom below, primitive art and a headboard from Toraja form the focus, while the simpler furniture on right is lacquered in red.

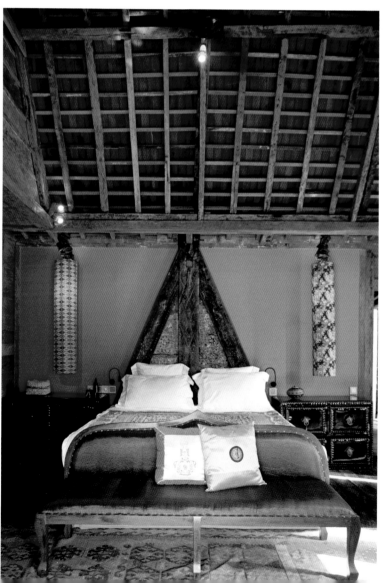

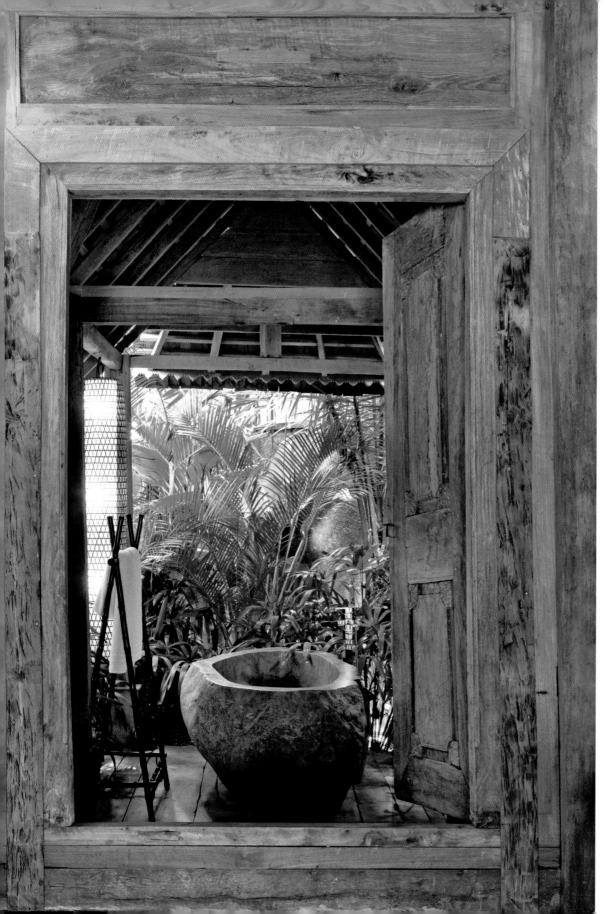

The defining exterior aspect of the structures at Villa Asli are found in the various roof forms: The joglo roof structure, for example, is a steeply pitched pyramidal form that joins a relatively flat-pitched outer roof; no nails are used in construction. In many cases, old tiles have been replaced by ironwood shingles.

Left A bathtub carved from a single piece of rock and framed by an antique door gives new meaning to the outdoor bathing experience.

Opposite, top and middle Furniture and finishings are luxuriant and chic, as exemplified by this antique desk and sexy fabrics in drapes, upholstery and carpet.

Opposite, far right and right *Lumbung* and *joglo* roof forms are etched out against a beautiful blue Bali sky.

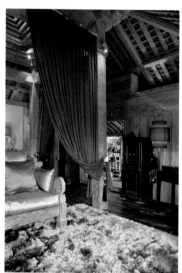

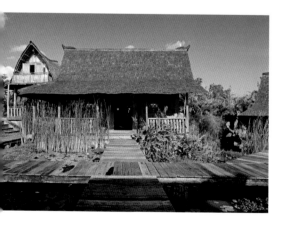

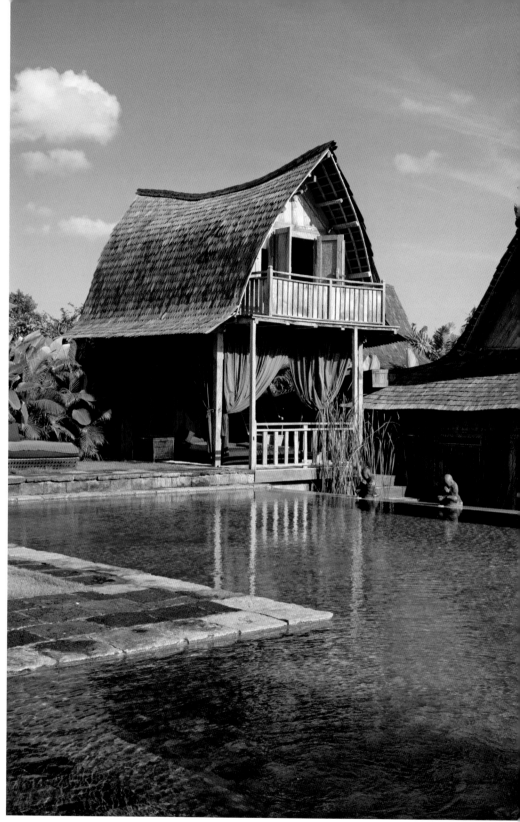

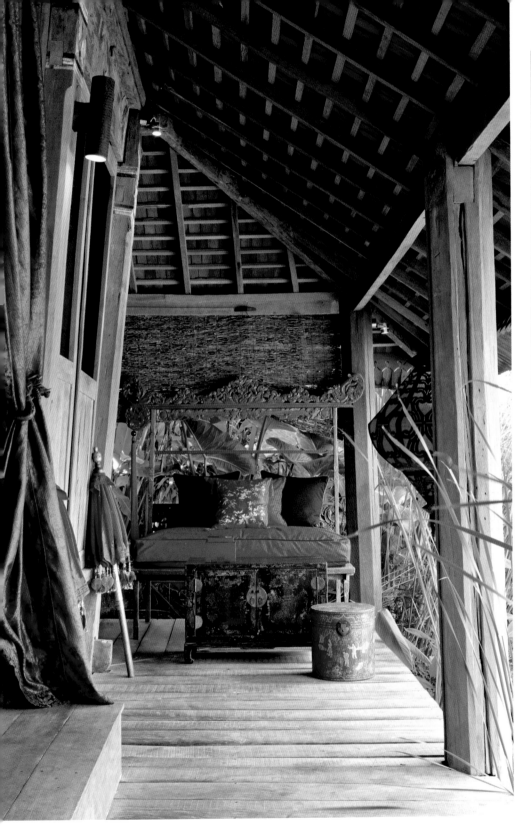

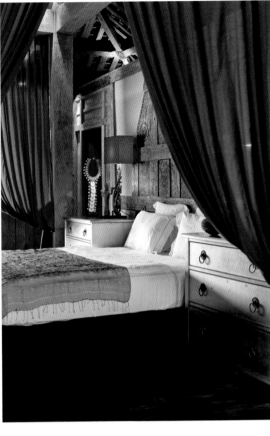

Left Self-indulgent, boudoir chic is the name of the game in the two-storey Sumatran house where a sexy black-and-red Chinese inspired theme predominates. The porch, decked out in lacquer and silk, leads into a room where an antique Javanese bed is teamed with a red lacquer day bed festooned with hanging lamps made from fish traps. Upstairs, another bed nestles beneath the eaves with a distinctly opulent Oriental air.

Above In the master suite, an old Javanese sofa sits at the end of the magnificent bed topped by a headboard crafted from a giant Torajan house panel. The desktop in stingray and the luxe of raw silk in decadent drapes are sensuous, textural additions.

Opposite, top A stand-alone tub in creamy terrazzo adds a touch of modernity amongst a rustic garden bathroom environment.

Opposite, below Decorative ornamentation at Villa Asli comes in many forms: Chinese cabinet lock; tribal totem; religious statuary; Chinese good luck charm.

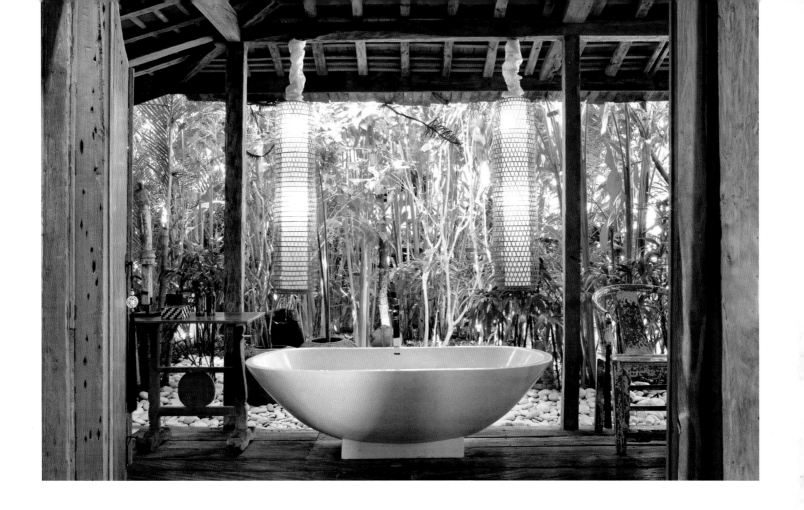

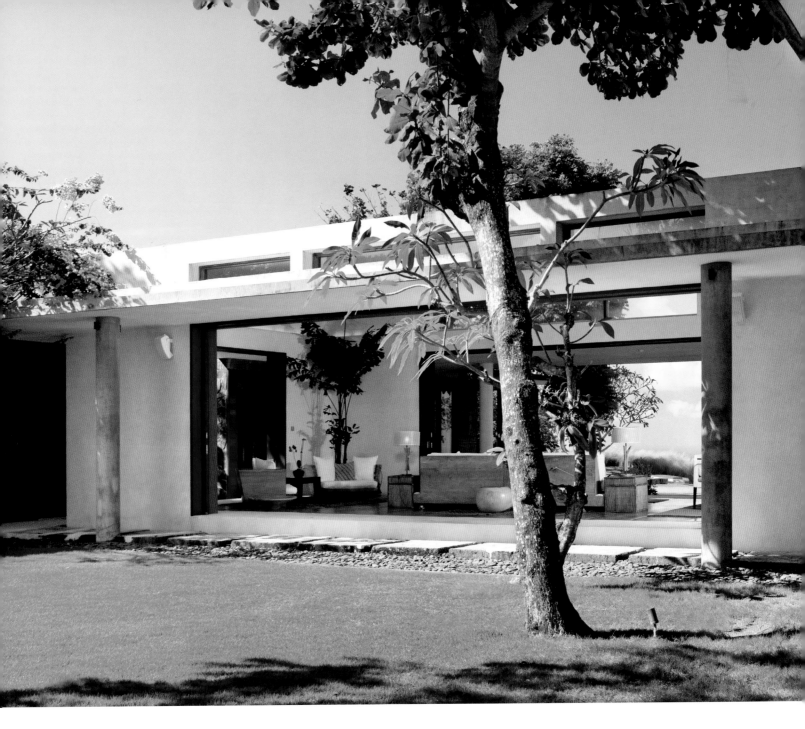

Above Architect Yew Kuan explains that he was able to experiment freely in the design of this house "because the Bukit is a unique place that is free from the cultural weight of many other parts of Bali". As it is dry, rocky, raw and full of light, he felt able to snuggle the house into the rock, make it discreet as it were. This view from the central court shows this aspect perfectly.

Opposite Fountain grass, similar to *alang-alang* but a bit more decorative, delineates the property at the cliff's edge offering just the right amount of softness between lawn, sea and sky.

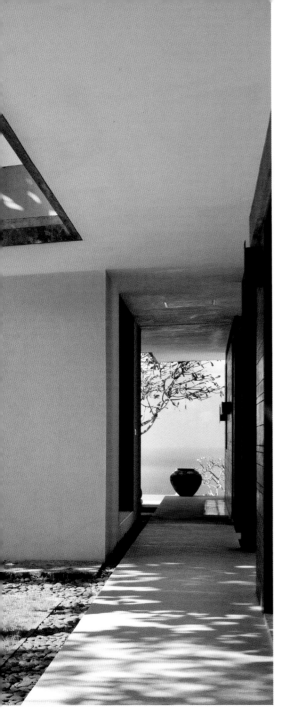

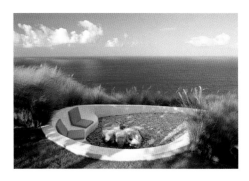

Bukit Beauty

Architect Cheong Yew Kuan
Location The Bukit
Date Of Completion 2011

Set high on the southern peninsula of the Bukit overlooking the Indian Ocean, this house is all about light and air, sea and sky, nature and—dare we say it?—the cosmos.

If that sounds too overwhelming a viewpoint, take a look at the view. I defy anybody who visits and looks out over the ocean not to initiate a small rumination on what it means to be a small cog in a huge machine, a tiny star in an immense firmament. Then, transfer your eyes from outwards to inwards, towards the simple yet sophisticated architecture of the residence—and you're likely to begin dreaming all over again.

Comprising a series of orchestrated spaces in two separate flat-roofed structures, the home was designed by Cheong Yew Kuan, an architect who is well known for producing bespoke works that are very much anchored in their individual localities. Here, the locality is all about the view. Each and every room employs carefully engineered sea, sky and horizon views. Indeed, there are views through views, and views within views. There's even a concrete cube yoga studio, hollowed out of the cliff below the house, with its own private view. A more sublime spot to meditate would be difficult to conjure.

As Bali is about equilibrium and balance, so is this home. The house mixes contemporary and indigenous elements—white-painted wood, bleached and roughly hewn stone, whitewashed walls, slim roofs in concrete—and combines them with garden, terraces, courts and water features, as well as the view. The rectangular living room is a study in tranquility; the airy kitchen, with all mod cons and fossilized stone countertops, is clean-lined and attractive. Bedrooms and bathrooms are no less inviting: cool under foot, each combines certain Asian elements (split bamboo opium mats, pebble-inset walls, roughly hewn giant fern poles, ethnic fabrics) with modern amenities and oodles of space.

The owners see the house as both a retreat and a living, breathing entity connected as it is to its surroundings. They are also deeply committed to preserving nature and the natural way of things, with a veggie garden going from strength to strength out front, and a garden that has been landscaped by Karl Princic of Intaran Design. "There's a very specific micro-climate in the Bukit," explains Karl, "so it didn't make sense to try to create a standard lush

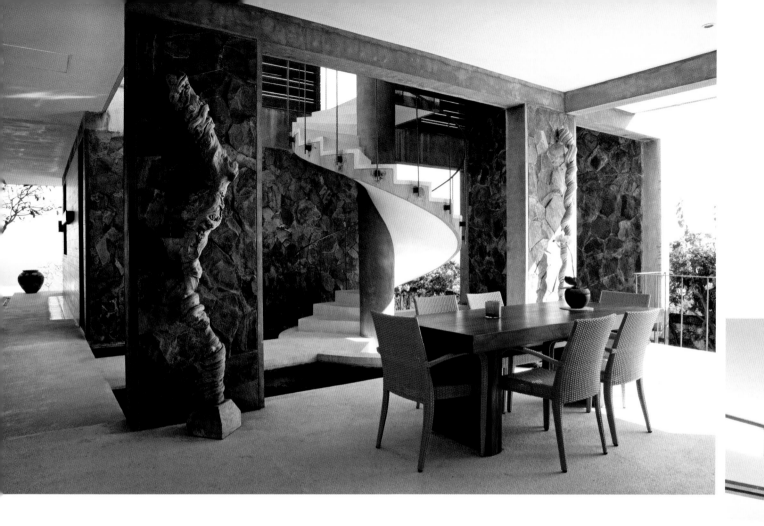

tropical oasis because it would not have blended with its surrounds and would have been difficult to maintain."

In addition to the large existing *juat* tree that is indigenous to the Bukit, Karl added plants and trees that withstand drought and are compatible with the Bukit environment. In the same way, Yew Kuan keeps the color palette light and natural, with many of the materials sourced from the immediate locality. It was his intention that over time the weather would further bleach the wood and steel to produce a patina that is borne from the site. As he puts it: "You don't want to compete with the site as there is such beauty there already. Serenity was a quality I wanted to achieve, along with gentleness of use."

Opposite, top This airwell with its concrete cast circular staircase is lined with selected rough stones from the Bukit. It leads down to the staff quarters and up to a roof terrace.

Below and opposite, bottom The vast living room features a large sofa, positioned so as to take in the view. It was a gift from neighbors, who own Old Java, a furniture company. Adjacent are two low chairs with angled arms designed by the architect.

Left and right The owner's study is lined with in-built bookshelves and features a trestle table as a desk. On the desk is an antique eye-glass case, the bottom made of wood and the carved top made of an ivory-type material, that the owner found in a market in Beijing. An old Chinese poem is etched in the top, while both ends sport finely carved dragons.

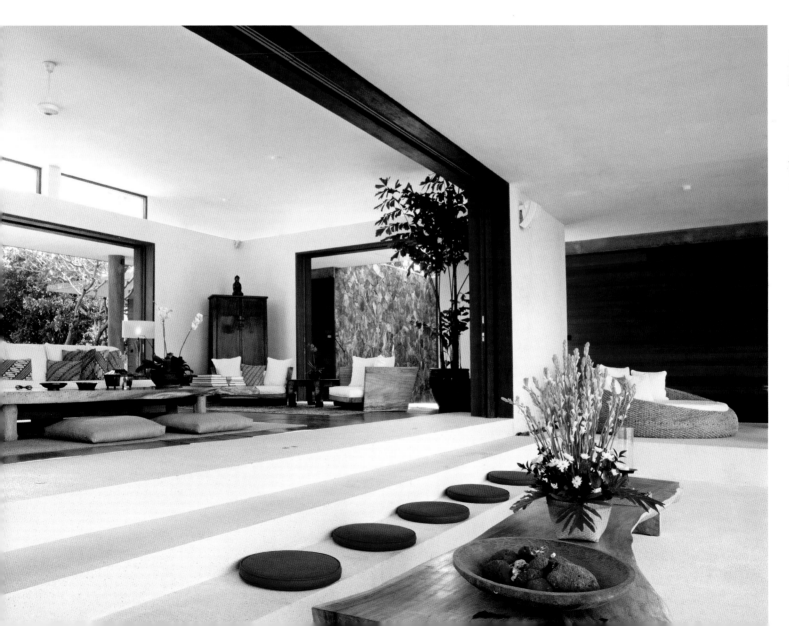

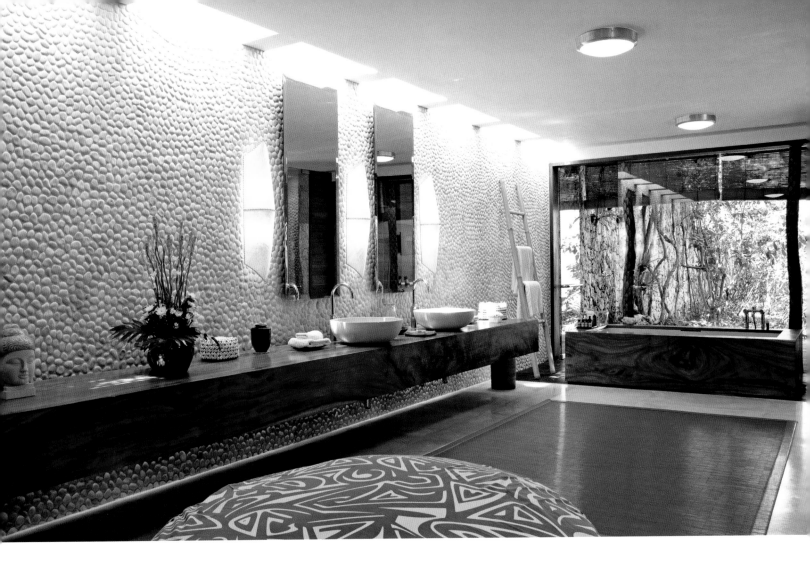

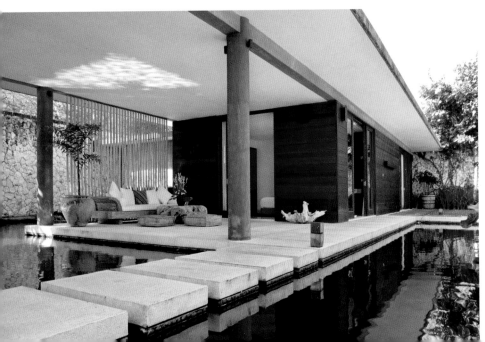

Above and opposite, bottom Minimalist, yet textural, the bathrooms feature pebble-inset walls, cool stone floors, and lots of wood. Most have an outdoor element; the elegant columns are trunks from giant tree ferns.

Left A water court separates the guest pavilion from the main house. A particular delight is the positioning of the terrace by the guest accommodations set at exactly the right level to view the horizon through the open-plan living room.

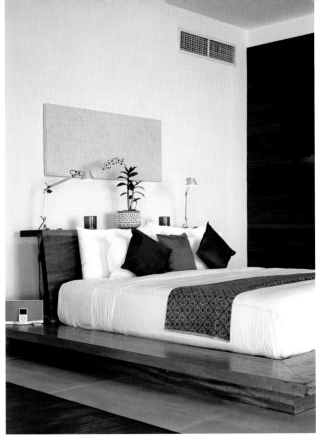

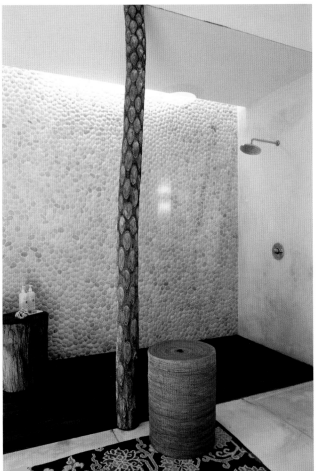

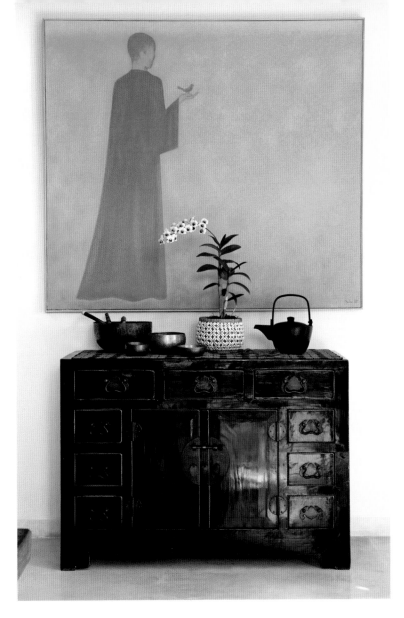

Above left A platform bed, a minimalist artwork and local color in the bed runner and throw cushions—what else do you need for a pleasant night's sleep? Made from traditional Japanese hand-made paper by the Ubud-based artist Naruse Kiyoshi, the artwork's texture comes alive at night with a magical design of shadows and dancing forms visible across the canvas.

Above The peaceful simplicity of "Monk with Lotus Leaf"(1997) by Vietnamese artist Hong Viet Dong matches the atmosphere in this serene, elegant home.

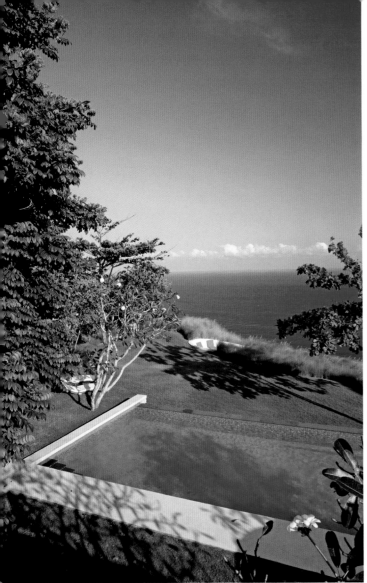

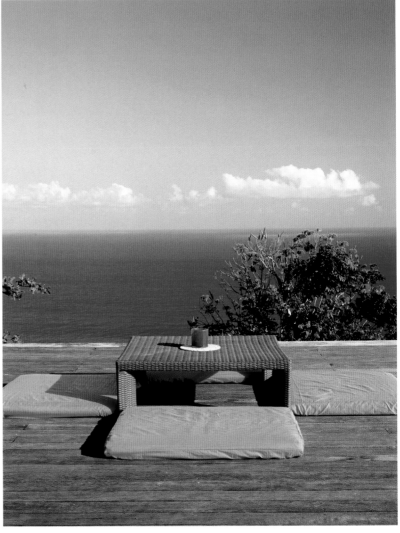

The owners say that the home makes them feel calm, quiet and reflective. Because of the design, they can feel the elements intensely—if a storm is coming, they can not only see it, but smell its approach. This connection with nature forms a large part of the experience of living in the house.

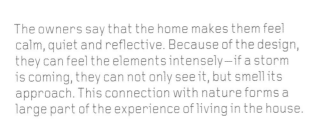

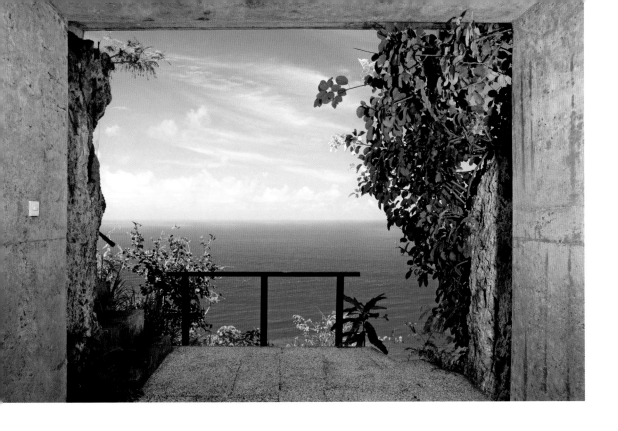

Left and below A rickety staircase leads down the side of the cliff to the yoga studio hollowed out from the earth beneath the house. Facing inwards is fine for those with vertigo; looking out is another matter entirely!

A Dose of Taksu

Architect **Yoka Sara**
Location **Canggu**
Date Of Completion **2009**

A dream project for Balinese architect, Yoka Sara, this villa was conceptualized, designed, built and furnished by the architect with minimal input from the client, a Middle East based businessman. The starting point was 42 *are* of land with a central *kayu santan* tree amidst the rice fields. From here, it was a huge imaginative leap to the end result: a gorgeously free-form central pavilion with a studio and reflecting pool on its flat roof, three separate bedroom structures, a huge lawn, and massive pool with modernist *balé*.

If first impressions are anything to go by, this house delivers. Even the front gate is gorgeous! Entirely composed in a palette of resins, grays and greens with cascading plantings, the project sports a distinctly organic ambience that is furthered by the huge swimming pool lined with roughly hewn Bali Green stone. Walkways and pergolas are covered in cascading thunbergia, while flat roofs sprout grasses and greenery. The sinuously curving, soaring main pavilion—ringed by teak and bamboo poles in key areas—furthers the natural feel.

However, this is no vernacular building. It is modern through and through. It also contains more than a dose of *taksu*—the indefinable

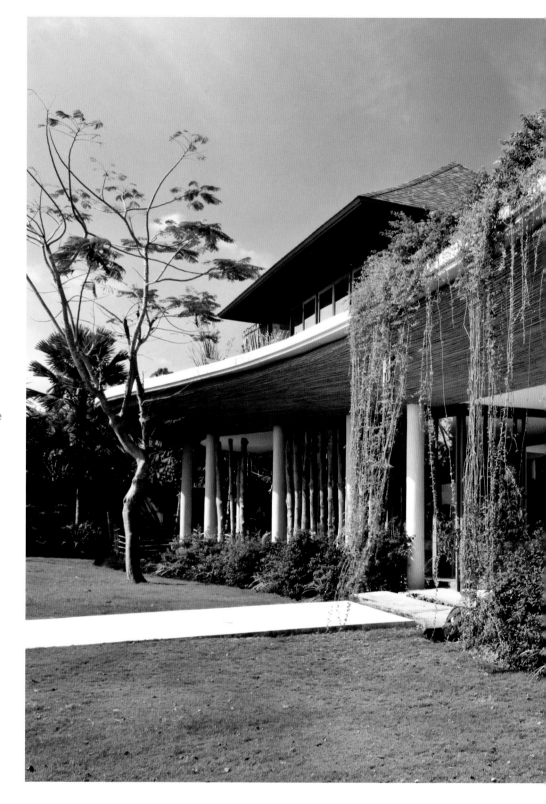

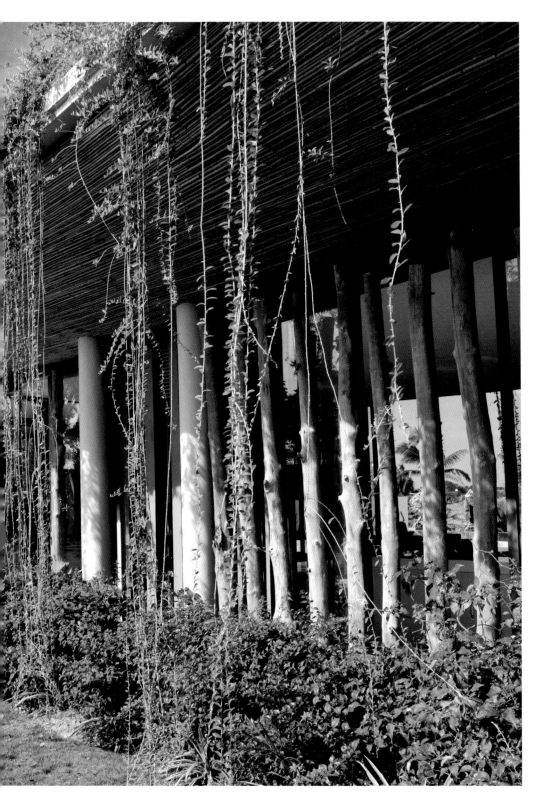

substance that Yoka Sara says he waits for whilst "sitting the land" and formulating ideas about a project. He believes that immersion in the landscape enables his imagination to soar, resulting in built forms that interact strongly and clearly with their natural surroundings.

In the case of Kayu Aga, the main volume stretches from north to south, so the sun rises over the swimming pool on one side, hovers above the house at noon, then sinks gracefully behind the front gate in the evening. Composed of floor-to-(high)-ceiling *benkerai* and glass sliding doors painted in industrial grey, it is semi transparent, thereby communing with its surroundings on all sides. This open-air aspect is furthered upstairs when studio windows are thrown open and the rooftop garden and pond bring cooled breezes into the interior.

The spacious living room and kitchen-diner are located on the ground floor, the latter opening out to a funky wine cellar that is covered externally in round resin balls that, in turn, are

Left A celebratory mix of industrial and organic, the sensuously curving main building at Kayu Aga is painted in factory grey; this is complemented by bamboo cladding on overhanging eaves, a lining of salvaged teak trunks that were originally used as offshore breakwaters, cascading greenery, and grasses sprouting from a flat roof garden.

covered in masses of thunbergia. There's more than a hint of humor here. Inside, simple, spare spaces are bathed in light, but tastefully furnished. The owner is an enthusiastic chef, so the cuboid island kitchen with laminated counters allows him to socialize whilst cooking. It overlooks a dining table and chairs crafted from *sonokeling* and steel with generously proportioned chairs. The living room is again fuss free, with custom-crafted sofas made in Jakarta and a few choice local artifacts.

In the words of Yoka Sara, the entire project was designed to "improve and emphasize the elements and surroundings of the site". Only after imagining movement within the site was he able to "build up the emotion and set the sequence of living spaces." The end result is a series of formally choreographed voids and volumes, totally attuned to Nature.

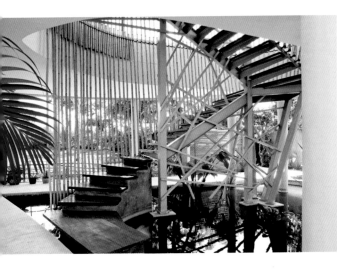

Above and opposite, right
The perfect combination of man-made and made from Nature, this sculptural oval staircase that rises up from a reflecting pool leads to the first-floor studio. Made from concrete, steel and wood, it features a sinuously curving bamboo balustrade.

Right and opposite, bottom left An expansive grey and blue tiled swimming pool is overlooked by a striking modernist *balé* that juts out over the water.

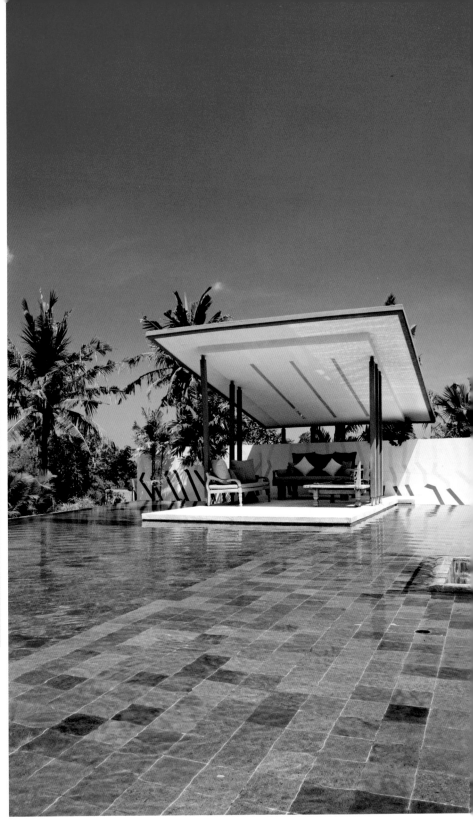

Below Balancing the modernity of the boxy glass building are rows of bamboo poles and tribal totems. Yoka Sara explains that they also bring privacy to the spaces behind and reduce the glare from sunlight.

Right One of the paths leading into the home is lined with plastic poles roughly modeled on the form of a dancing girl. This motif is featured elsewhere in the home—on the gate and painted on the wall at the end of the pool (see left). The owner is a bachelor, and the shape is supposed to resemble the ubiquitous dancing party girl from Kuta or Seminyak!

Completed in May 2009, this house was built for an Italian client who left all aspects of the design, including the interiors, to his Balinese architect, Yoka Sara. Yoka Sara "sat amongst the land" for many hours before he came up with a design that relies on a startling combination of natural and man-made, modern and tribal.

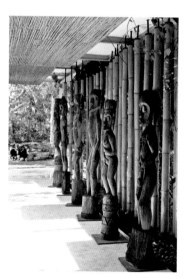

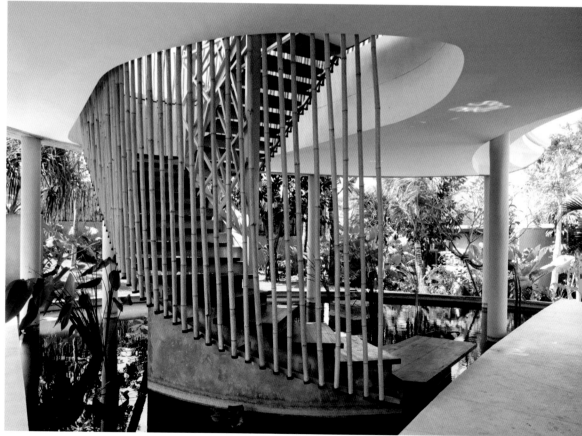

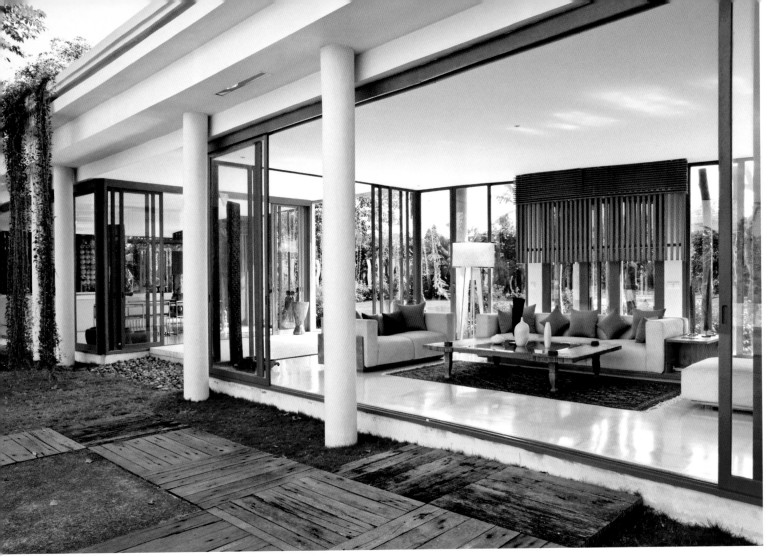

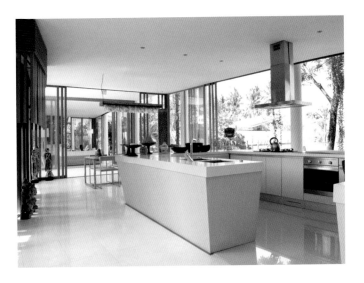

Above The living room is
simply furnished in pale
cream tones, with only a few
choice artifacts. In front are
two decks (see opposite in
photo with dogs) made from
railway sleepers that have
been cut horizontally in half
and laid into the grass. They
provide wonderful viewing
points to the pool and
rice fields beyond. On the
other side of the building,
to protect the room from
sunlight from the west, are
a line of teak tree trunks,
salvaged by Yoka Sara.

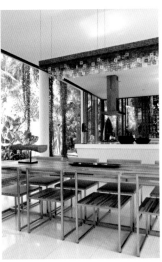

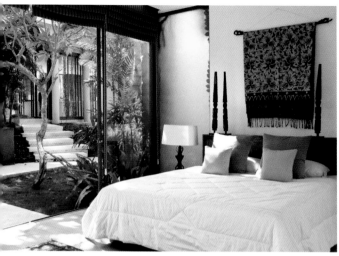

Opposite, below The spacious kitchen/diner features a central cooking unit and, at one end, the dining table. With tapered edges, it is sleek and stylish, the work of a company called B-Dutch. It sits beneath a gorgeous glass-and-wood hanging light from DeLighting.

Left and below Located at either end of the pool are two separate bedrooms, the master one of which has a plunge pool. A third bedroom is located in the northeast part of the compound by the oval staircase. Furnished simply, they look out on to small private courts. The master one below sports an innovative wooden headboard with in-built console, and contrasting "wintry-style" wallpaper.

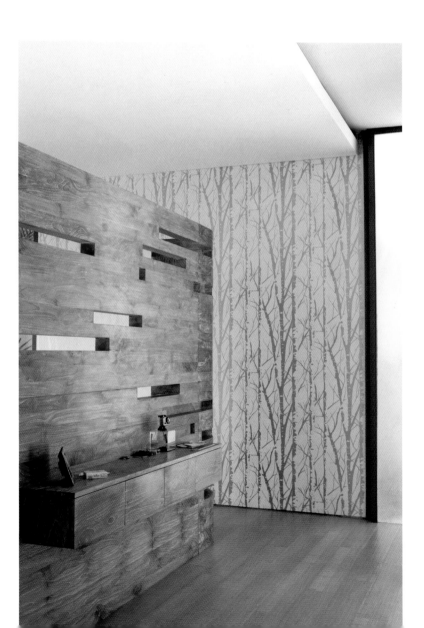

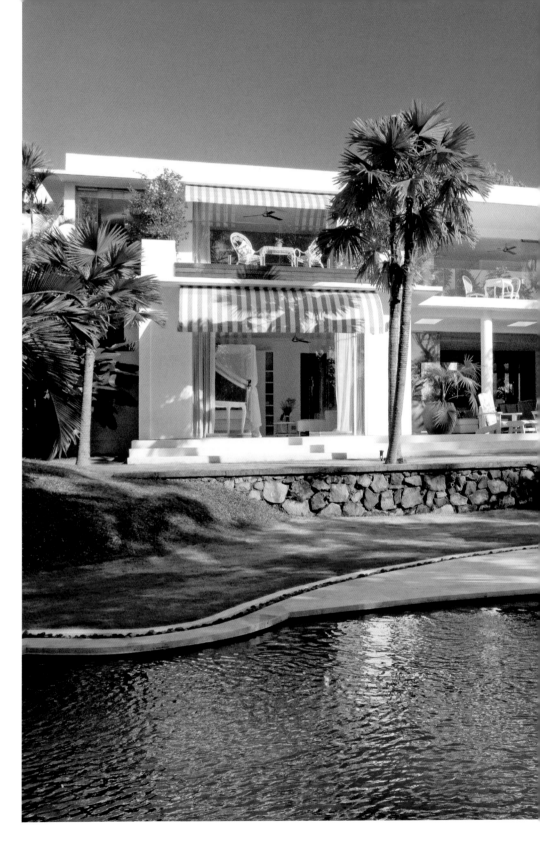

"This house is the antithesis of the typical Bali house," declares Beate. "In most Bali architecture, there are small, dark corners where you can hide faults. As this home is totally pristine, white and clean, there is no room for error. It has to be perfect..." — a challenge in anybody's book.

VILLA BHANU

Feminine Touch

Architect Ross Franklin,
Ross Franklin Architecture
Location Pererenan
Date Of Completion 2011

A very personal project of yoga instructor Beate "Billy" McLatchie, this intensely feminine home is an oasis of repose in Bali's Pererenan area. Spacious and airy, Villa Bhanu was designed by self-taught architect Ross Franklin, with the interiors supervised and realized by the owner herself.

Appropriately, the word *bhanu* is Sanskrit for "light". Beate interprets this in three ways in her home—light, bright and white. Her idea was to create a home that has a kind of weightlessness, a lightness of being, about it. *Bhanu* also indicates purity: as such, the rooms are uncluttered and serene in style, and flow seamlessly from one to the next. This type of layout, she hopes, leads to purity of mind and body as well.

Architecturally, the Miami-style structure fits this somewhat Zen concept admirably. Rectilinear and open-plan, with flat roofs and

a roof garden above, the house is oriented towards a lush garden and picture-perfect rice terrace vista beyond. The structure has a little of Le Corbusier about it, with *brise-soleil* above ground floor windows, and a sense of harmony and proportion that the master so venerated.

Inside and outside, the palette is white on white, with certain choice walls painted a deep taupe to break up the minimalism. "Villa Bhanu is a combination of styles like this island is a melting pot of cultures, people and nationalities," explains Beate, "Dutch colonial furniture mixes with styles from the '50s and '60s, but there are also Japanese Zen, Balinese and bamboo touches everywhere." The bamboo detailing can be seen most prominently in the custom-crafted doors and on the kitchen counter; designed by Elora Hardy of Ibuku, not only are they aesthetically pleasing, they are ecologically sound also.

This is a factor close to Beate's heart. "Villa Bhanu is environmentally aware," she explains, "We practice garbage separation, with proceeds of the villa sale going towards a recycling and river clean-up program in the village, there is solar water heating, and we use no chemicals in garden or house cleaning." This, no doubt, is also in line with the owner's yoga principles —the house acts as a *vinyasa* conduit "washing away the heaviness we at times bring into a space from the busy world outside".

Natural ventilation probably plays some part in this process, too. Ross installed a falling water and koi pond feature at the front door, both to counterbalance the slightly cramped, inelegant

Left The architect and owner worked on a house together before and were both a little bored with the familiar Bali-style generics. "We decided to go more hard edged and linear this time," says architect, Ross Franklin. However, the villa's rectilinear shape is countered and softened by the hour-glass shape of the swimming pool and the curvy rice terraces beyond (unseen).

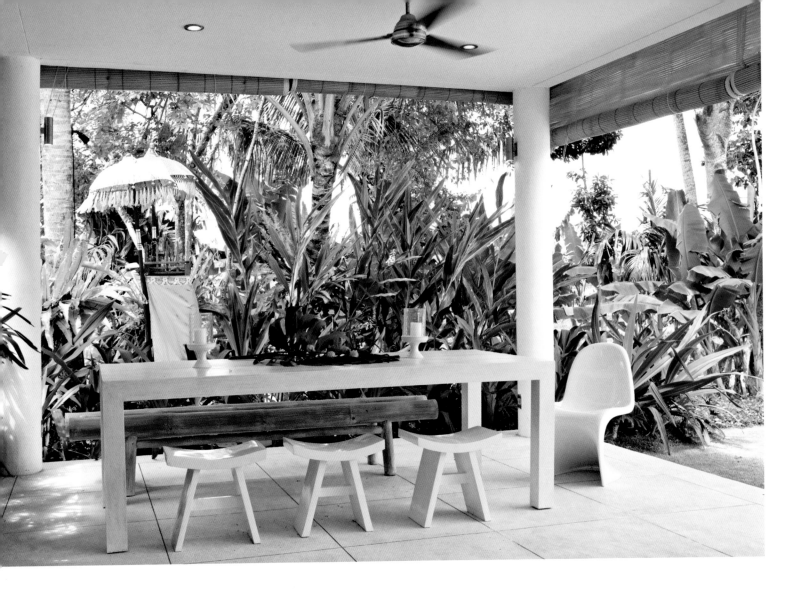

area out front and to provide a cooling element at the entry. Once you cross this and go inside, you are met by wonderful breezes that enter from the eastern side of the house; most days, the huge floor-to-ceiling tempered glass doors are pulled open and abundant Nature is invited into the interior.

"I try my best to design houses that are firstly practical and easy to live in," Ross sums up. "I believe if you get the fundamentals right, the building will have a beauty irrespective of style." In this case, the style of the sensitively decorated interior is an added bonus.

Above The Danish interior designer, Liv Clausen, helped formulate the design of the *balé* in the garden. Simple and symmetric, it offers great pool and rice field views.

Opposite, top left A series of terraces line the back of the house on the first floor. This elegant table and chairs sit outside the master bedroom.

Opposite, top right The master bedroom sports an outdoor bath (just seen) and two loungers on a rooftop terrace for the ultimate in outdoor bathing.

Opposite, bottom The downstairs terrace offers beautiful views of the pool and rice terraces beyond. The sculptural pool provides maximum swim line, but also has an amoeba shape symbolizing infinity and the lucky number eight. Lined with natural green *sukabumi* stone and *palimanan* limestone coping, it is the jewel in the crown of the garden.

"It's a very healing property," declares Beate, "it took me six months to find the land, also have it evaluated by Balinese priests and a Western energetic worker. The priest came to the conclusion that it is an extraordinary piece of land with seven guardians—which is very rare."

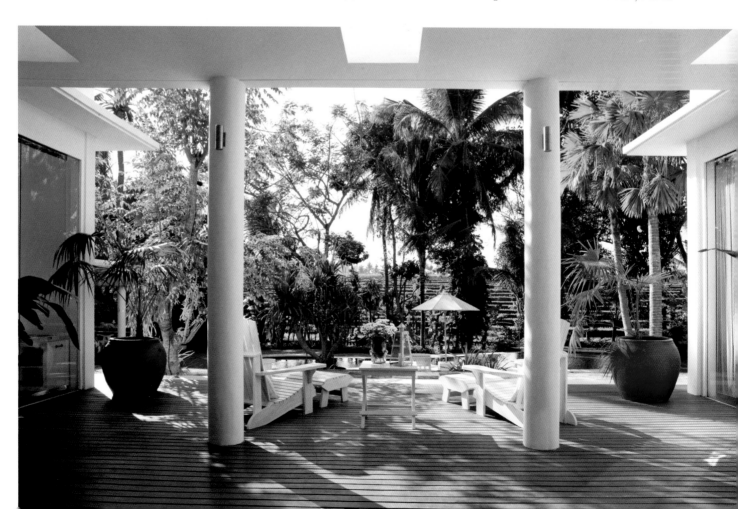

Above The open-plan
living room joins with both
kitchen/diner and terrace.
The shelving unit is the
work of Renato Guillermo
de Pola (see pages 50–55).
His team is also responsible
for the stunning Hollywood
-style bathroom mirrors and
stainless steel vanity mirrors.

Right The house's entrance
gives more than a nod to
feng shui, even though the
architect describes this
as "incidental". A narrow,
bamboo-lined driveway
opens out to a small parking
space where a geometric,
modern walkway leads
visitors over water to the
front door.

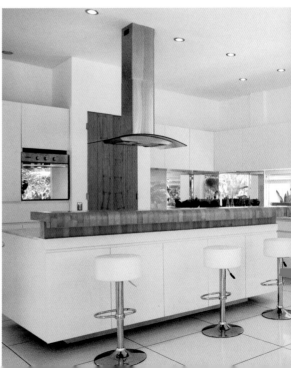

Left French artist, Veronique Aonzo, is a neighbor and she provided many of the artworks in Villa Bhanu. Much of the furniture was custom crafted by a carpenter, Pak Suro, who has a tiny workshop in the backstreets of Denpasar: the beds, for example, are adapted from a design by Ralph Lauren. Here and there, you see a few choice pieces from Saparua, a store up the road from the house.

Above and left Beate cites her father, Herbert Ellmerer, as the man behind the look in the kitchen and dining room: clean and simple, its centerpiece is a counter made entirely from laminated bamboo planks by Ubud company Ibuku.

Right A guest shower in indoor/outdoor style uses items from the natural world for a tranquil "Bali feel".

Far right The gorgeous master outdoor tub is set on a flat roof and is surrounded by inventive plantings in planter boxes: white jasmine for a feminine scent and *Brunfelsia pauciflora* "Floribunda" with sweet white and purple blooms for color.

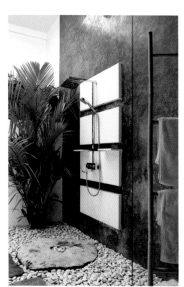

Below and previous pages Either featuring one strand of flattened bamboo inset into wood, a bamboo door handle, or a composite of laminated beaten bamboo, all the doors, designed by Ibuku, add an organic dimension to the interiors. This is especially evident when they are teamed with simple chick blinds and taupe walls. *Rapat* bamboo was split and laminated together under pressure to form the normal doors, while the graphic element is made from *duri* bamboo, sliced lengthwise in a technique that reveals the nodes and internodes. "The solid plank doors were hand-carved so that we could inlay the 2 cm thick slice of *duri*," explains Elora Hardy of Ibuku, "And for the entry doors, at a few of the internode sections, we carved through the door and added glass which was custom cut to fit the spaces, to allow light through."

Right Keeping to her ecological principles, Beate tried not to use too much wood in the home. The one exception is the upstairs bedrooms where flooring is made from stripped teak sourced from timber supplier Belindo. For every tree the company uses, they plant another.

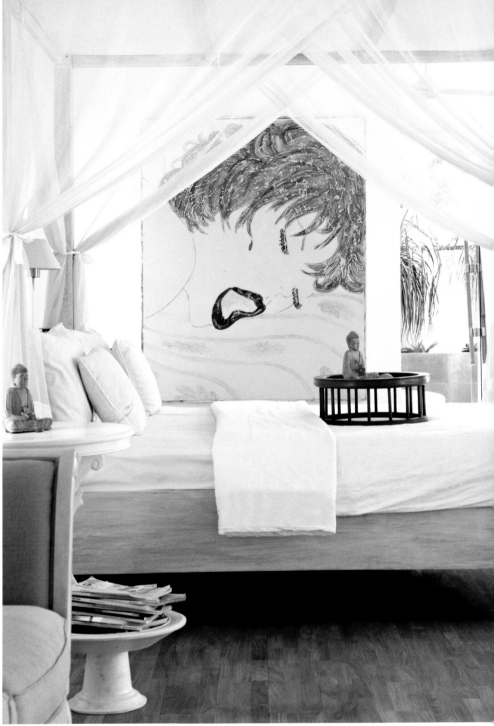

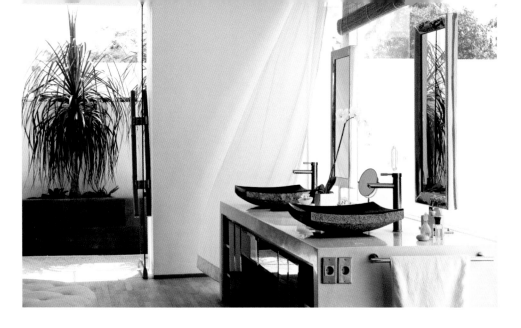

This page Keeping it clean: White-on-white is the name of the game in this house and the bathrooms exemplify this mantra. Taking advice from arbiter of style, Madé Wijaya, the owner created a spa-like ambiance in these indoor/outdoor rooms where white pebbles mix with color-washed concrete and custom-crafted terrazzo tubs and sinks.

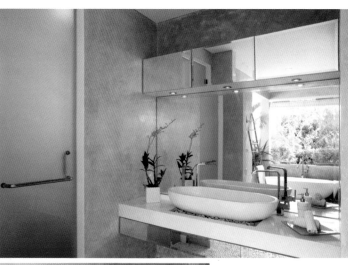

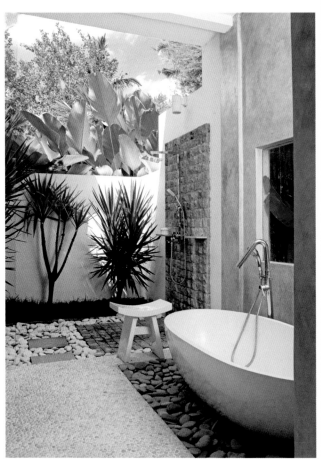

87

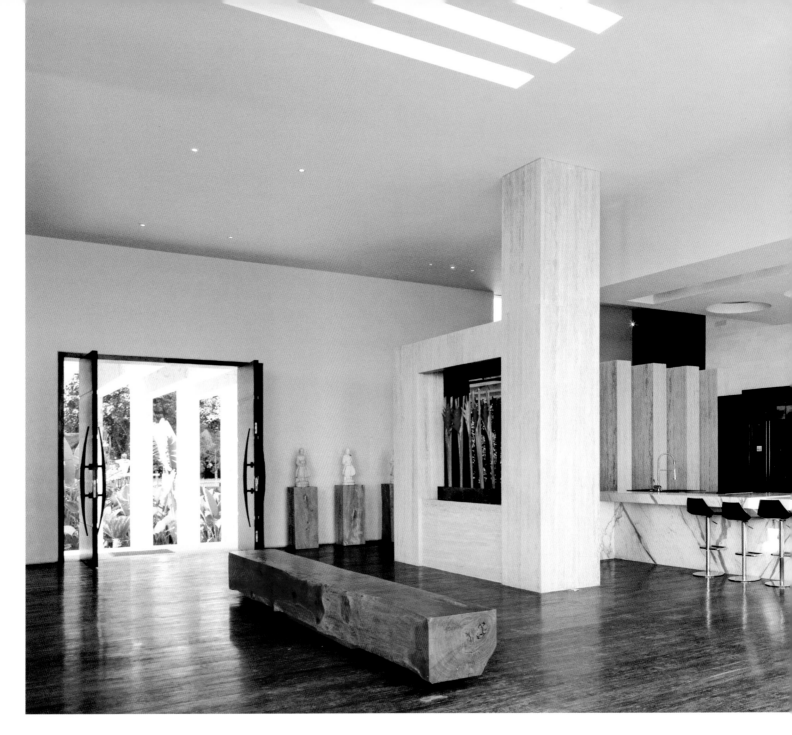

"Having such a large amount of land in which to build a house was an amazing opportunity for me—and to end up with all that garden space between the house and the beach was a dream come true." — Architect

Above Materials in this expansive home are the very best: marble from Italy and granite from Germany in the kitchen, travertine pillars, recycled ironwood floors— the epitome of luxury.

A House for Entertaining

Architect **Ross J M Peat,**
Seriously Designed Architects
Location **Pantai Berawa**
Date Of Completion **2010**

This home is one of the largest featured in this book and, most probably, is the grandest in size, scale and cost. Set on a 5,000 square meter plot fronting Pantai Berawa (Berawa beach) in the Canggu area, it is a magnificent accomplishment. The client's brief was for an expansive house that lent itself to extensive entertaining—and this has been more than adequately achieved by Ross J M Peat of Seriously Designed.

The house makes a statement at every step. Huge double gates open out into a *porte cochère* with large return columns and a flight of steps leading up to a grand double door. Once through this, you enter a large lobby, framed by over-sized travertine columns and expansive corridors leading to wings on either side. This area then extends into an airy living room adjacent a show kitchen that in turn

opens out onto an ample deck. Gradually, as you move forward, the ocean comes into view across the water of a large rectangular swimming pool. Huge sail-like awnings fly overhead and a decorative fountain plays with water, sunshine and air.

Everything is on a scale at once over-sized, yet perfectly in proportion. Nothing jars. The two architects Peat most admires are Frank Lloyd Wright and Luis Barragan, both known for their strong clean lines and mastery of space and light: "I love the simplicity of their work," explains Peat, "and try to get this into my designs as much as possible." That, along with the site's horizontal lines of ocean and sky beyond, inspired him.

At no point does he skimp on materials. The entire home is clad in soft sandstone sourced from Java that casts a luminous aura both inside and out. Over 1,200 square meters of recycled ironwood comprises flooring and the pool is lined with Indian slate. Massive custom-crafted hanging lamps in copper form a focus in the living area, while the open-plan kitchen is both functional and decorative with an island centerpiece. Here, veined *Statuario* marble from Italy contrasts with dark granite that was sourced in Germany—a real talking point if ever there was one.

Aside from 800 square meters that are devoted to entertaining, the rest of the house is no less grandiose. The master bathroom and powder room are lined top-to-toe in *Statuario* marble,

Opposite Picture window view through the scrubby, natural-looking garden to magnificent Pantai Berawa and the Indian ocean beyond: an inspiration for both the owner and architect.

"I'm very proud of the house as I had a lot of input into it and it was fun building it. My team did a marvelous job, it is a great credit to all involved. I must say the end result was beyond my expectations." — Owner

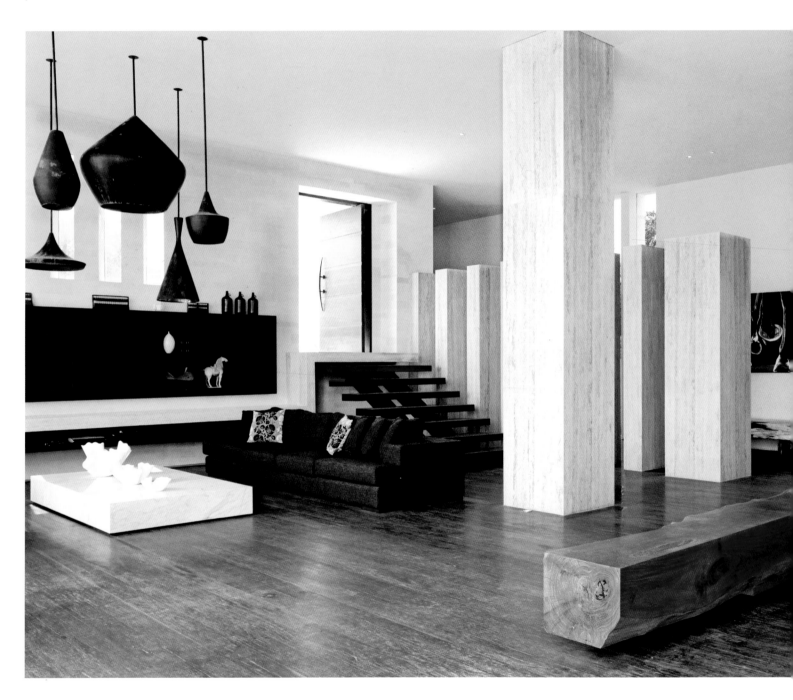

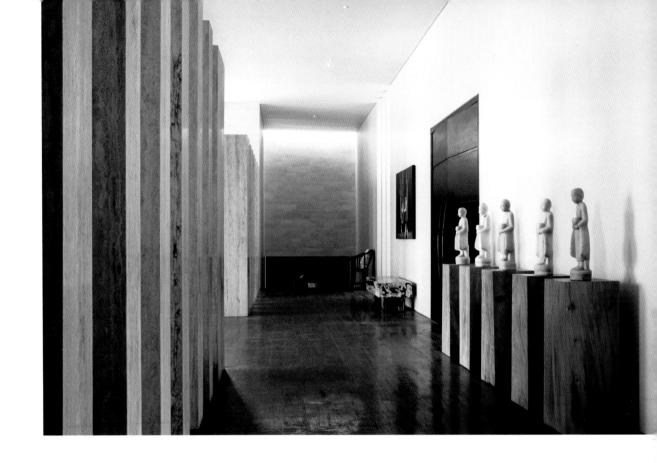

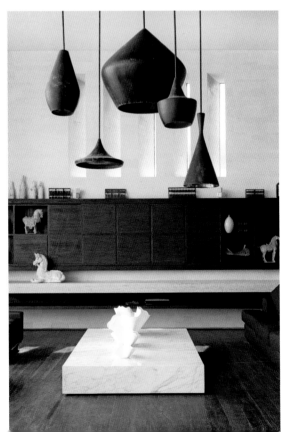

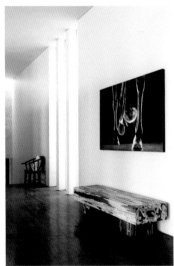

This page and opposite
Interior design was a collaborative effort by client and architect, and many pieces that the client has collected over the years are displayed in various areas of the home. "I have been collecting furniture and art for many years now," says the owner, "most of it is predominantly Chinese as I work in Hong Kong a lot and have property there, so I take every opportunity to visit all the antique shops in Hollywood road where my apartment is." The line of statues (above) draws the eye down the corridor to the family's bedroom wing. Bought in Bali, they are originally from Burma.

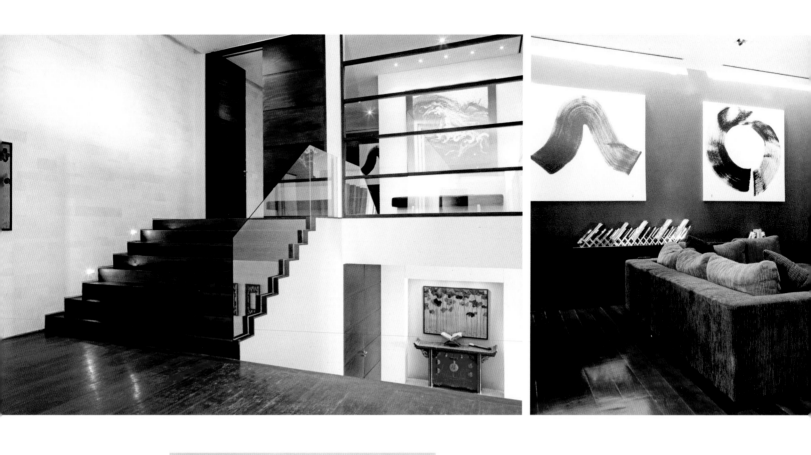

This page and opposite The family's bedroom wing is on a slightly more intimate scale than that found elsewhere in the home. At the moment, the owner's bedroom doubles up as her home office, but there are plans to add an additional rooftop studio.

Oopposite, far right With Chinese etched doors, television, freestanding bath, massive shower and view to die for, the master bathroom is the client's favorite room in the house. "I spend way too much time in there," she confesses.

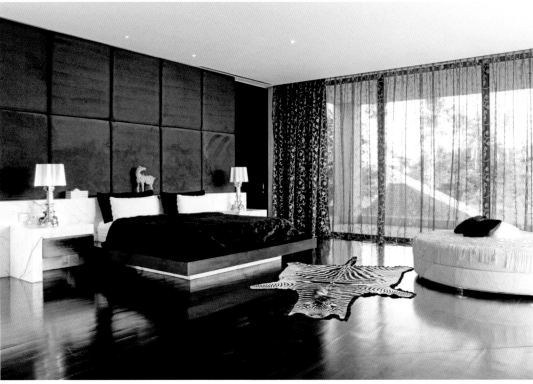

As the architect knows the client well, he was given "pretty much free rein" to articulate a series of spaces that would work both as a party venue and as a fun place for the family.

"The biggest challenge we faced in the beginning was the setback for the building from the 'high tide mark' which is decided by the government. This kept altering for some unknown reason and the house needed to move back away from the beach every time this changed, unfortunately so did the shape and design of the house but we never compromised on the original style. Other than that, the project went well." — Architect

while other bathrooms are in a reconstituted marble, also sourced from Italy. Much of the interior design tone was set by the client's existing collection of Asian antiques—Burmese statues, Chinese furniture and screens, an antique Vietnamese screen—and these were mixed with some new furniture and artworks.

Owned by an Australian businesswoman, somewhat surprisingly the house is first and foremost a family home. A hop, skip and a splash away from the ocean, the compound includes riding stables at the rear, as well as the 26-meter swimming pool and direct access to the beach—all plus points for the client's two young children. As for the client herself: "The sheer size of the house seemed daunting during construction, but the children and animals have helped to fill it up. Being able to wake up and be on my horse riding on the beach within 15 minutes is priceless; I feel blessed every day!"

Left and right With three sides of negative edge overlooking the ocean, a fountain and seriously spacious deck, the pool is a focal point in the overall design. Plants that thrive well in the salty sea air include screwpine and yucca, while an outdoor barbecue works well beneath the sail-like awning. The stairs below left (with sensible see-through balustrade) lead down to the guest quarters.

BALI BY DESIGN

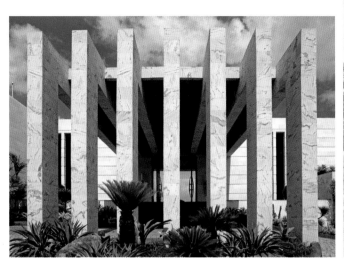

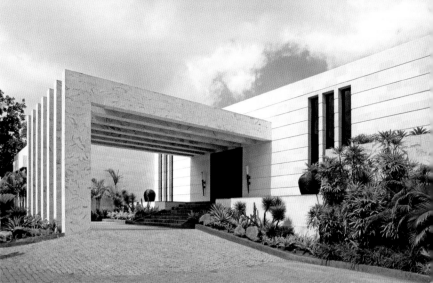

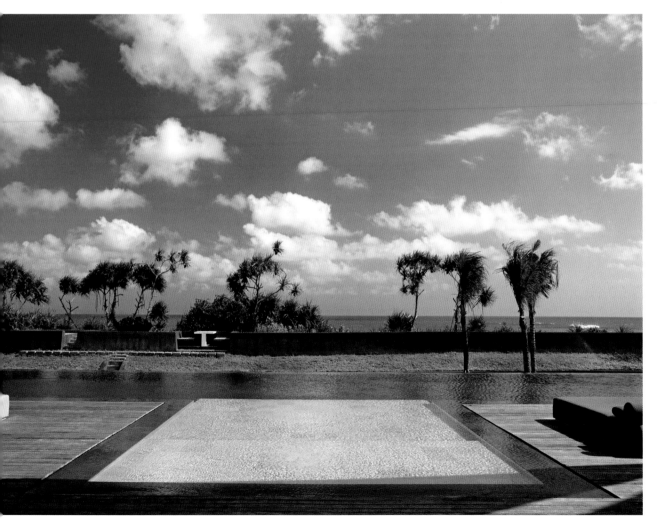

Above The impressive drive-through entrance to the house with reverse pillars sets the tone for what will follow. Clad in luminous soft sandstone, it somehow manages to appear both austere and inviting.

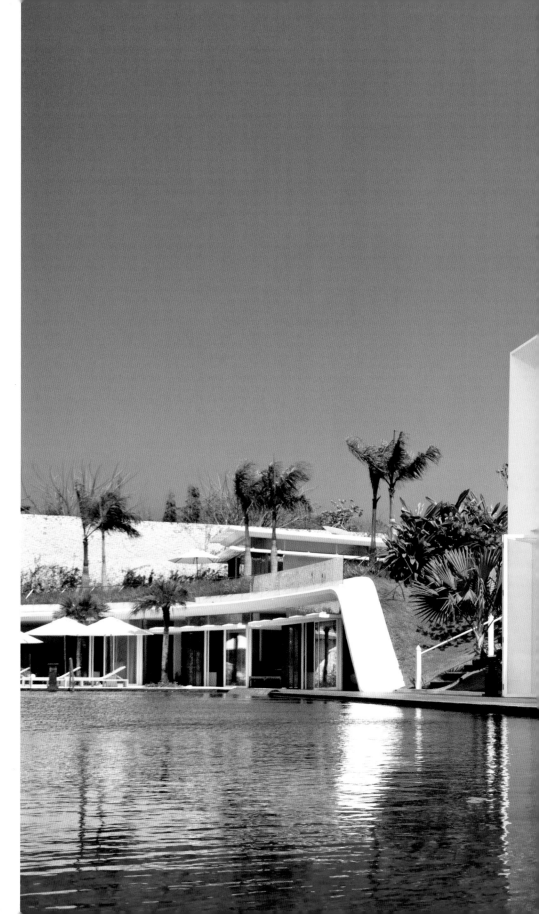

Right Each structure in this complex is lightweight in form—allowing the simple landscape and natural beauty of the site to shine through. However, the sight of the triple height central cube of cool set against the hillside is nothing short of awesome.

VILLA LATITUDE

Cool Cube

Architect **KplusK Associates**
Location **The Bukit**
Date Of Completion **Revamped in 2011**

If somebody told you they'd utilized the Bernouilli Principle and the Alhambra Effect in the architecture of a house, would you nod knowledgeably or look blank? Never one to baulk at something new, I was gratified to discover that both processes are actually quite old—the former refers to the dispelling of hot air from a structure and the latter is a natural cooling process. Both are employed to decrease the reliance on air conditioning at what has come to be known as the Bukit Cube, one of the stunning buildings that comprise Hein van Ameringen's Villa Latitude.

Designed by Johnny and Paul Kember of KplusK Associates as a single residential unit within the Karang Kembar Estate, the cube is accompanied by a number of discrete pavilions set adjacent, below and beneath each other and all connected by walkways, steps, corridors and decks. Mainly

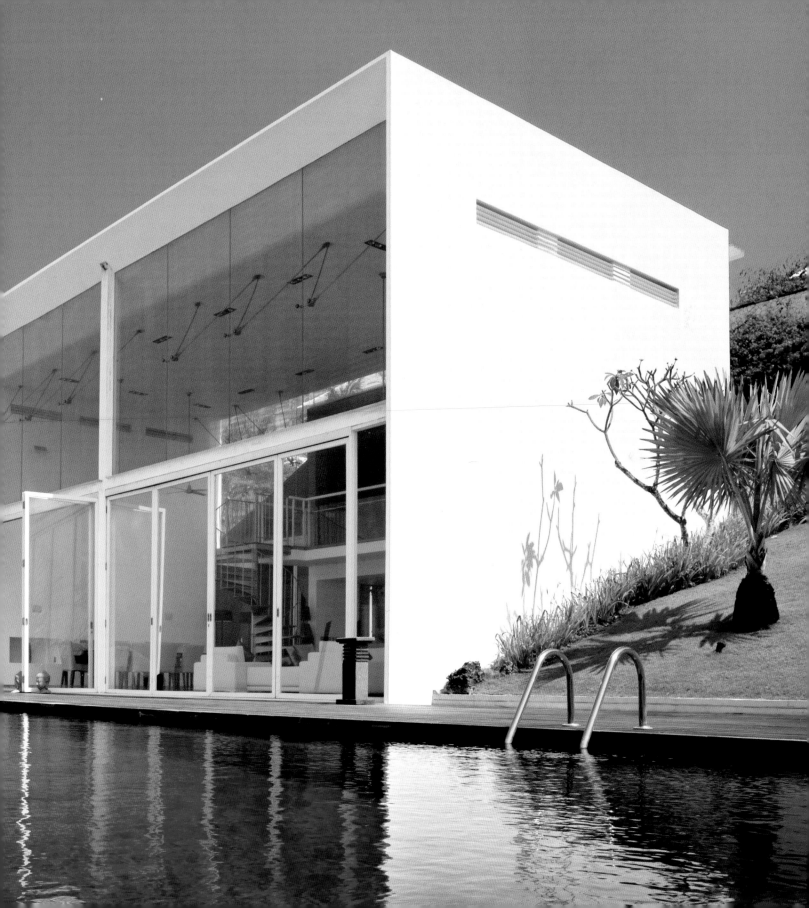

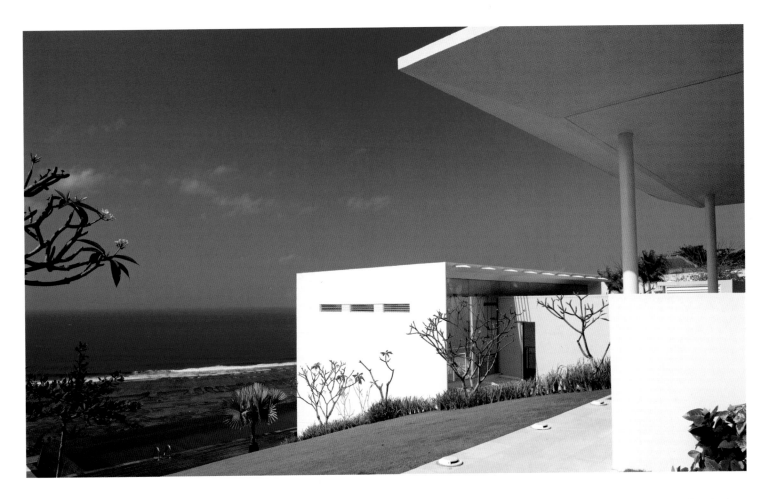

composed from local limestone in a combination of rough boulder and smooth finished slabs, expansive sliding glass and local wooden decking, the buildings perch precipitously above the ocean waves crashing below.

Building sustainably is an imperative according to the Kember twins, so they simply maximized the eco opportunities that Villa Latitude's site and climate presented. Luckily the client was amenable to this, wanting a pad that was both party zone and eco home.

The six-bedroom property comprises a central rectilinear glass and stone "box" housing a living room, kitchen and mezzanine games room, as well as a series of bedrooms on either side and a super-long blue infinity-edge pool in front. Beneath the striking pool is another

entertainment space. As befits the steep site, three of the guest rooms are semi-buried beneath a landscaped lawn that is positioned in front of a further bedroom. On the other side of the site is a slightly elevated master suite and deck with a smaller twin room behind; naturally, to maximise views, it juts out at right angles from the rest of the plan.

Of course, the 13 meter long and 7 meter high central pavilion gives the site its main wow factor, but another jaw-dropping feature comes in the form of a huge two-inch thick piece of glass that provides a transparent bottom to the shallow end of the pool. This, in turn, encourages light to flood into the entertainment area below, the movement of the water refracting and magnifying the sun's rays so beams of

sunlight act like a "kinetic sculpture" in the bar —just the ticket when mixing martinis.

Another sexy addition is the design of the three guest bathrooms: although situated deep below ground, they've been excavated with circular skylights, facilitating the growth of three tall, slim palm trees that thrust up through the lawn above. The effect is a little like one imagines a James Bond villain would position his deadly surface-to-air missiles!

In fact, there's more than a hint of Bond in both the technological sophistication and the visual panache presented in this project. But for Hein, Villa Latitude is a serious chill spot: "I entertain a lot of people in my business but once I get to Bali my house is entertaining me with nothing, if you know what I mean." I certainly do.

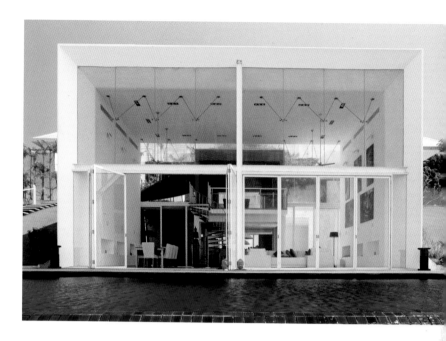

Villa Latitude is a stunning addition to the small body of innovative Bukit architecture. Situated 90 meters above a beach and fishing village, it has panoramic lagoon and reef views.

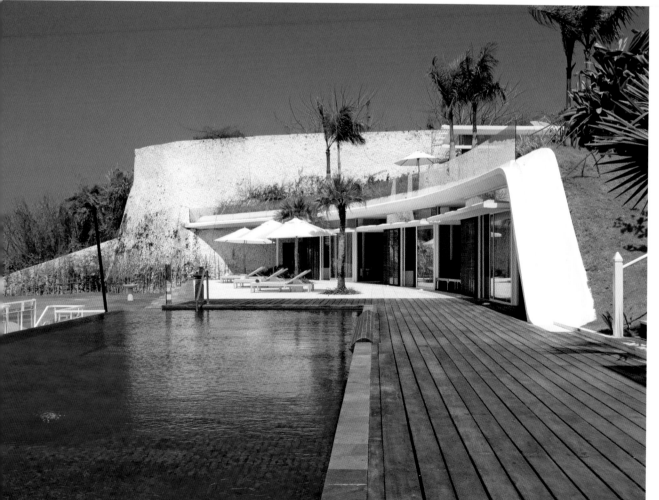

Opposite A view from the entrance through the "cube" to the ocean beyond.

Above left Certain features in the compound show signs of a nautical influence.

Above Large vents at the sides of the boxy cube encourage hot air to escape when offshore winds hit the face of the pavilion, thereby creating areas of low pressure around the edges of the building. Called the Bernoulli Principle, this creates a vacuum effect sucking hot air out of the cube. This, combined with super-long elegant fans reduces the need for air-conditioning inside.

Left The bedroom wing concealed beneath the earth mound.

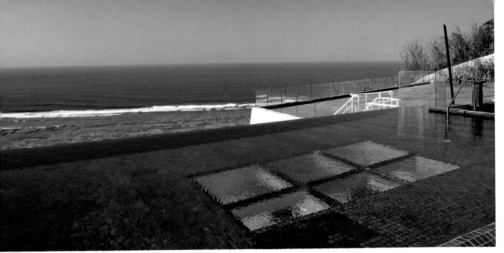

Above and top The crème de la crème of the 33-meter pool is its glass bottom in the shallow end. However, the sparkle that emanates from the whole comes from its terrazzo lining: made from a mix of cement, crushed marble and local seashells, it was built by hand by 3 workers taking 3 months to complete.

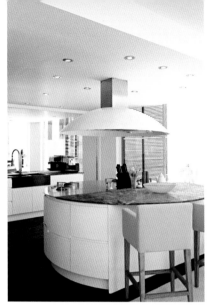

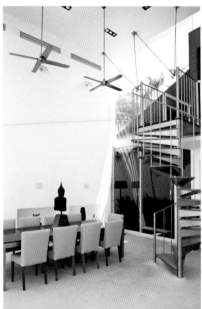

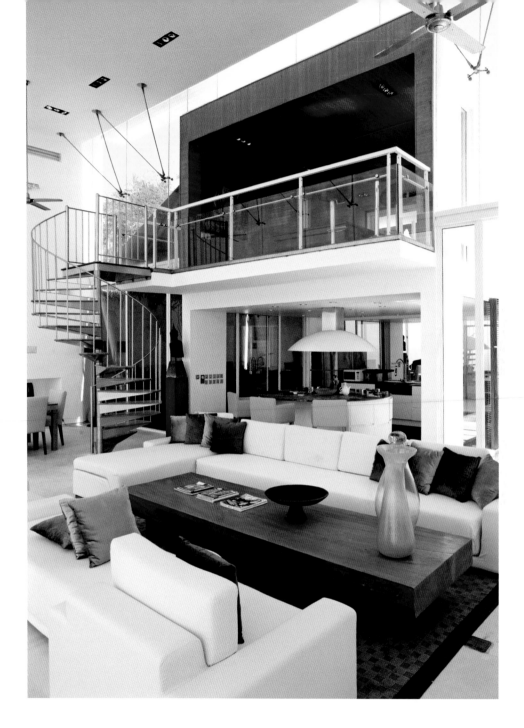

Interiors in the cube are a fine mix of the sophisticated and the casual, combining local fabrics and woods with metal, glass and stone. The galley kitchen sports all mod cons, while the upstairs mezzanine contains a snooker table and other games. As such, it has all the ingredients of a perfect holiday pad.

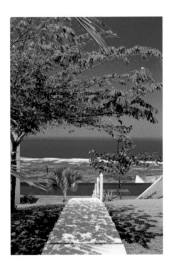

Right and below Rock removed from excavation for bedrooms and bathrooms is used in different ways in the complex. There is both rough and smooth cladding in the corridor that connects the bedrooms. The passageway has the feeling of a natural cavern, so is extremely cool.

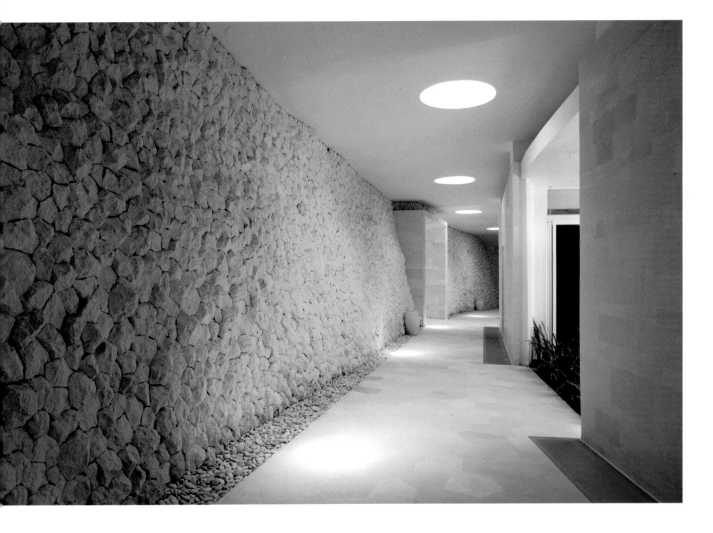

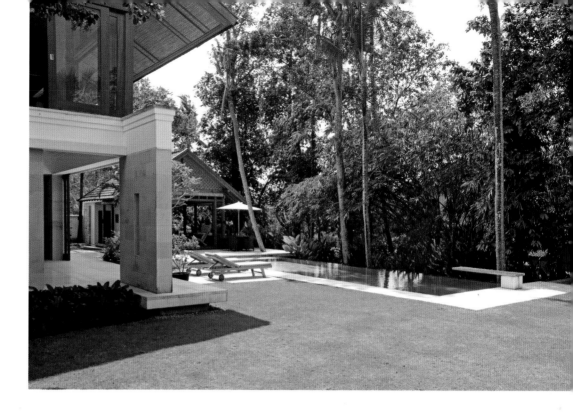

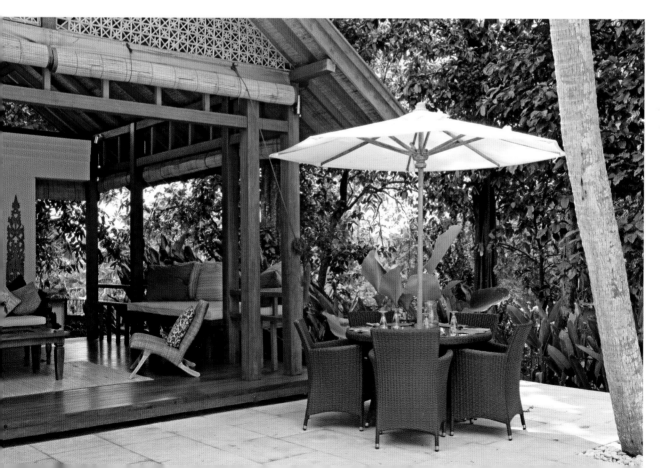

Above Even though the plot is compact at only 10 *are*, there is enough room for a small football pitch, with attendant goal (unseen).

Left A work in progress, but probably finished (at least for now!) is the tranquil pool pavilion that fittingly sports a fresh aqua theme. The tableware and napkins on the outside table match the bar inside which is clad in handcrafted tiles from the atelier of Pesamuan Studio, the ceramic design company directed by Philip Lakeman and Graham Oldroyd, two long-time resident artists in Bali. Local artefacts, gorgeous blue blown glass bottles, and aquamarine wood-and-metal bar stools from Java are just the right palette for a pool bar.

107

As such, it should come as no surprise that people are after his own home now! "Since I built it, I've been inundated with offers to rent it," he says, strolling round his secluded garden, "But I suppose it's practical, the location is good for an expatriate family with children, and it is —at its heart—a family home."

It's also much more. There's the main house, a slightly elevated, almost floating indoor/outdoor contemporary longhouse; a gorgeous infinity edge pool; a pool pavilion with bar; and a large games pavilion opposite; as well as the entranceway and car port out front. Thoughtfully planned, so that staff can reach the upper bedrooms along an external walkway without interrupting life at ground level, the compound is green, lush, pristine—yet very much lived in as well.

Designed for flexibility, the main structure can be integrated with the garden and pool with sliding doors fully opened, or closed off in inclement weather. In turn, internal doors can be slid back to allow one to journey from the kitchen/dining room to the living room, on to the master bedroom and back. It's the same upstairs where the three children's bedrooms are located.

And, even when the weather is rainy, all the rooms look over the pool to greenery and a little breathing space before the next house comes into view. This is because two *subak* channels run between Glenn's property and the next—a lifeline for the Balinese, and a connection to the land in which they live for the owners.

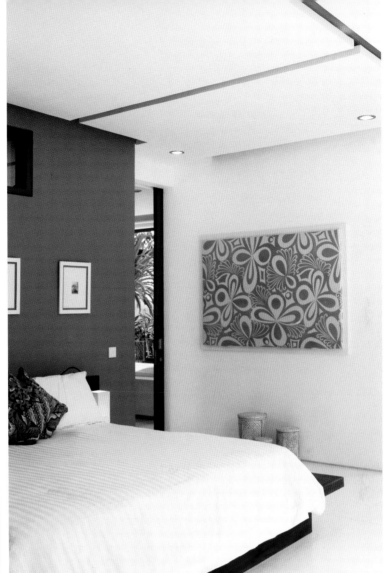

Below, far left and left Open to the garden and pool, the inviting kitchen/dining room is perfect for semi al-fresco eating. The dining table was custom made to fit the space, while the artwork above the long console is by Davina Stephens, a New Zealand artist who grew up in Bali and is still based there.

Below, middle The master bathroom is a cool, yet practical space; finished in creamy tones, it receives plenty of light and air.

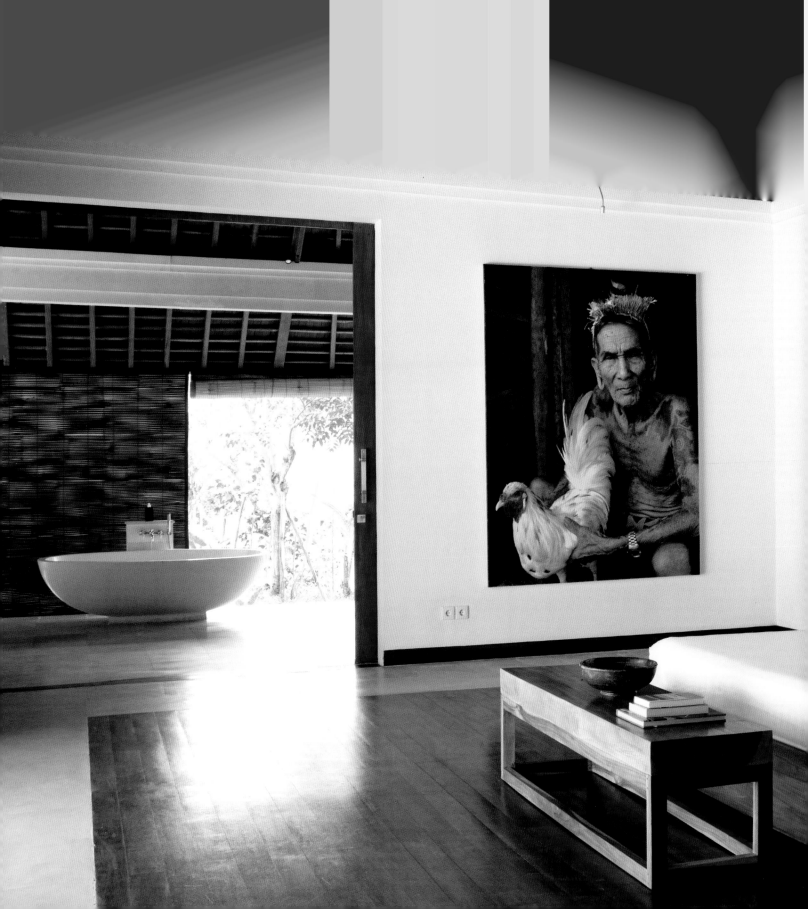

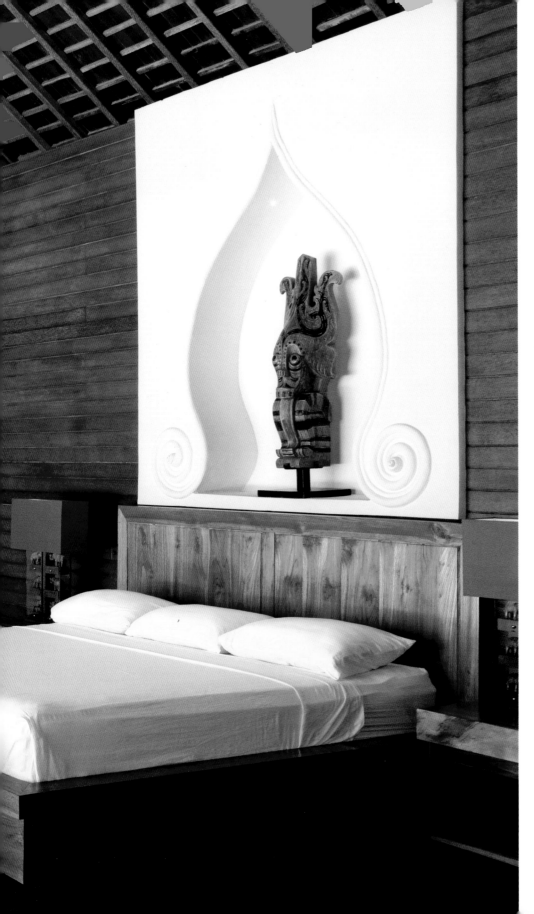

KETAPANG VILLA

A Personal Piece of Paradise

Designer/owner **Olivier Meens**
Location **Tegal Mengkeb**
Date Of Completion **2009**

Although Ketapang Villa displays many architectural styles—some traditional, some more contemporary—it is distinctly forward-looking in its overall aesthetic. It is also built on a scale that is scarcely seen elsewhere: the property fronts on to nearly 300 meters of beach, there is an Olympic sized swimming pool (50m x 8m), and all the suites are a minimum of 100 square meters inside each room. Even individual furniture items are seriously over-sized.

However, to call Ketapang massive is to do it a disservice. Set on a two and a half hectare piece of beachfront land on Bali's southwestern coast, it is definitely spacious: Open and airy, breezy and spread out, for sure. But you find, on close inspection, that each building and each

amenity is built one in relation to the next—and, even if they are all somewhat high on the scale charts, they all have an innate sense of restraint and proportion.

There are *joglo* roofed, wooden tile-roofed and thatch-roof pavilions, a water tower that turns into a bar, a huge underground theatre and wine cellar, an elevated dining and sitting pavilion, some more modern, shingle-roofed suites, a tennis court and, of course, the huge pool. And with near to 300 meters of ocean frontage, dark black sand and cresting waves, Ketapang is all about location, location, location.

The nearby village is called Tegal Mengkeb, a phrase that translates as "Hidden Garden" from the Balinese. Appropriately, Olivier has created a hidden garden within a hidden garden. He called it Ketapang after the sea almond tree, as it is beneath these trees that the Balinese gather socially in the shade to talk about village matters and exchange gossip. In fact, there are more than a few *ketapang* on site, along with spiky pandanus, sea grape and the ubiquitous water hyacinth, all of which can withstand salty sea breezes. Even so, maintenance at the estate is always an on-going issue.

A bit of a property collector, Olivier first came to Bali five years ago and first of all fell in love with the people, then in love with the land. Within five minutes of seeing this plot, he had decided to buy it. Another five later, he had envisaged the layout of the property; within three days he had bought it; and less than 10 months later, all the building works and interior finishings were complete.

As for the end result, Olivier is a contented man. His dream, a very personal quest, has turned into a private estate—and he still gets invited by the local fishermen to go out fishing.

Above One of the owner's aims was to try to build as local as possible, so all the building materials come from Bali. This sweet rotund bedroom has an elevated position in the compound.

Below left The first in Bali, an Olympic-length swimming pool, is lined with a stone from Singaraja—it changes color from brown to green-purple depending on the sky. The pale stone around the pool is *palimanan*, a local limestone.

Below middle Most of the furniture was constructed in a workshop in Java, but this all-weather wicker suite was bought for its ability to withstand the elements on this open-air deck.

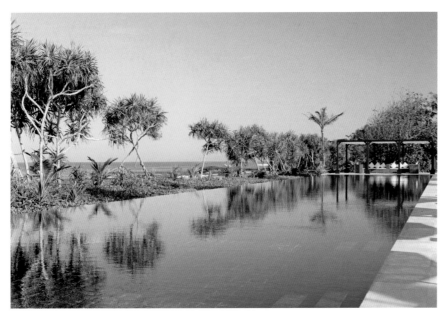

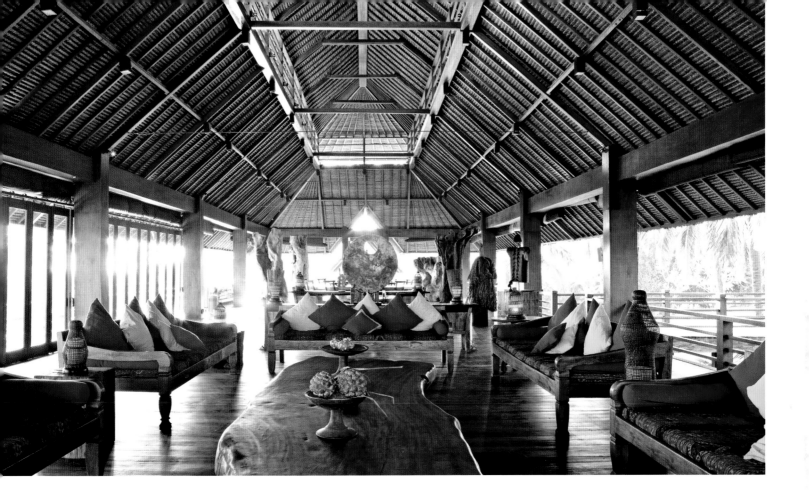

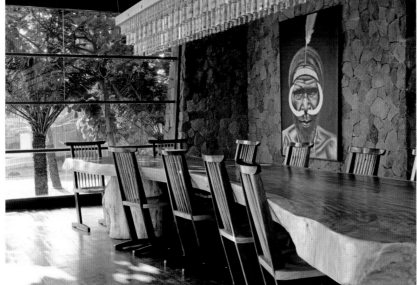

Above Traditional Balinese benches in the main pavilion are based on a trad style, but were made on a much larger scale, so they fit the space.

Below left Wood from the same *suar* tree used for the table above was handcrafted for this super-long 6.5 m dining table in the down-stairs air-conditioned dining room. The 5.5 m hanging light was custom-crafted by DeLighting to a design from Olivier; because of the color of the numerous resin Buddha figures, it brings warmth into the exposed stone room. The walls, made from volcanic blocks from Karangasem, are purpose-fully angled to give the idea of a temple structure.

A Personal Piece of Paradise 113

Left and below The Air suite, (*air* translates as "water" and this luxe villa is surrounded by fountains, pool and sea) sports a pleasant seating area in front of a custom-crafted cabinet filled with Indonesian artefacts.

"I love modern design," says owner Olivier Meens, "but once I had settled on the site and bought the land, I realized that I needed to build something quite natural, something not sophisticated." This is eminently sensible as the plot is bordered by two rivers (and the ocean) and is surrounded by the rice-terrace countryside people associate with picture-postcard Bali. Olivier envisaged a semi-wild garden estate dotted with separate suites and rooms, clustered round a central pavilion and rectangular pool. And that, ultimately, is what he got.

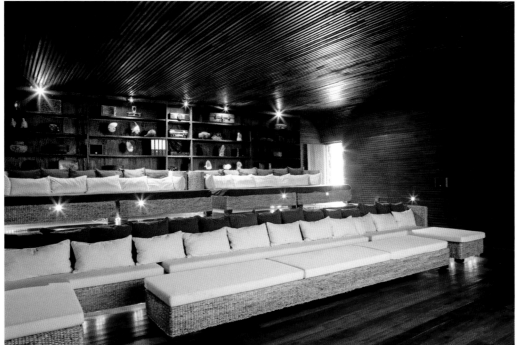

Above The central pavilion is built from volcanic stone, *batu Karangasem, benkerai* and coconut. The double-tier roof is of *alang-alang*.

Left The massive AV room is well thought through. "Many people forget that it rains a lot in Bali," explained Olivier, "so I created the media room for bad weather days. I put a lot of wood in here, and rounded the ceilings to hide the aircon and absorb the sound, so you can't hear the waves, wind or rain when you are watching a movie. I also have great hi-definition professional equipment, and three levels of seating."

115

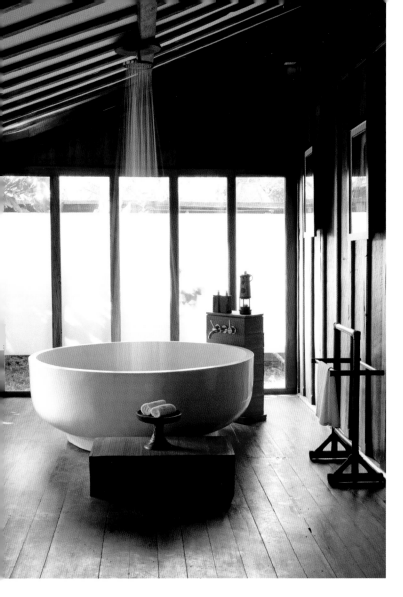

Above, right and opposite
Olivier formulated the design and situation of all structures himself, but enlisted the help of two young architects—known to him only as Kadek and Komeng—to turn his rough drawings and plans into reality. During construction, he tried to keep to the land's natural contours as much as possible, building some new guest pavilions and placing three *joglos* from Java in key positions. One has a private pool and follows a pineapple form—simple on the outside and very intricate inside. One right on the beach, Joglo Pandan, sports its original paint, while the third, placed high on a rock facing the ocean gives the feeling of being in a treehouse. All are furnished with genuine antiques that Olivier picked up during his travels. With such thought and care, it comes as no surprise to report that the villa was awarded the title of Best Resort in the World by *Hotel & Lodge* magazine in January 2011, something Olivier is very proud of.

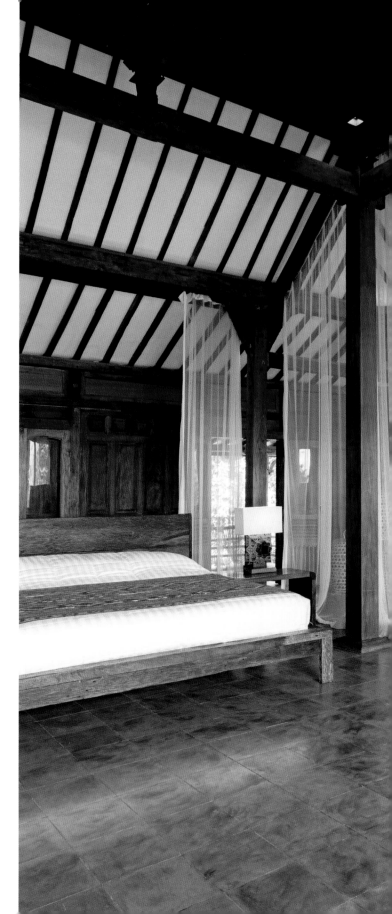

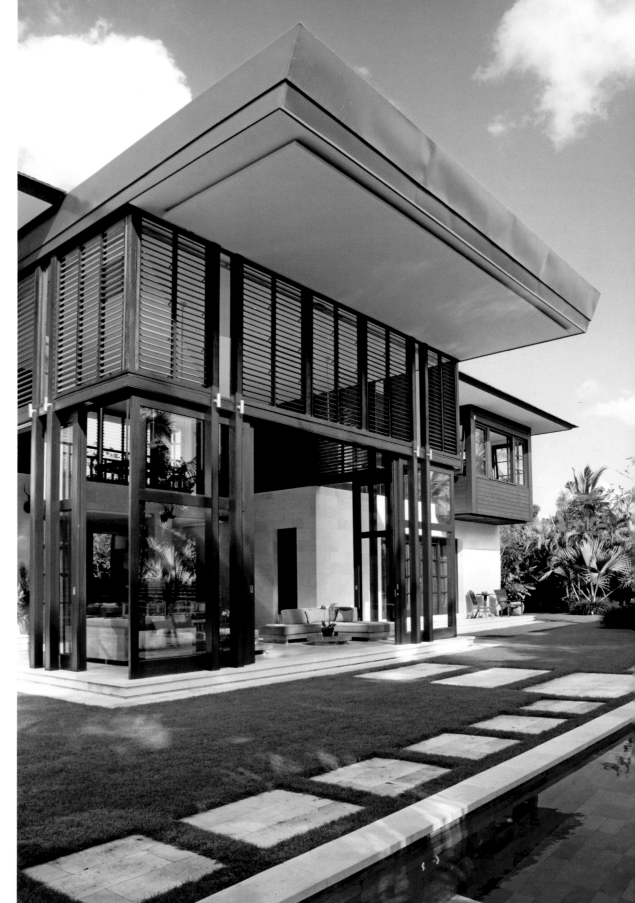

Internal courts are synonymous with Asian architecture, and in this house, one enters first into a tranquil garden courtyard with fountains and pond, lily pads and the welcoming sounds of running water. A large Ganesh statue acts as both guardian and screen at the entrance.

VILLA BIRDSNEST

Oasis of Calm

Architect/Designer Glenn Parker,
Glenn Parker Architects Indonesia (GPAI)
Location Pererenan
Date Of Completion 2010

A mix of East and West, indoor and outdoor, this Swiss surfer's home is located at the end of a secluded lane in Pererenan and is bounded on three sides by a stream. As such, it is intensely private—which suits the owner just fine.

Designed by Glenn Parker, the home is serene, light-filled and inviting. Composed from the architect's signature stone-and-wood palette, it does, however, signify a certain stylistic departure for Glenn. "Recently I've been trying to get away from the heaviness of so much of the architecture you see in Bali," he says of this 2010 creation. "I've been moving away from the dark wood, dark stone, *alang-alang* model towards something lighter, sleeker and more contemporary. Nevertheless, I still like to keep a connection with Asia."

This is unsurprising, as the architect has always stressed the importance of the social and cultural issues inherent in a location. In this particular house, which he describes as "Asian contemporary architecture" he has opened and enlarged the volumes, but still retained a connection with the land. Asian elements include the integration of an internal open-to-the-sky entrance court with Ganesh statue and salient water features; antique Indonesian doors and painted wooden panels incorporated here

and there; a strong connection with the site; lush landscaping; and, of course, the use of local building materials.

The main focus is the double-height living/dining room with attached open-plan kitchen. Sporting travertine floors, and large sliding French windows in *benkerai* and glass, it has a slightly Japanese feel. This may be the result of combining two different types of wood—the upper part of the atrium room is composed of louvers in teak—or it may be because there are glimpses of honeycomb wooden detailing beneath balconies through the windows. Either way, the room is restful and informal, with 180-degree views to the pool, garden, tree-lined perimeter and rice fields beyond.

The sophisticated, well thought-through kitchen is integral to the design and is representative of the improvement in quality in building work and materials in Bali. Designed and built by Deweer Interiors, it features lime washed teak cabinetry and a robust countertop for informal dining. If sit-down dinners are in order, there's the alternative of a large dining table and chairs made from recycled boats from Kalimantan; sustainable (and widely attainable nowadays), such renewable resources are very much à la mode.

Opposite A view of the oblong shaped, symmetrical house from the garden. The huge, double-height living room, flanked by a games room and guest quarters on the ground floor, has three bedrooms above.

Above A cooling pond with dyeing vat and water plants ensures that the entrance to the house is tranquil. A Buddha statue sits against the wall.

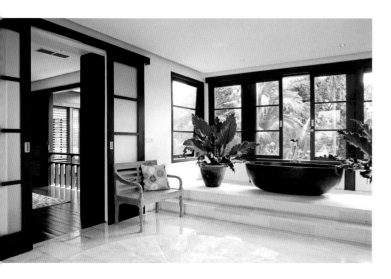

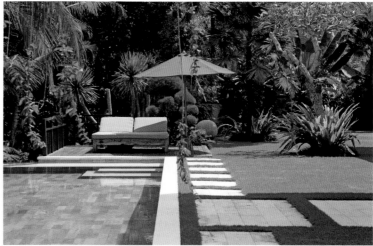

Villa Birdsnest is the name given to the villa which, according to the owner, has "good vibes" that make him feel right at home. A hybrid house, the architecture and interiors mix Asian and contemporary Western elements: An antique Indonesian front door gives a feeling of welcome from the very start.

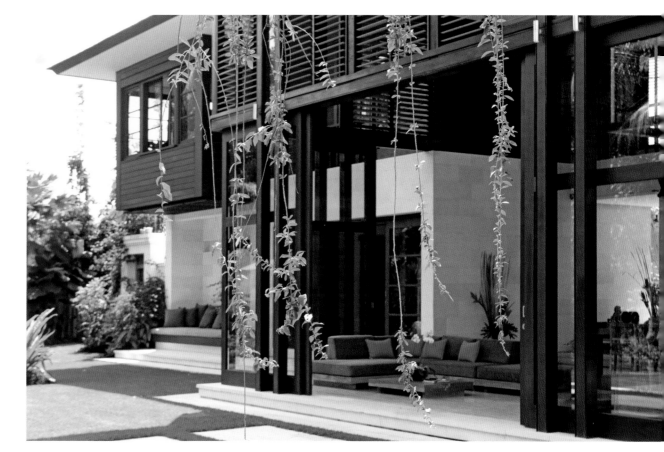

Above left All bedrooms and bathrooms are a picture of tranquility. The master bath, with freestanding dark tub, is a good example.

Right This photo looking back at the house is taken from the *balé*, a modernist reinterpretation of this traditional Balinese structure that features a sprouting landscape on the roof and hanging vines on all sides. It offers a contrast to the wood shingled pitched roofs found in the main volume.

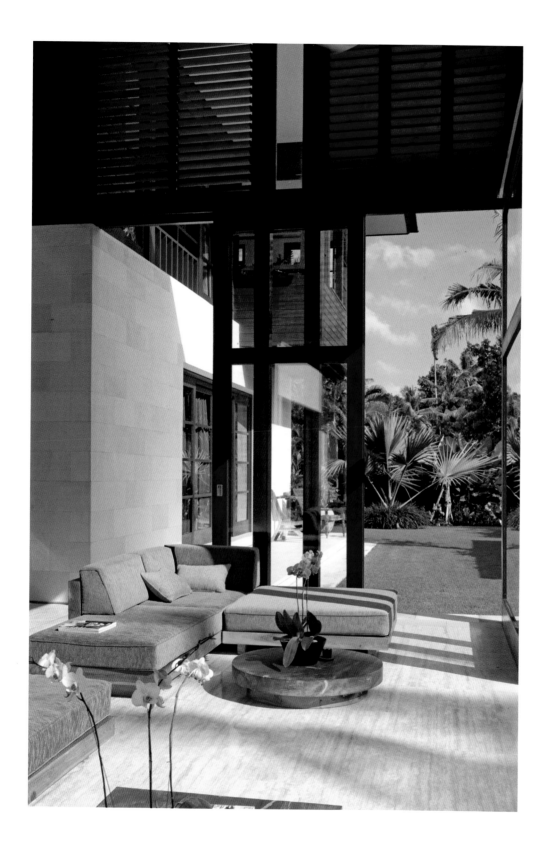

Left The double-height living/ dining room features low level seating in teakwood with sage upholstery built by a carpenter in Kerobokan to a design of the owner's friend. Realized in teak so as to contrast with the use of *benkerai* elsewhere, high-level louvers ensure plenty of cross ventilation below.

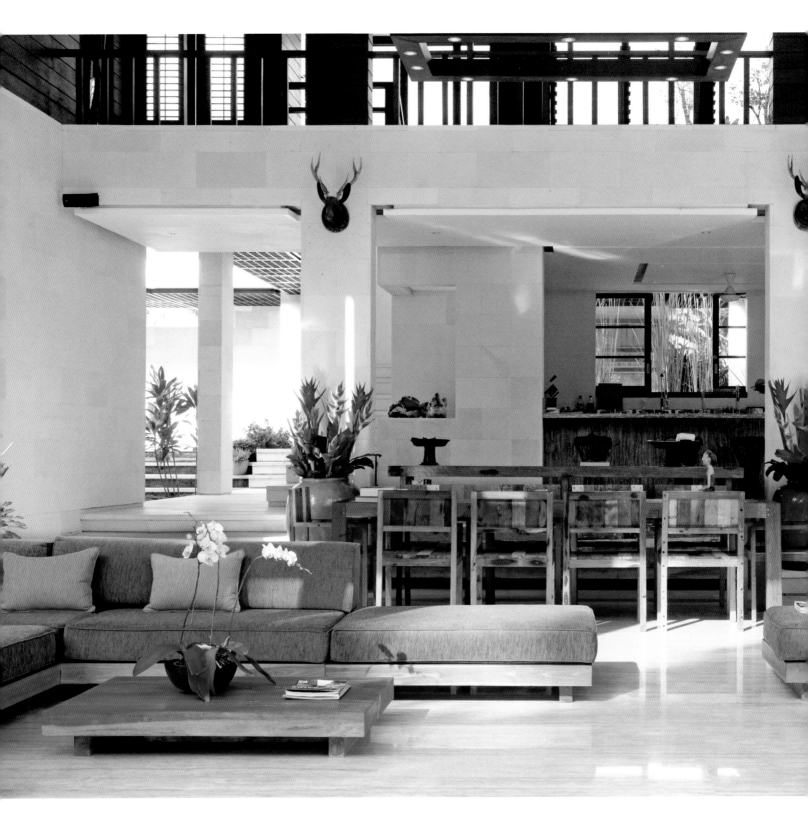

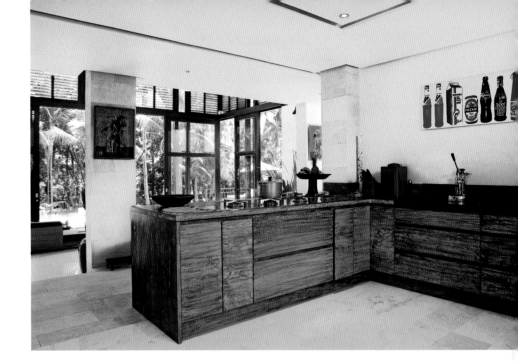

Top Johan Meyers of Deweer Interiors crafted all cabinetry in the kitchen from lime washed teak and coated it with a VOC-free protective coating that deepens the color of the wood and adds durability. Lime washing deters wood-boring beetles and helps sterilize the area. The Pop Art painting is by Canggu-based Australian artist, Andrew Wellman. Wellman is an artist inspired by Magritte, Matisse and Warhol, and the naïve simplicity of his subject matter appeals to the owner.

Above The nautical shades of the recycled dining table and chairs adds color to the light-filled room.

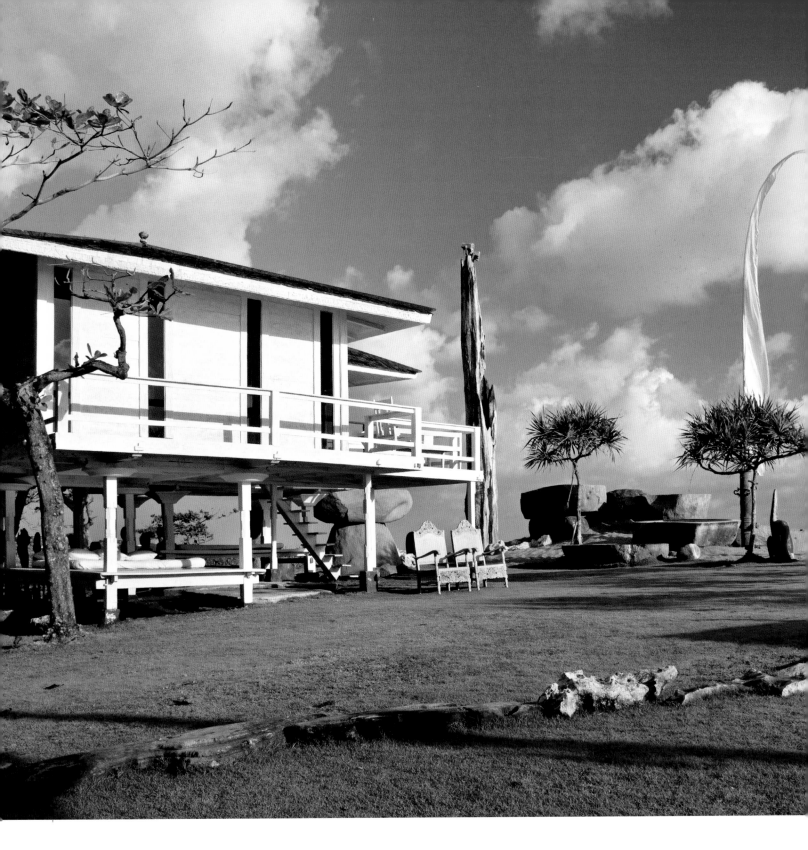

BALI BY DESIGN

Left The breezy beach house sits between the ocean and the lawn—with a collection of rocks and petrified wood all around.

Right A symphony in white: A desk lines one side of the double-height master bedroom.

MORABITO ART VILLA

Artful Retreat

Architect / Designer **Pascal Morabito**
Location **Pantai Berawa**
Date Of Completion **Work in Progress**

The elements that Pascal Morabito strives to have in his life—harmony, proportion, love, freedom—are patently on show at his spacious home in Bali. Set on a huge plot fronting Pantai Berawa, it comprises a number of seemingly disparate separate structures that miraculously fit together like the pieces of a somewhat random puzzle.

There's the central linear, two-storey, mainly flat-roofed volume with living room and kitchen below, master bedroom, expansive open-air bathroom (along with two swimming pools—one white, one black!) above, all oriented to overlook the garden and ocean ahead. Then, there's a massive studio, more sleeping quarters, a second staff kitchen, a hammam and spa presently under construction, another volume with guest quarters. Out front, workers scurry about building a platform over a lake where a semi-open structure from Kalimantan is awaiting placement. At the moment a mobile of graceful wooden birds

hangs from the rafters; circling gently in the breeze, they may be replaced at any moment by their idiosyncratic owner.

Opposite this, right by the oceanfront, is a beautifully constructed beach house on stilts. Entirely composed of distressed and whitewashed wooden boards—Javan panels and wood from a Balinese granary or *lumbung*—it is a vision of Caribbean cool. Interiors and exterior are bathed in a sea of white—there's a quilted bed beneath white rafters, a cute outdoor bathroom and a rustic balcony. The perfect honeymoon suite, its aura is encapsulated by Pascal's words: "Life must be a piece of art."

Buildings aside, the house is more than worthy of note as a treasure trove of art, artefacts, ceramics and ethnic statues that literally fill the rooms to the brim. Much of the furniture has been designed and custom crafted by Pascal —a low table full of ceremonial krises under glass, some faux rattan furniture in geometric shapes, a Javan carved panel incorporated into architecture—and pieces of his own individual ceramic works are also on display (see page 186). Massed collections of wooden statues or bronze

Buddhas are arranged in clusters, often startling the eye with one individual piece painted bright red. There are also untold numbers of Hirsts, Harings and works by other modern artists in strategic locations. Pascal names many of these artists as personal friends.

The garden is no less impressive: old seats from Sumba, individual pieces from the Middle East, huge rocks from all over the archipelago, two 17th century columns from France, totems, ancestor figures and graves from east Indonesia, amongst others, are all woven into a tapestry of green lawn and reflecting pools. It's here that the Morabitos stage events, mainly weddings and parties—all for the joy of sharing their estate with others. It's a truly inspirational setting, one that buzzes with a type of energy that transfers as if by synergy to its highly creative owner.

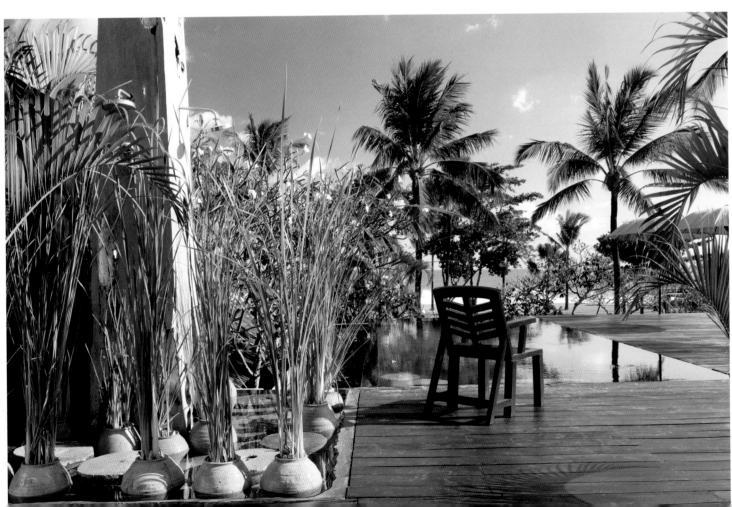

Opposite, top A large terrace overlooking the main 14 x 7 meter swimming pool and lily pond behind is furnished with all-weather loungers custom made to a design by Pascal.

Opposite, below One of the two 400 square meter pools on the first-storey terrace outside the Canopy guest suite, so named because it lies at the heart of the compound in the "crowned canopy" of the home.

Left View of an a-frame structure that houses the Morabito's bedroom suite on the first floor. Inside are artworks from a variety of artist friends including some wonderful pieces by Damien Hirst who stayed at the property for three months.

Below The entrance with a *porte cochère* clad in greenery is quite modest, making the surprise of the house all the greater when you enter.

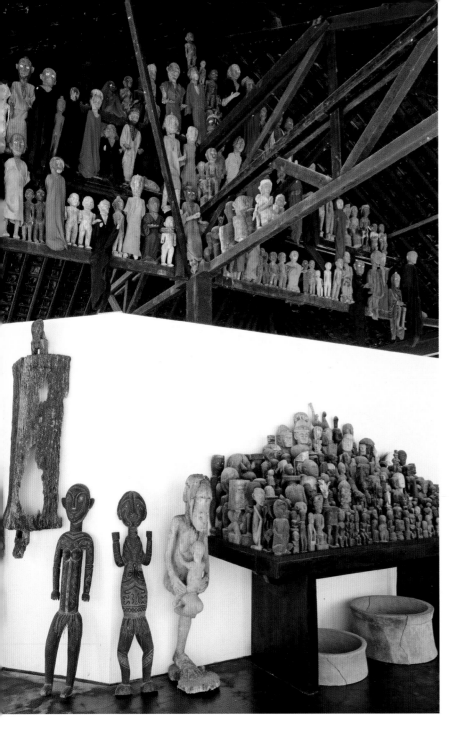

Pascal's artworks are as individual as the man himself with ethnic statues collected over the years arranged carefully although they give the impression of a hodge-podge mix. There's usually a Hitchcockian "splash of color" with one bright red piece set amongst the cluster. The table below was created by the owner using three large rocks as stabilisers, each poking through the glass top; behind are a number of statues atop old Dutch plant pot stands—a highly effective display case.

Oher eclectic items in Pascal's studio awaiting future assembly include countless betel boxes lined up on a workbench, a complete skeleton of a whale—and much more.

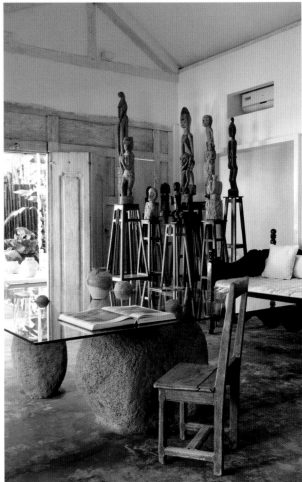

"I spend all the day creating new things," Pascal explains, "But I'm not seeking perfection, just something new, something that interests me at the time. Nature makes perfection, not humans," he concludes—all the while casting his eyes over his paradisiacal surrounds.

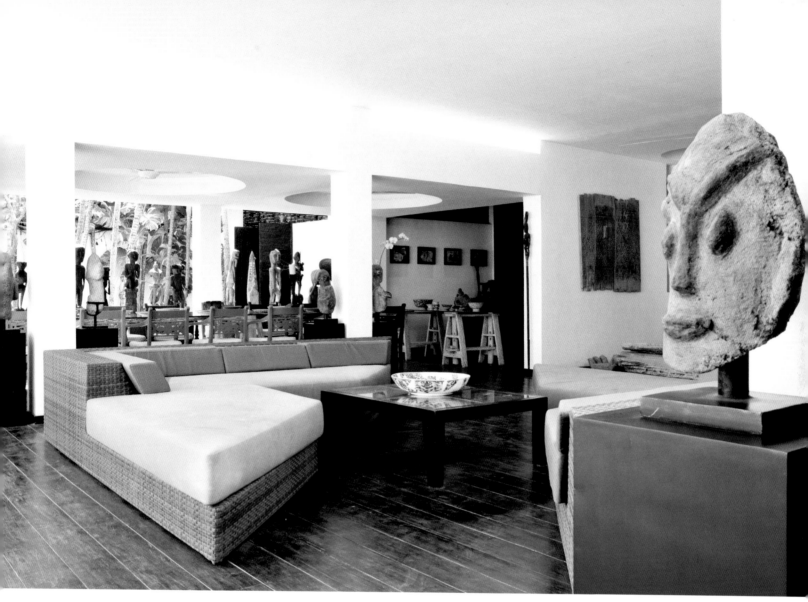

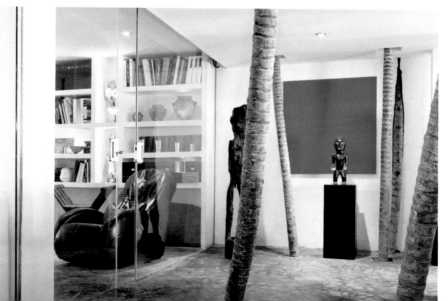

Left A small antechamber outside Pascal's study was built around the existing palm trees.

Above The main living/dining area features low-slung sofas and a long table behind that comfortably sits 20 people. The ceramic bowl on the coffee table was assembled by Pascal from different shards of another pot (see page 186 for more details). Examples of Pascal's extensive stone collection are displayed all around.

Top, right and opposite, top left
All in white, a *lumbung* on the beach has been transformed into a romantic honeymoon suite with the addition of Javan panels and distressed furniture. At front is an ocean facing terrace (unseen), while interiors are Bohemian and beautiful, yet comforting and comfortable nevertheless.

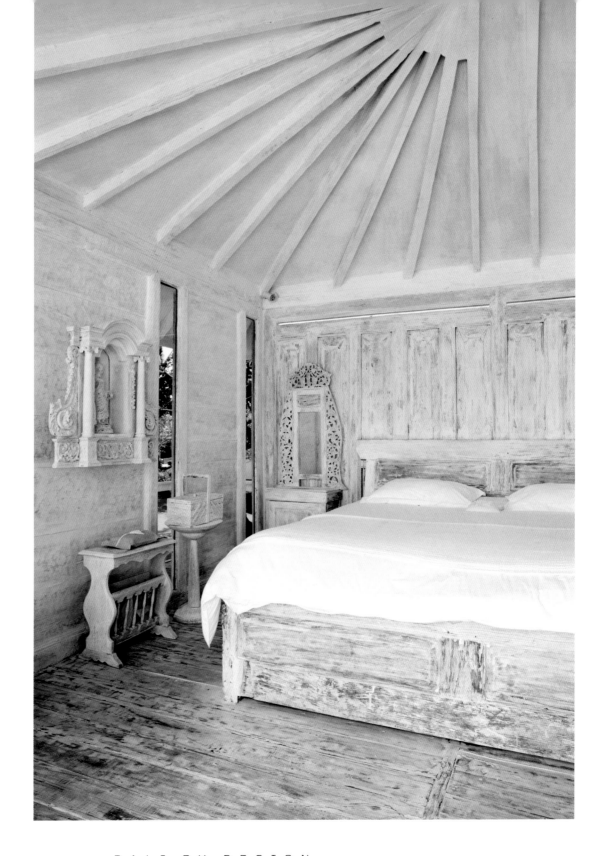

BALI BY DESIGN

Interior décor—in keeping with the locale—is relaxed and homey. An appropriate mix of nautical blue-and-white homespun fabrics and artworks mixes with naturalistic furniture, all custom-designed by Zapp: distressed armoires showing patches of aqua and cream, expansive sofas, an extra-large hanging swing chair in bamboo, a super long irregular shaped dining table and benches in *suar* wood, as well as hanging lamps in bamboo and wicker are meticulously crafted. This, combined with wooden flooring and a soaring ceiling painted white, ensures the beach house looks (and feels) lightweight, floaty and outdoorsy.

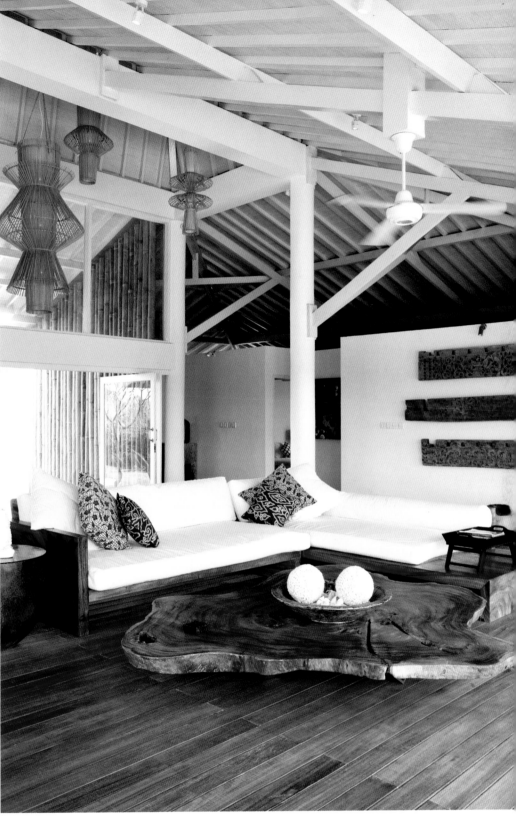

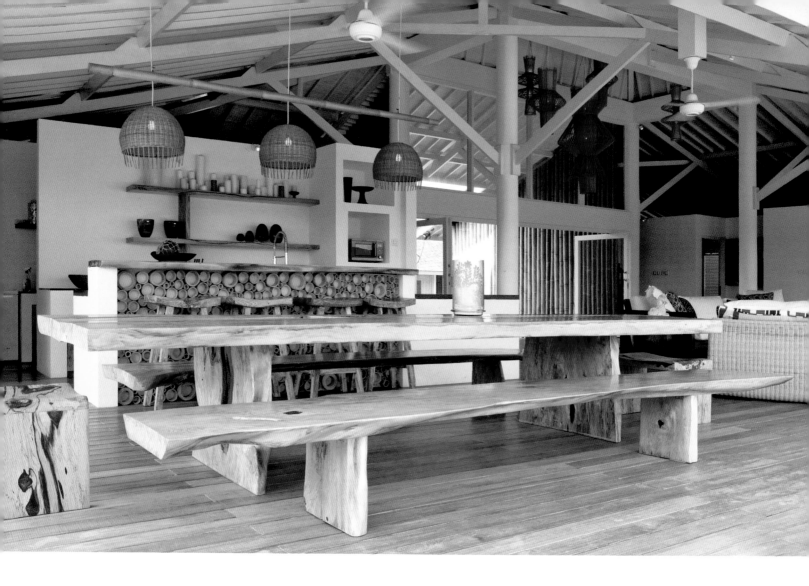

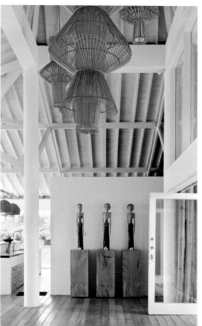

Above and right Zapp Design's furniture is both practical and well crafted, combining a contemporary aesthetic with durability. This is especially important in this type of house where sea air, salt, and rains enter frequently. Added to the mix are some local touches, such as the puppets and fish trap lights on right and the bamboo detailing in front of the bar above.

If you are looking for a little rest and relaxation away from the hustle and bustle of Bali's south, Nusa Lembongan could be just the ticket. It's easy to get to, yet once you are there, you could be a million miles away. At approximately 8 square kilometers in size with a permanent population of about 5,000, it is slow-paced and quiet. Most people are involved in seaweed farming or fishing, with a few catering to the tourists who come to dive, snorkel, chill and recharge. Who knows, Villa Tranquilla could be the place for you?

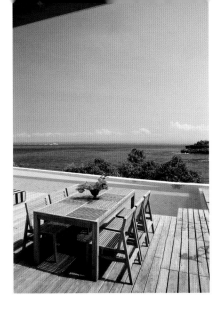

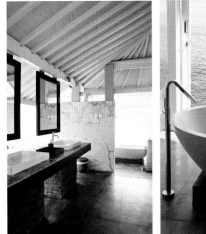

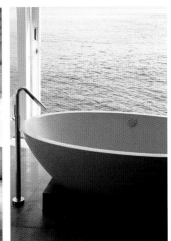

Below and right The master suite contains a spacious bedroom with platform bed that looks over the pool and ocean and a gorgeous bathroom divided into two areas—one housing his and hers sinks and closets, the other a terrazzo tub close to the edge of the cliff. Needless to say you don't need a book in the bath; the views provide endless entertainment.

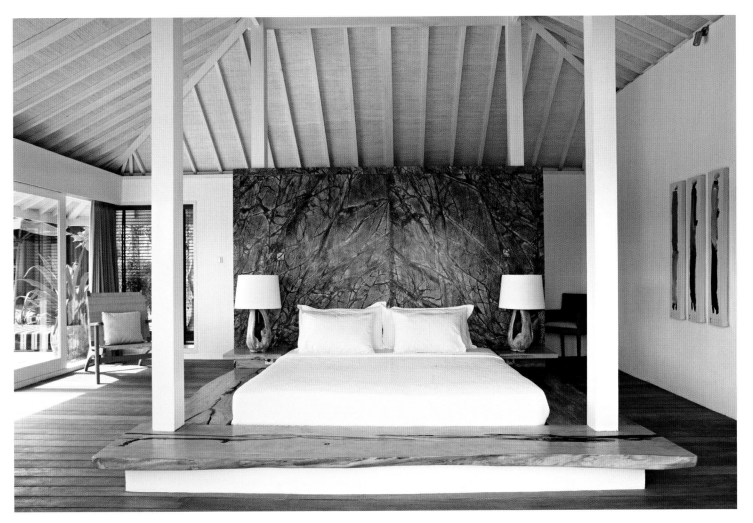

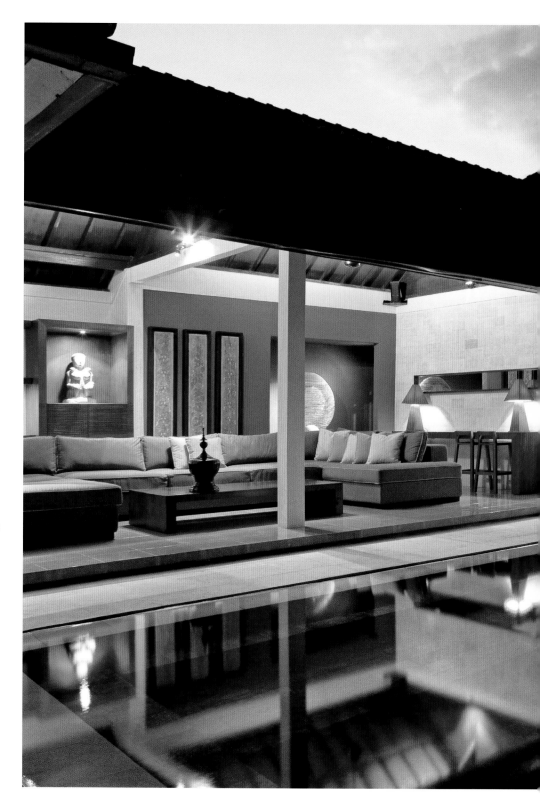

VILLA ASRI

Organic
Growth

Architect Ross J M Peat,
Seriously Designed Architects
Location Petitenget
Date Of Completion 2011

Built over stages and situated on a quiet
gang (lane) in Petitenget, the home of Ross
Peat of Seriously Designed could be described
as a modern-day longhouse. Long and thin,
with an open-air colonnade stretching nearly
the length of the home, rooms are situated
on one side, with garden, pool and deck on
the other. Sleek, full of light and space,
comfortably furnished and imaginatively
decorated, the house is 200 square meters
in size but seems larger.

It wasn't always like that. When Ross first
moved in ten years ago, the original structure
was a simple, small Balinese house on a tiny
plot of land. Over the years, the space has
nearly tripled in size; each time Ross gained a
little more land, he worked on enlarging and
modernizing the home. His first task was to

double the living room area, then, when he acquired nine meters of the house next door, he made further changes: "This gave me more room to work with, so I put in the swimming pool and changed the layout of the two bedrooms," he explains.

Three years later, the house next door became available, so he nabbed it, and elongated his home with an additional two bedrooms with bathrooms, walk-in wardrobes and a two-car garage. Today, very little is left from the original buildings and the clever design and manipulation of spaces makes it difficult to visualize what it must have been like before.

Ross likes contemporary design and wanted something comfortable, spacious and easy to live in. Rather than renovating and rebuilding immediately, with each land acquisition, he preferred to live in the space for a while before attacking it with the demolition block. This restraint has resulted in a harmonious home —rather than something that looks like it was built in stages.

The main open-to-the-elements living room features a custom-crafted loungy sofa and garden views. Separated from the kitchen by a very high bar-cum-divider, it's a relaxed space. A few art pieces from Ross's favorite artists such as Stephen Hall, Geoffrey Ricardo and Jody Candy adorn the walls and he has also collected a few pieces in Bali. "I didn't want the kitchen to be the focal point," explains Ross, "so I added that divider to somewhat conceal it; that's why

the refrigerators are behind cupboards and you can hide all the mess from view behind the high bar top."

In addition, there's a further lounging area overlooking the pool, in what was the beginning of the second house. Ross explains the rationale behind this space: "This is my favorite spot in the garden to sit, there's the sound of running water from the water wall, a nice view up along the pool to the garden in the distance, and you're close enough to the kitchen to get drinks and so on."

He is thankful to be doing a job he loves in a place he likes to be, and wakes up each day happy in his home. And now he's completed the design of an office on the opposite side of his *gang*, it's a very short walk to work.

Below Sixteen meters long and two meters deep, the pool is lined with a slate called Angle Green from India. Sitting flush to the house and slim garden, it is surrounded by different seating areas—including this outdoor bench at one end.

Above and opposite, top The comfortable living room is nearly filled by the sofa: "I designed the low-level sofa so it filled the space," Ross says, "It allows for a great place to have lots of friends over, relax and enjoy a lazy afternoon."

Opposite, below Bedrooms are simple, yet sleek, and tastefully accented with choice paintings and artefacts. The oil above the guest bed is by a local Balinese artist called Ngurah. As Ross notes: "It is perfect for the space."

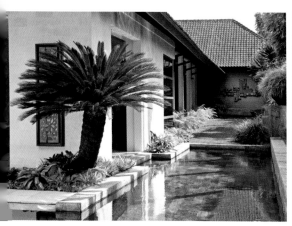

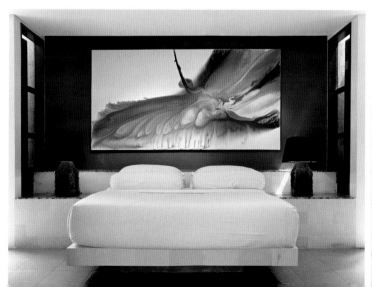

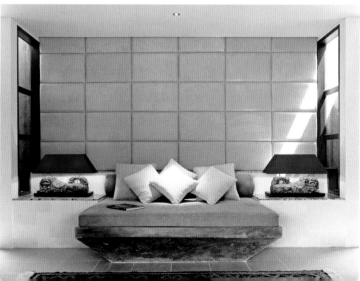

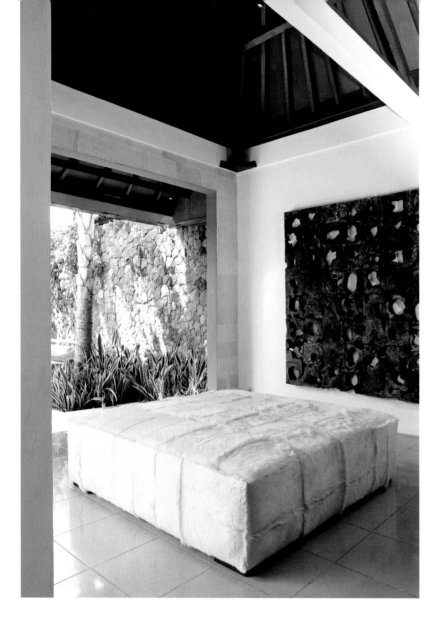

Above, left and opposite
Ross has designed houses, hotels, and commercial spaces and likes to do projects that incorporate more than the bare bones of the building: Overseeing the landscaping, lighting and interiors ensures he gets the final impression he wants. This, obviously, has extended to his own home where lovingly crafted and collected items fill the various spaces. The seating area on left is enlivened by a salvaged wood panel Ross designed in his office and commissioned locally; the statue above is a detail from the the rock wall that Ross used to divide the sleeping quarters fom the living spaces in the home ("This was to give the observant a laugh as they walk by ... few people actually notice them which I like"); and the sculpture on opposite bottom is a piece by Seike Torige, a Japanese glass artist who lives in Bali but is collected and exhibited internationally.

Right Sitting in a niche lit from above is a statue of Omar, a protector of the spirits for when people are cremated. "She apparently sits to the side when there is a cremation to protect the leaving spirit from evil," explains Ross. "I added the crucifixes for a little humor."

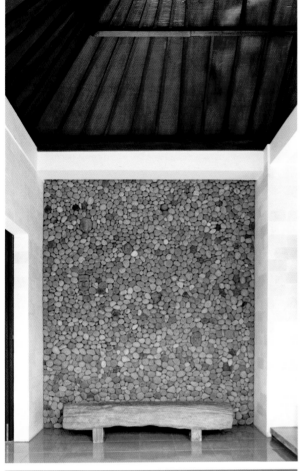

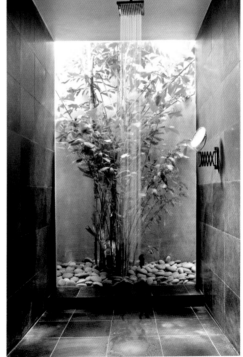

Left below Slightly more luxurious than the other bathrooms in the home, the master bathroom is very masculine in style with a black-and-white color scheme and a wall of glass by the shower. "I did all the bathrooms in a similar style," says Ross, "the white stone is *palimanan* and the black is andesite. Andesite is a very hard stone and unaffected by water but *palimanan* is porous, so the andesite is on the wall areas which are in contact with water and on all the floors. I have also used a marble from India called Forest and you can actually see the branches of trees in the marble which is amazing."

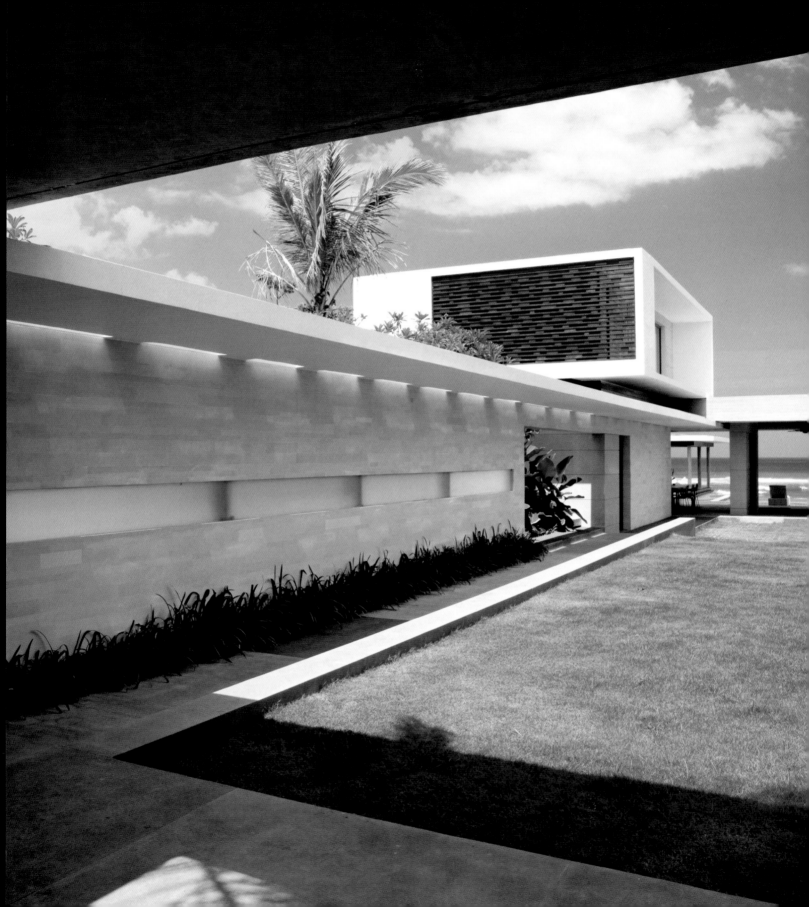

CEMAGI RESIDENCE

Resolutely Modern

Architect / Designer **Gary Fell, Gfab Architects**
Location **Cemagi**
Date Of Completion **2011**

Even though the owner is very much a mountain person and this villa is perched on a rise overlooking the ocean, it does have a certain wild, natural beauty that reminds him of the mountains. There are rocks, the ever-changing waves, a dramatic vista—and the whole is slightly elevated on a bluff. As the architect notes, the long thin shape of the villa is dictated by the plot and land size. "The composition (as a whole) is predicated on the resolution of line and material," explains Gary Fell.

Built on a long thin plot that faces out over the ocean, this concrete-and-limestone home is superbly minimalist. There is absolutely no compromise in the spare palette of materials, the resolution of line, and the complete absence of surface ornamentation. As such, it fits the owner's brief to the architect perfectly—"a grey brieze block, a lawn and a pool"!

Designed by Gary Fell of Gfab Architects and owned by a Singapore-based businessman, the house is intended as a focused retreat, a place of calm, a respite away from the world. And, standing at the back of the property where two bedrooms are situated at ground level, looking forward to the sea, one immediately senses a rigorous order. The view is over a stretch of green through a framed view of 25-meter pool

that opens out to virtually full width, a deck, sunken seating, and contemporary *balé*— and beyond to ocean, horizon and sky. All is bounded by concrete and skinny slabs of *paras Jogya* limestone. There's a long low-level open "roof" stretching from a second storey "floating box" bedroom over an open-plan kitchen and across the pool to the house boundary wall on the right; there's definition and rectilinear form; there's grey and green. It's like looking at a constantly shifting painting: Depending on the time of day, the season and the weather, the vista is always different.

An out-and-out modernist, the owner has been interested in clever design for as long as he can remember. "Be it beautiful furniture, clothes or cars, I've always liked clean lines," he explains,

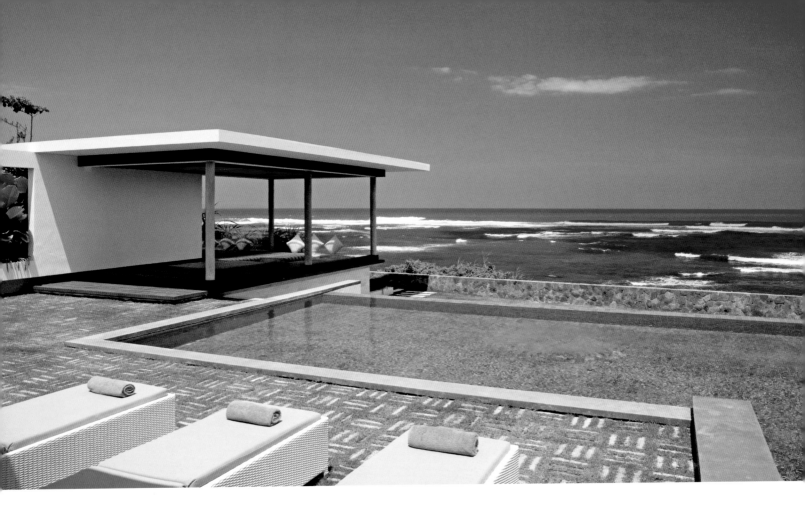

"so in terms of living spaces, it isn't surprising that I look for a spare palette of materials, forms and colors. I am quite a messy person, so a pristine, clean environment forces me to tidy up and put things away." It also helps to alleviate stress, he notes.

The layout of the villa was predicated, in large part, by the shape of the plot. At one point, there was talk of having the master bedroom above the other bedrooms at the back, but placing it at mid point to one side makes the structural form a whole lot more interesting. "That really worked," enthuses the owner, "and the views from up there are sensational."

Interiors-wise, the home is decorated with a few choice pieces that the owner shipped to Bali from previous homes in Europe. An avid art collector, especially of light installations and large, contemporary canvases, he was somewhat restricted in his choice of furnishing by the inevitable wear and tear that salty sea breezes inflict on fragile items. Nevertheless, life and texture are brought into the overall scheme of things with custom-crafted inbuilt furniture and clever recessed lighting. The kitchen furthers the utilitarian theme: the indoor section is strictly functional, while the outdoor area comprises a black terrazzo block inset with hob, sink and fridge.

When asked about his tongue-in-cheek brief to the architect, the owner quips: "All I wanted really was the lawn!" Surprisingly, the grass grows really well here, so a lawn he has—a jewel box of green that stretches from the rear of the property up to the pool and deck.

The owner has lived in traditional houses in the past—in Europe, India and the US—but they've always been furnished with a contemporary edge. His Chelsea mansion block in central London dated from Victorian times, but the interiors were strictly 21st century in style, as they are here.

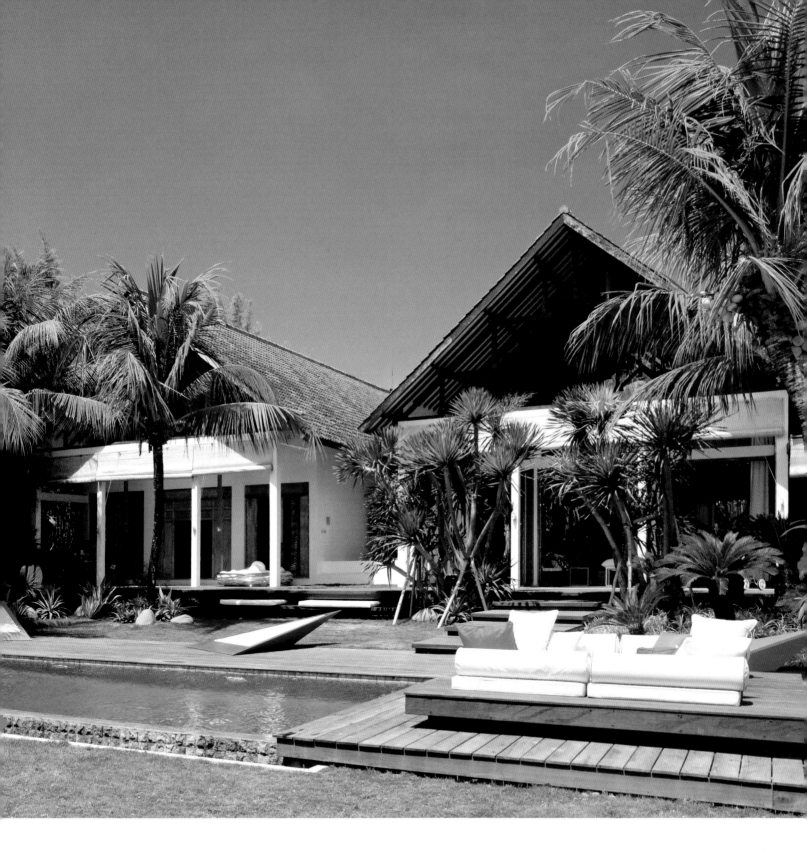

Word of Mouth, the company Valentina Audrito owns and runs with her husband Abhishake Kumbhat, designs and sells an array of items ranging from furniture to lights, clothing, jewelry, and more (see pages 212–215). The duo is also into designing and producing graphic printed fabrics.

First shot goes to the furniture, second to the art, third to the graphic printed fabrics, fourth to the carpets, fifth to the …. You get the picture. This is a home chock-a-block with a fabulous array of things to look at: There's a fair amount of the egg-inspired furniture Valentina designed when she had her first child, Leon; some newer pieces produced in collaboration with her husband, Abhishake Kumbhat, such as the transparent acrylic Starstruck bench; older icons like the lips sofa designed by her father, world renowned designer and architect Franco Audrito of Studio 65 fame; a Kenneth Cobonpue organic-mod sofa. Numerous artworks, tons of prints, plenty of color. You could never get bored here, that's for sure.

There may be things that need work, but that's the way with things, right? A little clutter removal, a little tweaking here and there, a little redesign are always in order. But remember, Valentina: "First and foremost, this is a home where you, your husband, and two children reside, work, relax and play. Secondly, it's an environment in which to get inspiration and develop ideas for design and architectural firm, Word of Mouth. Third, it's a work in progress."

It's also a residence that won't date; it could never elicit anything less than a wow response; and it's a true family home.

Looking around, what can be seen is a series of lively, fun and diverse spaces, filled to the brim with enthusiastically and lovingly designed furniture, *objets d'art*, fabrics, quirky items and more—and Valentina keeps apologizing for the mess! I want to sit her down and tell her, sincerely, she is super talented and gorgeous —and so is the house.

The actual bones of the home are not the subject matter here. Sure, they're interesting, but they're overwhelmed by the sheer audacity of the contents. Over the years, the three *joglos* have been lightened through the removal and raising of roofs, the replacing of wood with glass, the installation of walls and more, so much so that today they retain little of their original forms. Now, they play a secondary role in the home.

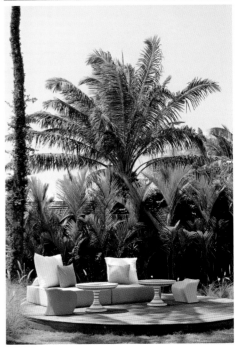

Top The main living room is an eclectic mix, all set beneath a curious "chandelier" made from kitchen utensils. Above the red lips sofa is an artwork by Filippo Scascia in red and black called "Kadek", while the coffee tables in foreground sport acrylic tops above an educational game.

BALI BY DESIGN

Opposite, far left Valentina's foray into furniture design began when her son was born and she decided to design a storage unit for his clothes. This was followed by other items—furniture, homewares, lighting, all inspired by the shape of an egg. This "egg toilet" in the garden follows the theme!

Below A super scary timber tread staircase leads up to a new family space currently being designed in the loft space above the bedrooms. This is a real family home, with colorful spaces for kids' and adults' play. An egg light sits below the stairs in the left corner.

Right The old beamed woodwork of the living room *joglo* is clearly in evidence here, but it has been transformed with boxy, modern couches, geometric rugs and colorful cushions and artworks. The painting by Farid Stevy, "Mundur", was extended by the artist onto the wall.

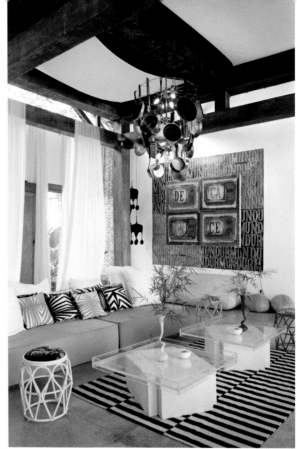

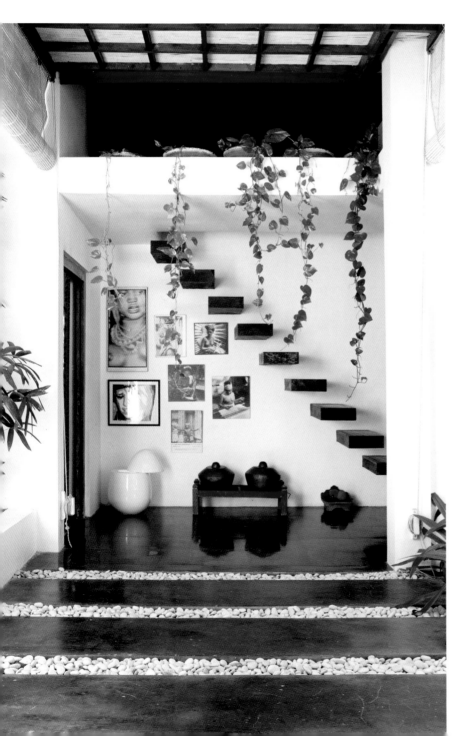

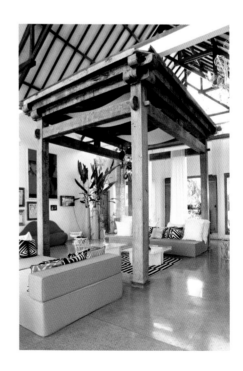

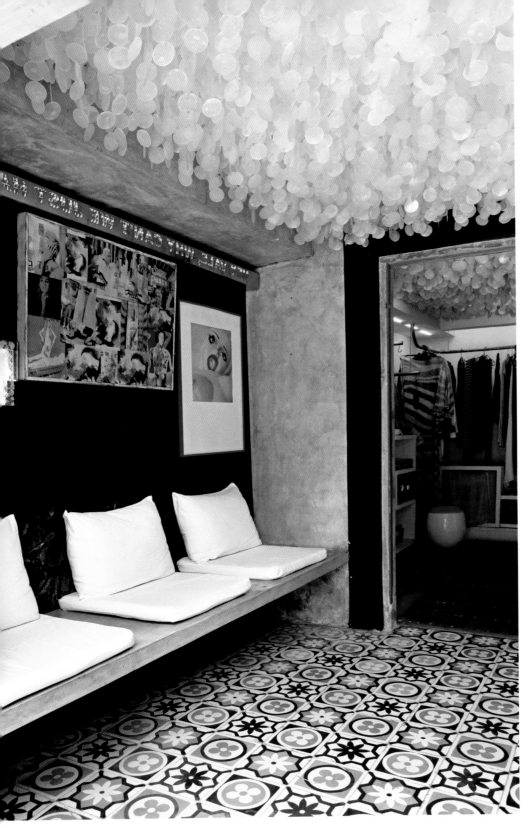

Left and below In contrast to the zen bathrooms found in other villas, Valentina and Abishake continue having fun with the décor in the master bathroom. Tasteful ceramic sinks fom Gaya Ceramic and Design on a terrazzo counter work well with the colorful tiled floor.

Opposite, left bottom Referred to by Valentina as her "office!", a stand-alone egg-shaped toilet sits amidst verdant greenery adjacent the front entrance (see previous page). If that doesn't stand testament to the fun element in design, I don't know what does.

Opposite, left middle Leading off from the inside area of the bathroom is an open-air garden court that features an elegant stand-alone tub.

Opposite, far right The couple's bedroom is light and airy, with a bed set by the window and an l-shaped lounging couch positioned beneath the old carved beams of the original *joglo* structure. A large collage artwork printed on canvas by Valentina hangs above the bed, a detail of which is seen opposite top left.

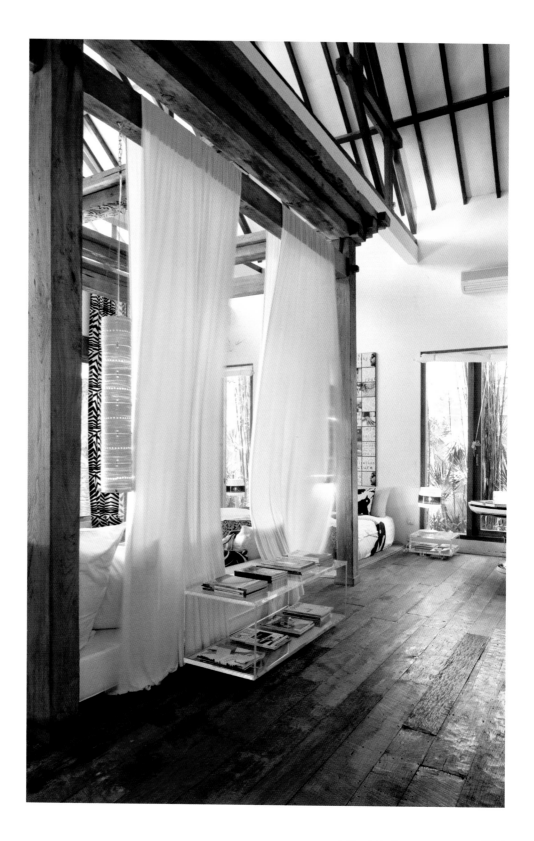

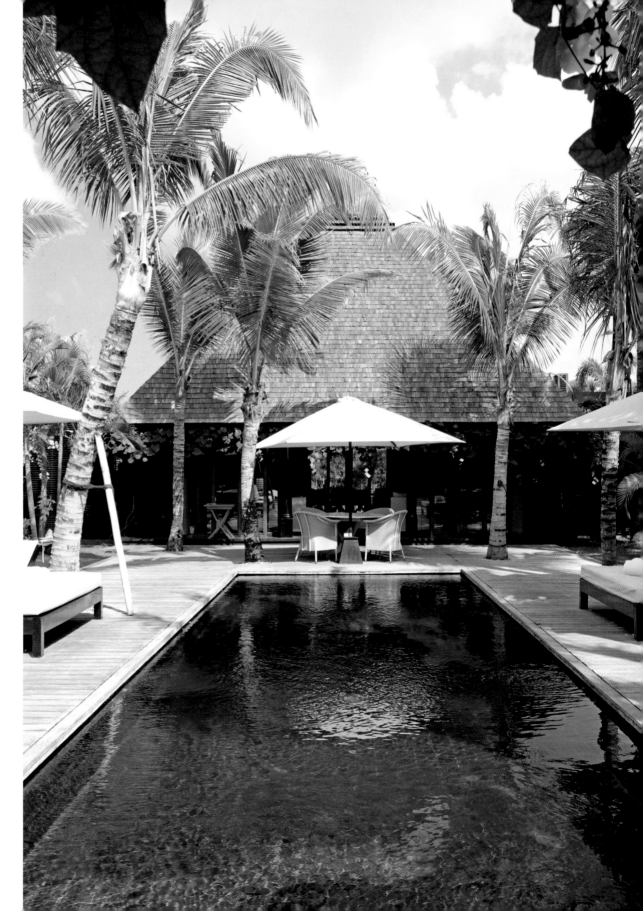

Originally from Amsterdam, the couple divides time between Bali and Holland. Hans mainly designs commercial work, but usually takes one residential project per year. He sees being an architect as part designer, part psychologist. "Clients don't often tell you straight out what they want; you have to investigate and figure out their needs," he explains. Certainly, trying to ascertain what he and Rien wanted in their own home had its challenges ... yet the end result is totally harmonious.

VILLA SAMUAN

The Art of Compromise

Architect **Hans Witt**
Location **Seminyak**
Date Of Completion **2009**

Villa Samuan in downtown Seminyak takes its name from Pura Samuan Tiga, a temple in Bedulu not far from Ubud. Translating as the "Temple of the Meeting of the Three", it is dedicated to the Hindu trinity of Brahma, Vishnu and Shiva. The owners appropriated the word Samuan for their villa, as the home is a meeting point between East and West, guests and owners, Balinese and European.

Designed by Dutch architect Hans Witt with much of the interiors formulated and realized by his costume designer partner Rien Bekkers, the home is also a meeting point between their two styles. Hans describes himself as the more modern of the two, while Rien's tastes tend towards the classical. "There were other differences too," Hans explains, "I wanted a

big garden, Rien wanted an inner court. In the end we got both ... the house is, shall we say, an exercise in compromise!"

Diplomatically put, and beautifully executed ... as is the house. From the minute you enter the serene compound, you immediately feel a sense of calm and order. This probably has something to do with the geometry of plot and plan—a highly symmetrical placement of buildings on 16 *are* of long, thin land—but it is also derived from the harmony of garden, court and buildings and the muted color palette used throughout.

A severe, modish entrance leads into a court planted with boxy bamboo. This separates the quest quarters on the left from the main house on the right. They are mirror images of each other. As you turn right into the main pavilion which houses a bedroom, open-plan living room and small kitchen, you walk through to a large swimming pool and garden with another pavilion at the far end. Here, there are further bedrooms, offices, a massage/spa room and a large open lounging section fronting the pool.

Hans describes their home as "quite personal, but with a Bali feel". Being in Bali, he wanted some vernacular touches, but decided to keep the house strictly linear as a counterpoint to the Asian elements. The duo sees the home as a balance between Western and Balinese: "As the Balinese are extremely creative, we added lots of Bali touches," but they also desired European functionality and a streamlined look.

All the buildings are situated on an outdoor *ulin* wood deck that runs the full length of the plot—the backbone of the site as it were. *Ulin* was chosen for its hardwearing qualities and because with time it turns a little grey in color, thereby contrasting with the interior's dark coconut wood walls and the stained *benkerai* louvers used elsewhere. Similarly, the pool is dark and seems to sink into the decking. The wood shingle roofs sport wonderful detailing at the tips: this serves the practical function of pulling hot air up from below and adds sinuosity to an otherwise streamlined form.

Opposite The pool, which has grey painted dark tiles "so that it disappears into the deck", is flanked by two loungers with footrests that are based on a design originally executed by Jaya Ibrahim. Rien has adapted Jaya's design, flaring out the back-rest and separating the footrest from the sofa for adaptability.

Above Dark stained pillars and cascading thunbergia lead to the entrance of the living room.

The rigor and fierce discipline of the linear architecture is derived from Hans; the interior flourishes—beautiful fabrics, textural wall finishes, handcrafted furniture—are the work of Rien. The two clearly complement each other famously, both in their home's design and in their lives.

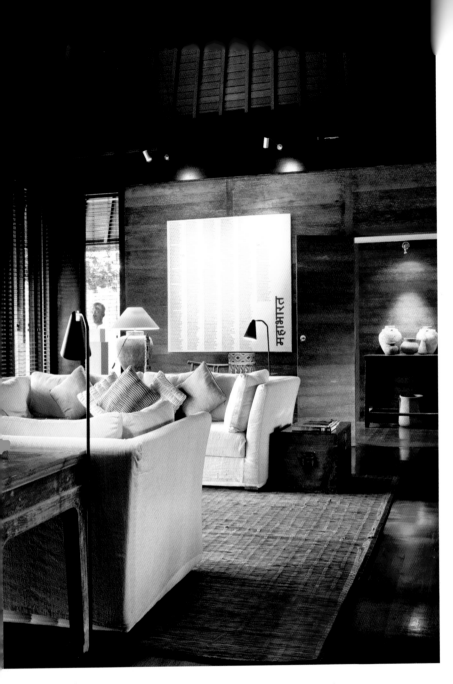

Open on two sides, the main pavilion (this page and opposite) overlooks the pool on one side and the bamboo stand that separates it from the guest house on the other. With composite coconut walls stained dark brown, the living/dining room is a mix of sophistication and homeliness.

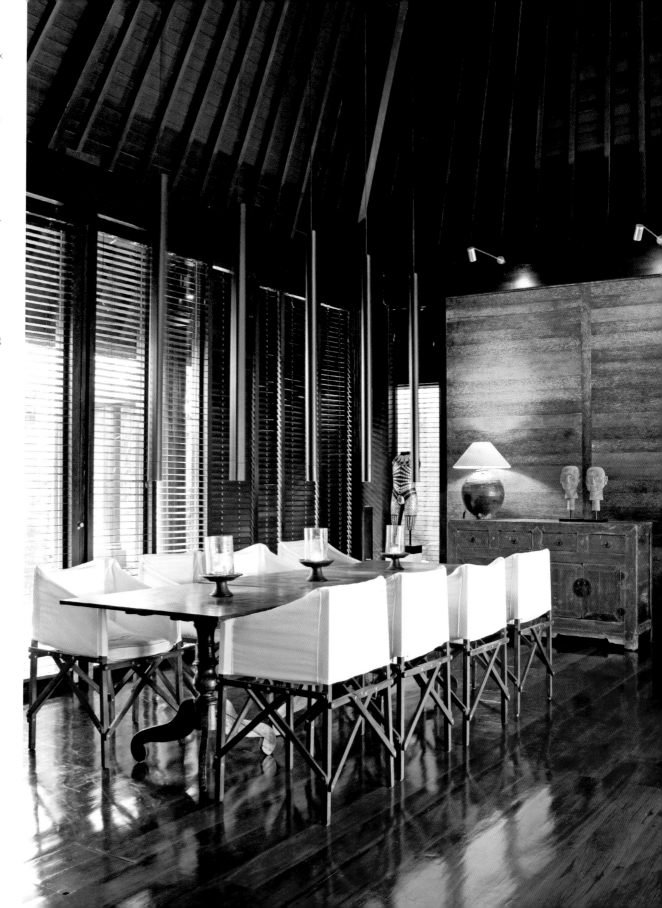

Opposite Artworks are a mix of the duo's Dutch heritage and an Asian sense of place: In the comfy, tastefully furnished, living room recessed lighting illuminates a gorgeous reproduction of the first chapter of the first book of the *Ramayana* in Sanskrit. On left is a poster of a Marlene Dumas exhibition: it depicts an image of Naomi Campbell by this South African, Dutch-based artist. Below, on a console, are some ceramics salvaged from a shipwreck with shells and coral still embedded in their sides.

Right The dining table is made from separate square tables, so can be extended or shortened at will. Hanging black lamps disappear into the void.

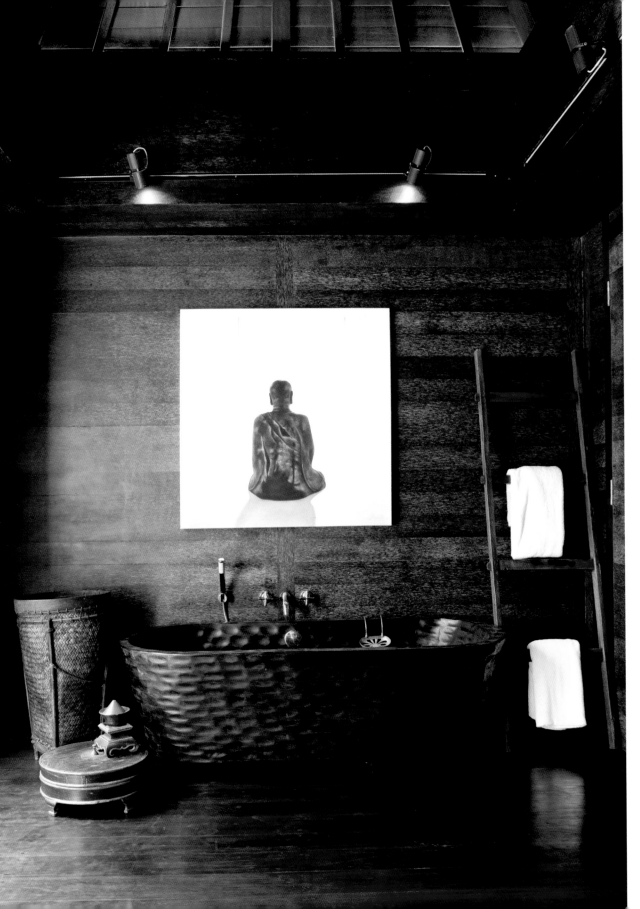

Left The spa bathroom features a beautifully carved wooden tub and suitably rustic-looking accessories. The painting is of Buddha looking into Infinity.

Opposite Villa Samuan is a showcase of the couple's tastes and styles. Top row, we see a detail from the *Ramayana* painting; the baskets below are hand-embroidered with beads and come from the island of Sumba. Middle row, left to right: A cast of an actor's face, handpainted by Rien and covered with pieces of silver leaf. Two wooden head sculptures from Tora Toraja, Sulawesi. A statue of Dewi Sri, the goddess of rice, placed in the garden in homage to the fact that the house is built on a former rice field. A cast of an actor's face, handpainted by Rien and covered with pieces of silver leaf. Bottom row: An antique wooden Chinese incense burner.

Villa Samuan's temple namesake is situated in the village of Bedulu, five km from Ubud. Built in the reign of King Chandrasangka Warmadewa in the 10th century, it was the royal temple of the ancient Warmadewa dynasty. A venue for meetings of the gods, deities and saints, it is filled with ancient artefacts. This home too, is a repository of fine art.

Right The far pavilion houses the home spa and the two offices of the owners. Each reflects the professions and personalities of the couple: the one pictured here belongs to Rien; the other houses a large drawing table and isn't the tidiest in the world! In Rien's office, atop a Dutch cupboard is a collection of baskets used in the rice fields, while the chairs are Chinese. In front of the window are examples of Rien's work and interests—a bead necklace from Papua; a miniature 18th-century costume designed by Rien from bark cloth; a cast of an actor's face with a crown of laurels, designed by Rien and made to his specifications in Bali.

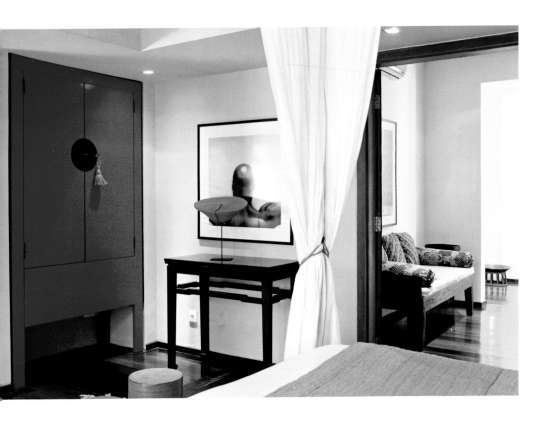

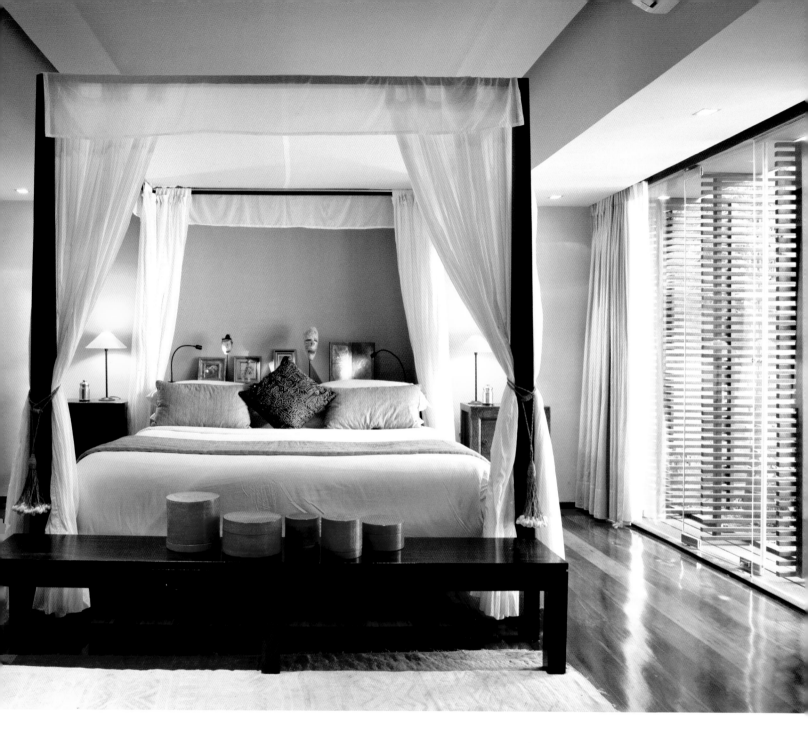

The tranquil master bedroom with en suite bathroom (left and above) features various pieces that reflect the couple's diverse tastes: a Tuareg carpet, a Zulu hat on the headboard amongst other gifts, a hand-embroidered pillow fabricated by Rien to an African design, as well as inbuilt Chinese lacquered cabinets, antique Chinese side tables and a custom-crafted four poster bed. On the console is a collection of lacquered alms' boxes used by monks in Burma.

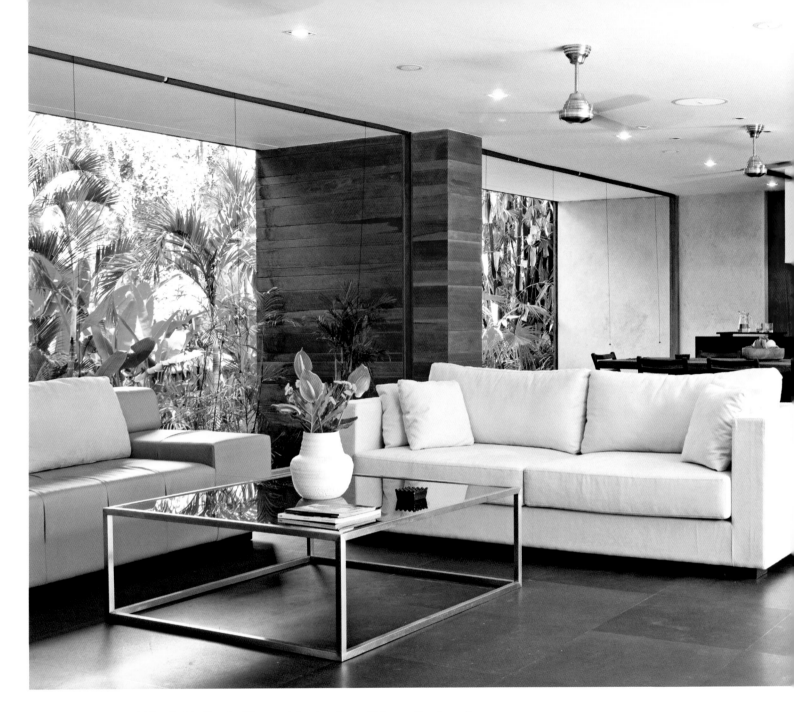

A Veritable Oasis: The architects chose this particular site partly because of the stately stands of bamboo that gracefully rise and fall in key areas. Also, there are a few mature mango trees that provide shade. In keeping with a strong environmental ethos, buildings were located around the existing topography; in fact, nothing was cut down during the building process and, subsequently, many more ornamentals were planted.

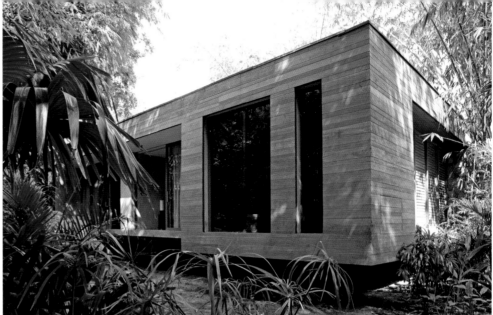

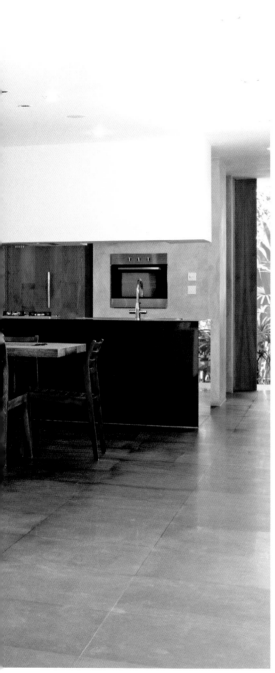

Above and above right Thoughtful touches in the central volume include details made from black granite, *nero marquina* marble and *candi* stone. All the doors are made in teak, as are the floors in the bedroom. The exterior cladding is in ironwood.

Picture of Proportion

Architect/Designer **iLAB Architecture**
Location **Seminyak**
Date Of Completion **2012**

Recently completed, this hugely photogenic picture of proportion is the work of iLAB Architecture, a relatively new firm on the island. Combining as it does history and modernity, *joglos* and floating cuboid, light and space—its individual parts make up a truly harmonious whole.

Called Wahyu, a Javanese word that translates as "divine spirit" or "revelation", this compound indeed comes as a revelation amidst the busy, traffic-clogged streets of Seminyak. The last thing you expect to find in this downtown vicinity at the end of a small *gang* (alley) is

a unique villa complex in a serene bamboo garden communing quietly with Nature.

A spokesperson for the firm describes the property as "a mix between traditional and modern, blending Javanese vernacular with contemporary architecture and style", but it is actually a little more complex. Consisting of two salvaged *joglo*-roofed structures, modernized and simplified with pared-down unadorned interiors, a small *gladak*, a semi-central swimming pool and a European-style, flat-roofed rectangular prism set on piles, it is a heartfelt experimentation of forms and

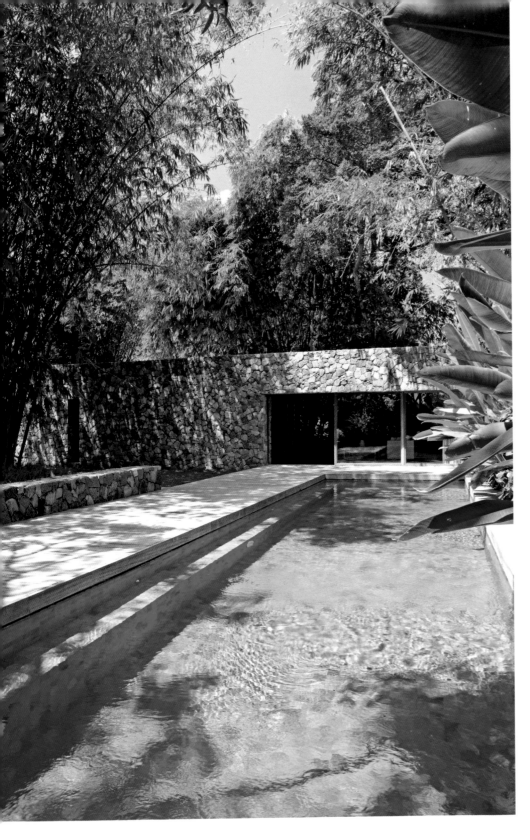

materials. Mixing two *joglo* hipped roof forms with the flat roof of the boxy loft structure gives the whole vertical, as well as horizontal, interest.

When viewed from the back of the site, the contemporary cube seems to float above the ground. Made from roughly hewn blocks of Buleleng stone and ironwood, with colored cement walls and black andesite floors, it has long sliding glass doors that disappear totally when pulled back within the walls. This gives the volume a transparency that allows it to fully integrate into the environment of garden, pool and sky; you feel not only is it hovering in the air, you can fly through it as well. In addition, there's a flexibility element: the building can be fully enclosed and air-conditioned while still retaining its relationship with the outside.

The interiors of the two traditional Javanese houses have been re-interpreted using the modern, Western concept of loft living. Even though the original character of these 100-year-old buildings has been preserved with many of the teakwood walls and roof tiles retained, the massive interiors have been given a modernist twist with finishes of polished concrete and brick. The clean lines and exposed brick, in particular, give an urban vibe.

Studio personnel hail from Florence, the city "where the rules of perspective were created and where the Renaissance was born"—and the firm is constantly striving for balance, harmony and proportion in all its projects. The studio sees architectural evolution as a journey, one that is ever-changing. It also believes there is an element of responsibility: As the profession uses the planet's resources, its structures should be carefully thought through and be built to last for some time.

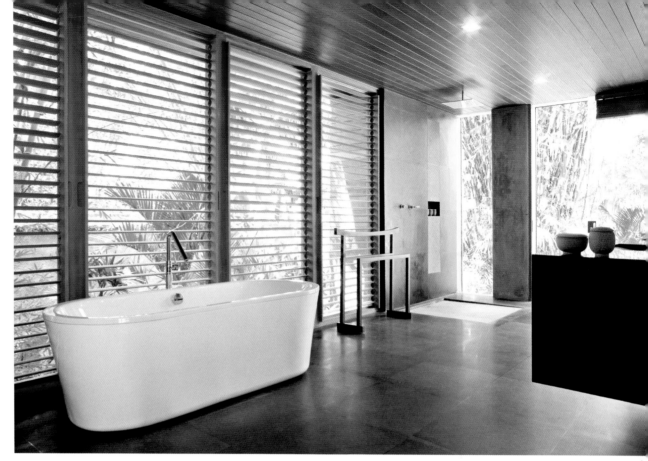

Opposite Looking to the future, experimenting with styles and materials, Balinese and European—Villa Wahyu is the new face of Bali Contemporary. This view of the long, flat-roofed modern building encapsulates i-LAB's focus on combining old and new. Cladding is vernacular, the form super-modern.

This page Interiors in the main volume are sleek and simple, with high quality fixtures, fittings and materials. "Sometimes the simple things are the best," the architect concludes, all the while striving to combine local architectural traditions with a European sensibility in the work.

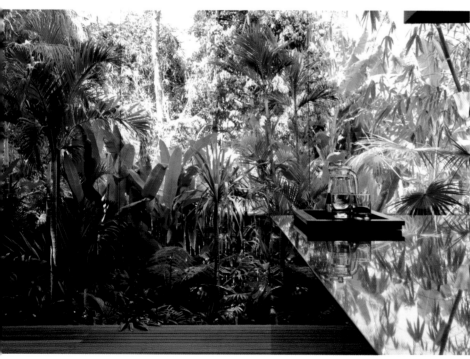

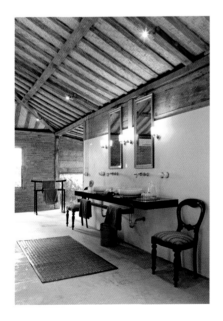

Villa Wahyu is a four-bedroom compound in the heart of Seminyak: consisting of a sleek modern building that contrasts—in shape, style and materials—with two antique joglo houses seen on these two pages. The whole nestles in a sculptural, yet lush, bamboo garden with dense shrubs of flowers and mango trees.

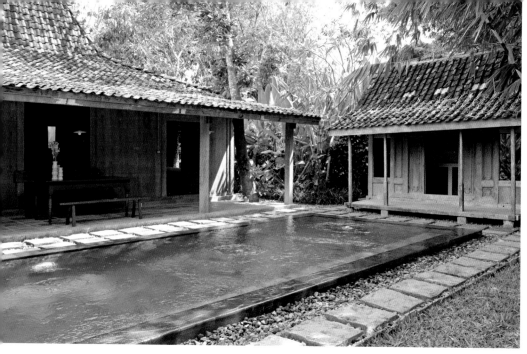

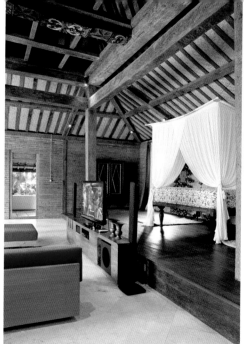

This page and opposite
Interiors in the *joglos* are spacious and calming, with local marble—Java brown and *ujung pandang*—along with recycled terracotta tiles keeping things cool underfoot. Recycled wood and exposed brickwork contrast texturally. The photo above depicts the master suite that also has a small kitchen in an adjacent *gladak*.

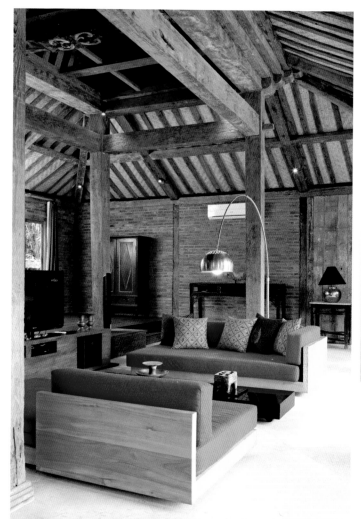

VILLA VANILLA

Open Space Living

Designer Mario Gierotto
Location Echo Beach
Date Of Completion 2008

"If I was in Italy, I would be a terrorist," the mild-mannered Mario Gierotto proclaims, as we stroll around his tranquil back garden some 200 meters inland from laidback Echo Beach. Milan born but Bali based these days, Mario is everything but a terrorist in appearance and demeanor—warm, amusing, passionate about art and design, family-oriented, a cook, an aesthete.

And clearly a man with a vision architecturally: The home featured on these pages is his family abode, a lovingly crafted and well-planned space that is as functional as it is visually interesting. "It isn't elegant or Zen," he explains, "it's a place for living."

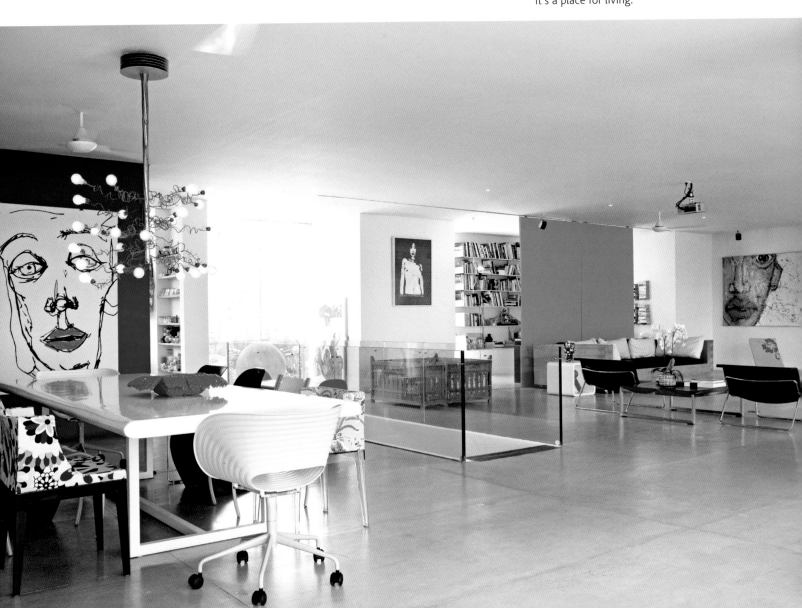

This page and opposite
The entire first floor is an open space with areas for dining, cooking, lounging and reading. It is filled with items that the owner has picked up over the years from all over the world. His taste is reflected in his store, which is a first in Bali. Annual visits to the Milan Furniture Fair or Salone Internazionale del Mobile and an eye for the unusual ensure that simpleconcepstore's goods are design-savvy and smart.

Left Stonewalling? The area that houses the dining table fronts a wall made in the manner of Tadao Ando. Mario supervised the manufacture of several large octagonal boxes, then placed sticks in their centers and had cement poured into them. When the blocks dried, he installed them with all their imperfections—à la the Japanese master. The wall works well as a changing gallery space: pieces of art can be moved at will as they hang on small wooden pegs.

Certainly the house is comfortable, spacious and homely—but it's also clever and timeless. Made entirely from recycled *ulin* wood salvaged from old piers in Sulawesi and concrete, it comes with impeccable environmental credentials. The main living space is in an open-plan, first-level loft area; clearly loved and lived-in, it communes via 17-meter-wide floor-to-ceiling windows with the garden, beach, ocean and horizon beyond. Quirky artefacts such as the resin spaghetti bowl by Gaetano Pesce, a selection of original Danish designer chairs set round a custom-crafted dining table, and artworks by local Indonesian painters and Filippo Sciascia are randomly displayed. Whimsically, the Ingo Maurer Birdie chandelier above the table is stripped of its goose-feather wings (they disintegrated in the salty ocean air) and the copper strands are green with verdigris—but somehow it manages to retain a quirky elegance.

There's a small library with seemingly floating books—actually stacked on shelves (see over-leaf) that Mario sells in his trendy home wares, furniture and fashion store, simplekonsepstore, and a kitchen that offers framed views into other parts of the house. Built with an obsessive eye for detail, the hob and prep bench have an especially angled counter top so that Mario can enjoy the sunset view over the beach whilst cooking. "I love to cook, to relax," he explains.

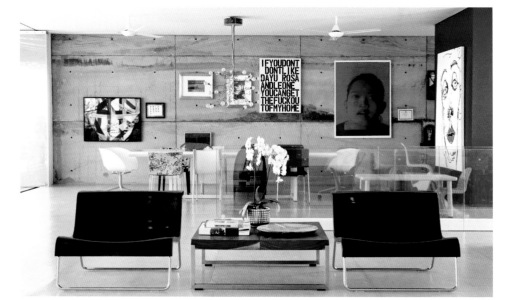

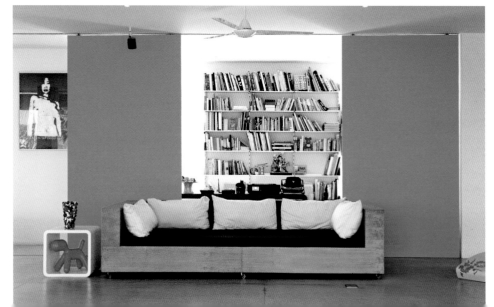

Right and opposite, bottom
Two canvases by the Italian artist, Federico Tomasi, one of four Indonesian-based Italian artists whose works were on display at the 54th Venice Biennale. The lounger is a design of Mauro Tomasi's, but has been enlivened by a painted hibiscus decoration realized by Mario.

Middle Two Filippo Sciascia paintings and a child's chair by Accupunto, an Indonesian father-son company that uses a unique pin system that fuses modern innovation with Asian practice. When the weight shifts on the chair, the pins shift on their axis and support the user following his or her contour.

Far right Mario's daughter in her bedroom.

Below A close up of the "Minus" shelves made in Italy by Kriptonite and sold at Mario's store.

The three downstairs bedrooms are accessed by a cement corridor inset with *poleng*-style ceramic squares made in the kilns of Gaya Ceramic and Design. Striking in their simplicity, they were originally envisaged as a complete floor covering, but because of their uneven shape they work better as details. As is to be expected, the bedrooms are simple yet functional, with large sliding doors leading out to a garden deck, where a modular sofa crafted by Wijaya Ketut of WK Concept from wood recycled from abandoned boats in Sumbawa overlooks a rectangular pool and a luxuriant, peaceful garden.

Personal touches continue here, as Mario points out a coconut palm planted on the day of his daughter's birth four years ago, and an avocado on the date of his son's two years later. Of the latter: "It is getting stronger all the time", he notes with satisfaction.

Left and opposite, middle top Mario has a a few pieces by the artist Filippo Sciascia, the red one on left and the grey "Coming in to Land" and smaller yellow one beneath. Based between Italy and Ubud, Sciascia is known for his monochrome paintings depicting pixel-like images on a fractured space. His interest is in the relationship between high tech digital systems and the human eye. In the plane artwork, it is difficult to focus on the plane close up; further away it comes into shape with startling clarity.

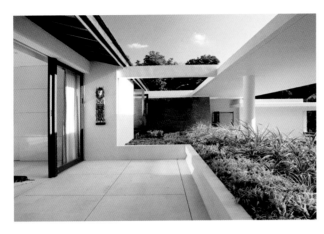
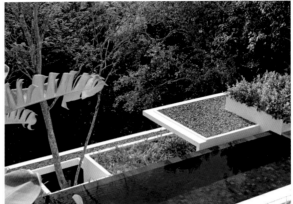

Above The entrance is dominated by a huge pond that reflects sky and mature trees (on right, unseen); it also ensures a tranquil feeling from the beginning, an atmosphere of calm and serenity that continues elsewhere in the home. "The house does have a very peaceful feel," agrees owner Bev, "Everyone who comes here says the same thing".

When Bev and Brett Stewardson holidayed at a Gfab-designed resort called Samujana in Koh Samui and found the architecture restful yet invigorating, they knew from the get go that they wanted Gary Fell to design their retirement home. When the piece of land they had acquired in Thailand fell through, they widened the search to Bali—and found this gorgeous, tranquil spot in Buwit Kaja village in the Regency of Tabanan.

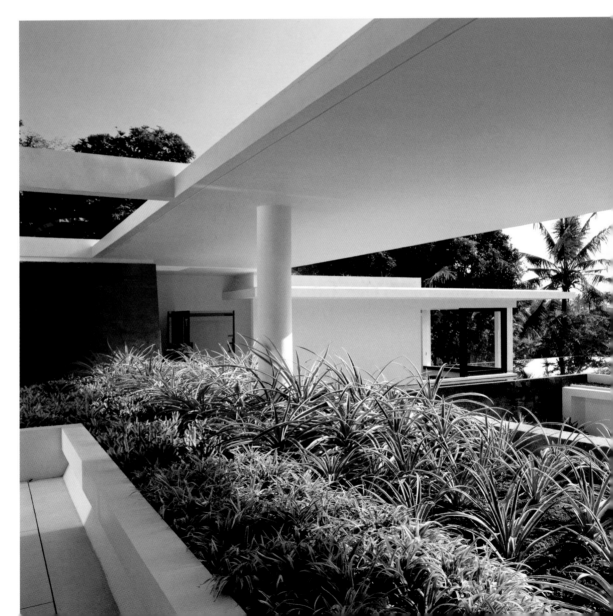

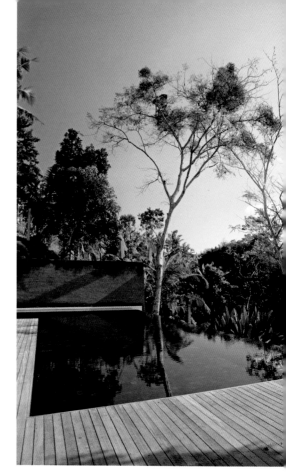

Left and below Cool contrasts: Clean lines and horizontal surfaces predominate in this sleekly modern home. *Paras Tabanan* and *paras Kerobokan*, quarried from nearby river beds are used for walls, while *paras Jogja* and rough terrazzo and *benkerai* form flooring.

VILLA NGOMFI

Designed from the Top Down

Architect **Gary Fell, Gfab Architects**
Location **Buwit Kaja, Tabanan**
Date Of Completion **2010**

Completed at the end of 2010 to a design by Gfab Architects, this house (despite, or perhaps in spite of, its obvious modernity) is remarkable in that it looks as if it has always been there. Set on an extremely steep site that tumbles down from village level to a river some 30 meters below, it is inserted into the hillside and set over five levels. Its "top down" form is becoming something of a trademark in the Gfab repertoire.

Company principal, Gary Fell, says that the site itself played a large role in predicating the design and final layout of the home. "Where the site allows," he explains, "I normally choose to 'go with the flow' and let the house negotiate the topography, so to speak. I enjoy the fact that, as such, my buildings seem to

blend with their sites well, not appearing too big on entry, then revealing their size as one progresses through them."

This is certainly true of Villa Ngomfi, owned and lived in by a recently retired couple, Bev and Brett Stewardson. On entry into the car park, one sees what looks like a low level structure set behind a large 25 x 6 meter reflecting pool made from *batu candi* and planted with local trees. The feeling is very low key, very calm. It's only after a walk down a narrow corridor into a large kitchen and den area that one begins to see the extent of the home. This reveals itself slowly as one descends—through an internal court with plantings and existing trees to a gorgeous full width living/dining room that makes full use of huge floor-to-ceiling windows

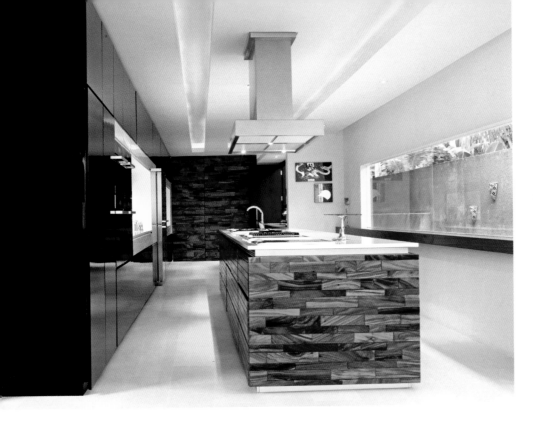

to give calming vistas out to more trees and river gorge below. From here it is down another level to an open-air pool deck and infinity edge pool, then one descends to a final level where a balcony, two guest bedrooms and two bathrooms are located.

It is only from here, when you look back up at the house, that you fully appreciate how large it is. Nevertheless, because of its location—a teak forest on one side, river gorge and more trees on the other—and clever "softening" via the incorporation of reflecting pools, natural stone walls and floors, flat roof and internal court plantings, and the retaining of existing trees, the hard architectural lines don't jar. "Somehow, the biggish, contemporary structure fits very easily into the Balinese village—incongruous, but true," notes Bev.

Having never lived in a contemporary home before, the Stewardsons are reveling in the new experience. Brett's favorite spot is on the poolside *benkerai* deck, while Bev loves the spectacular view from their bedroom. "To use a hackneyed phrase, we wanted a 'wow factor' when you enter," she continues, "and we wanted to go as green as we could given limitations in Bali." She certainly got what she asked for: Her jaw still drops every time she opens the front door and Fell is a practical designer: he tends to use local materials, often with a skinny cut; opts for flat roofs with plantings to retain views and enhance cooling; favors cross ventilation; and minimizes the use of glass, hence less air-con.

"Who wouldn't?" he concludes. The effects may result in more sustainable architecture, but as far as he is concerned, it is simple common sense.

Above and opposite, bottom Recipe for success: Totally unlike the usual Bali back of house, the Stewardson's modern kitchen is definitely at the forefront of the home. Boasting sleek lines and impeccable workmanship, the cabinetry was designed and manufactured by Detlev Hauth of Casa Moderno, a company that primarily makes high-quality contemporary furniture for the export market. Detlav, who previously worked for many of the big names in product and furniture design—Boffi, Poliform, Artemide, Flexform, Minotti, Zanotta—set up the company eight years ago and is a close neighbour of the Stewardsons. Marrying the best of Western technology (note the sophisticated rail system here) with local materials and skills, the kitchen is the epitome of cool.

The two paintings on the far wall are by Yap Chin Hoe, a young Malaysian artist who uses the genre of still-life as his main form of expression, work well with the pristine, modern kitchen.

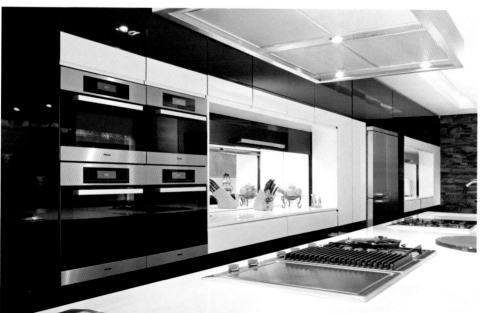

Above The massive, open-plan room that comprises the formal living and dining room is furnished with a mix of old and contemporary pieces, some recently acquired and some older. The Italian lounge furniture is from Natuzzi, while the dining table is a Fendi piece. The chairs were designed by the architect. In the dining room, two Balinese puppets stand atop an antique Chinese Gansu chest, while an antique red lacquered cabinet and red Persian carpet bring color to the lounge area.

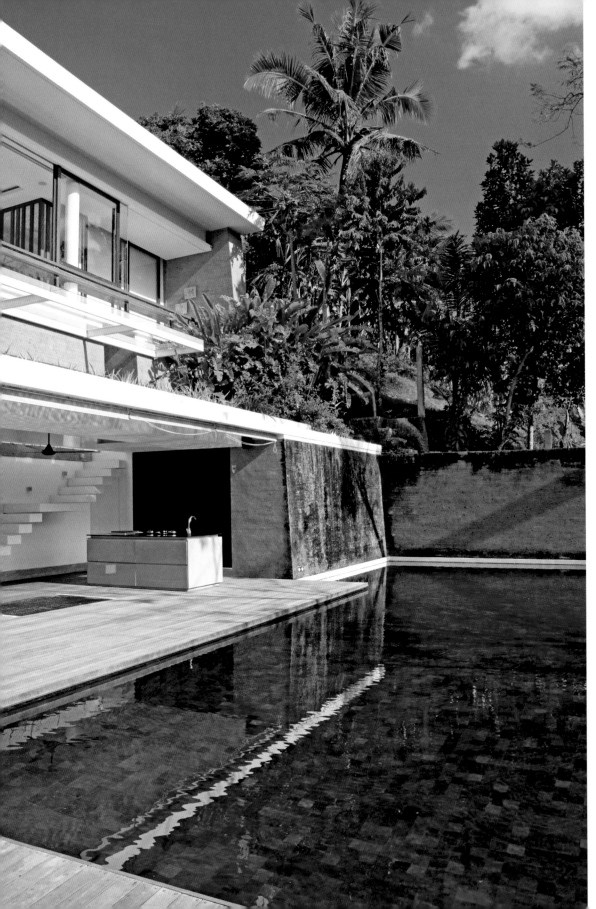

"We have always had homes with a 'borrowed vista' rather than an internal locus," explains owner Bev Stewardson, who lives in the house with her husband, Brett. "So our main priority was the site. We needed it to be perfect for us, so after we found it and bought it, we then asked Gary to see what he could do with it. Needless to say, we were delighted with what he envisaged— and the end result."

Opposite The wonderful pool area boasts *benkerai* decking and a built-in barbecue grill for al fresco dining. The cabinetry behind the grill is also by Casa Moderno; beautifully realized, it conceals a large fridge, storage space and a small restroom.

Above The many-layered home was built by local construction company, Adi Jaya Utama, and the finishing is very fine. "The entire build with them was a pleasure," says Bev, "If we ever thought about building again, we would not hesitate to use them!"

Top and above Bedrooms with en suite bathrooms are a beguiling indoor/outdoor experience. The sound of the river is ever present at the lower level, while the top-level master bedroom has stupendous views over the gorge to trees and scenery the other side of the river.

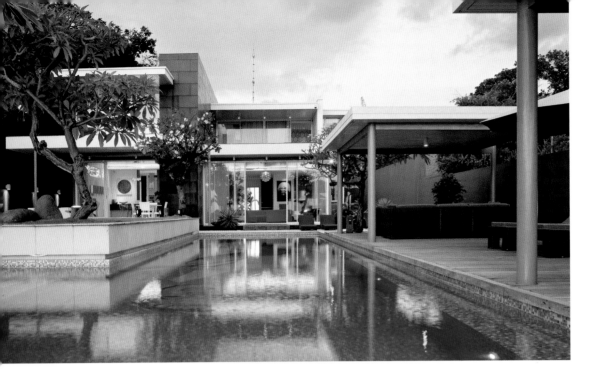

The owner, Melanie Hall, terms the villa style "funked-up modernism" and its bright interiors are as far away from the bamboo and alang-alang trad Bali style as Luna 2 was from the moon when it was launched. She planned and executed all the interior design and the bulk of the furniture design, all of which was produced in Jakarta. Added to the custom-crafted items is a range of classic furniture pieces and accessories, mainly sourced from Europe.

LUNA 2

Bali Enters the Space Age

Architect David Wahl, Wahl Architects
Location Seminyak
Date Of Completion 2008

The driving force behind Luna2 is owner and designer Melanie Hall, who worked with Maryland-based architect David Wahl to create something mid-century Modern, not something Tropical or Bali-style, in this villa on the beach at Seminyak. Melanie, who clearly has more than a sharp eye for interiors, was the driving force behind the villa's look: retro-luxe meets Bauhaus with more than a nod to Miami-style South Beach might be one way of describing it.

Wahl calls the architecture a "reinterpretation of the contemporary designs of the 1960s"— and the clean lines of Richard Neutra and Mies Van der Rohe are clear inspirations. Set on a plot fronting the beach in a prime location, the villa comprises a series of flowing spaces cut horizontally by a gray stone wall and vertically by white lacquered beams. All are oriented out to the Indian ocean. Whether you are lounging on an upper balcony, swimming in the artfully designed Marilyn Monroe-mosaic pool, or having a drink at the bar, huge floor-to-ceiling glass doors and open-air vistas guide the eye to the beach.

Similarly, the interiors are a giant step away from the usual troppo-Balinese style now looking a little tired elsewhere. It's here that Melanie really shines. Confessing to being a Bond fan, she also says that the swanky Hollywood home in the iconic film *The Party* and the general feel of the more recent *Down with Love* gave her visual inspiration. Certainly there's more than a touch of the early 1960s in what are undeniably stylish interiors. Custom-designed furniture, carpets and cabinetry mingle with some instantly recognizable classics—a set of Harry Bertoia mesh chairs and an Isamu Noguchi coffee table in the lounge, Philippe Starck Ghost chairs in the dining room, Bisazza mosaics in bathrooms and bar.

Bedrooms are color themed, with accents and accessories often leading the way for Melanie's layout and choice of furniture. She's used some gorgeously textured vintage wallpaper from Europe in some; others are generously endowed with high-end art pieces. Running the primary color spectrum—from vampish purple to bright green and rose in the kids' room— they are all extravagantly executed.

Opposite View of Luna 2's exterior across the 20 meter pool that is lined with Bisazza mosaics in the form of a custom-designed image of Marilyn Monroe in her ubiquitous white dress. "Finding workmen to install small mosaics neatly was difficult," Melanie opines, "Yet we finally found someone to do the job which took about four weeks to complete."

Right Philippe Starck Ghost chairs surround a custom-crafted dining table. The pendant light above was purchased in a cute shop on London's Fulham road and was hand-carried to Indonesia. Melanie's good friend Peter Colman from Australia, custom-painted the orange nude Marilyn.

Initially envisioned as a private holiday home, Melanie realized pretty early on in the building process that the scale of the project would not allow the property to remain empty for any period of time. Salty sea breezes play havoc with everything from central air con and electronic wizardry sound systems, to light fittings, furniture and fabrics, so maintenance-heavy Luna2 morphed into a "private hotel". And very successful it's been too: heavily in demand, guests have all the privacy, amenities (and more) of a home and all the services and facilities of a five-star hotel.

Unlike anything else on the island, Melanie named the villa after the first spacecraft to reach the moon in the late 1950s. Now, she is capitalizing on Luna 2's success by building further accommodations behind. Perhaps these, too, will aim to reach for the stars.

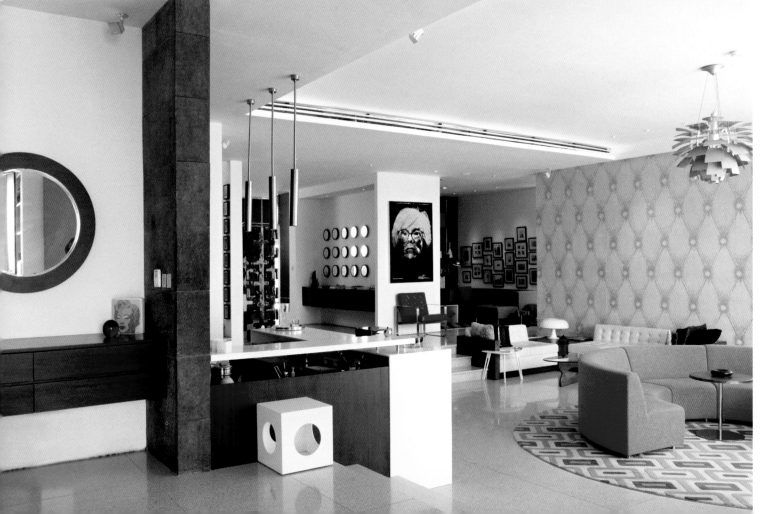

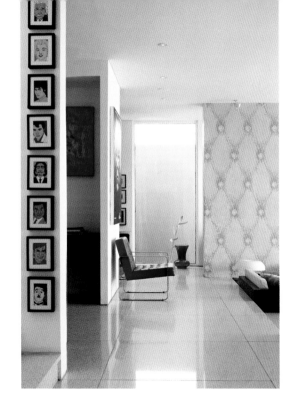

Opposite, top Even though design-wise Melanie was aiming high, she had to come down to earth at times with seemingly insurmountable practicalities. The kitchen (seen at end of dining table) is a case in point. All the Smeg equipment was bought in Jakarta and Melanie designed the kitchen around it, using a combination of walnut veneer and 50s sunflower yellow formica and stainless steel. She sent all the appliances to her trusty woodworking factory in Jakarta for all the appliances to be precision-fitted. Following this, the kitchen island was trucked across Jakarta to her equally trusty stainless steel worker, who fitted the steel surface to the cabinets. All cabinets and appliances were then returned to the original factory, for final checking, and then trucked down to Bali! Six workmen spent a week during the installation process. "Simple, really," she says.

Opposite, bottom In the living room, a Louis Poulsen artichoke light hangs above the custom-designed circular sofa and Noguchi table.

Above, right top and left Melanie likes to think her forte is creating unique spaces that combine old and new. Here we see three spaces artfully using color—purple, red and orange—to advantage. "Shag" (sunglasses on shagpile carpet) in the entrance hall above the long purple bench is by Australian artist Peter Colman.

Right middle and below Each bedroom's accent color is followed through to its ensuite bathroom. A framed Hermès scarf is the basis for the orange suite; and, capping the style stakes, is the green bedroom that boasts original Picasso etchings on the bathroom wall. The sanitaryware is also pretty high end.

BALI BY DESIGN

NEW DESIGN
DIRECTIONS

A combination of talent and tradition is behind the excellence of the designs on the following pages. Handpicked from both commercial and residential projects, they include examples of artifacts, lights, ceramics and furniture, as well as complete spaces: restaurants, clubs, bars, rooms and more. Even though all are very different, each piece or space is exemplified by a striking modernity.

These days, every atelier worth its salt is eschewing the cookie-cutter approach for something more individual, seeking to create bespoke works that appeal on many different levels. The quality of materials, processes, and finishing is paramount, while form and function are never neglected. Whether it's a resurgence of 1940s and '50s industrial chic, or something that looks further back (or indeed forwards), old forms are constantly being reinterpreted in new ways. In addition, inroads in different technologies are fueling experimentation and sustainability is becoming more of a force.

In contemporary spaces where every nook and cranny is on stark display (no dark corners to hide things!), detail really matters. Every texture, nuance and color needs to work both with the overall scheme and stand alone in its own right (as seen on left at the wow-factor W lobby). Cutting, carving and coaxing local materials into contemporary forms seems to be the name of the game; raising the style stakes is the end result.

CONTEMPORARY CERAMICS

Ceramic making and trading has a long history in Asia, so it is hardly surprising that Bali has a rich tradition of producing ceramic wares. In neighboring Lombok, most families own a potter's wheel, and in Bali itself there are numerous companies producing innovative stonewares—for hotels and restaurants, the home, the spa and the garden.

Modern ateliers such as Jengalla, Pesamuan, Kevala and Gaya Ceramic and Design still tend to hand throw and kiln fire their wares, even though, for the most part, their products are contemporary in style. As a result, they have all become household names on the island; indeed, all four have an impressive portfolio of international clients as well.

In particular, Kevala and Gaya are only involved in handmade production, with both houses emphasizing that an imperfectly thrown pot may actually be a perfect piece. Similarly, the way the glaze is applied can result in an object that can be defined as "art" as opposed to mere decoration. Naturally, both companies have artists working with their artisans on particular high-end lines.

Whether the end product is a ceramic container glazed in bright colors for the garden, a bathroom set, or some accessory or structural piece for a home, the designs are improving all the time. Indeed, an impressive ceramic accent, light or even bathroom sink in ceramic can up the trend factor in any home. Check out some of our selections on these pages.

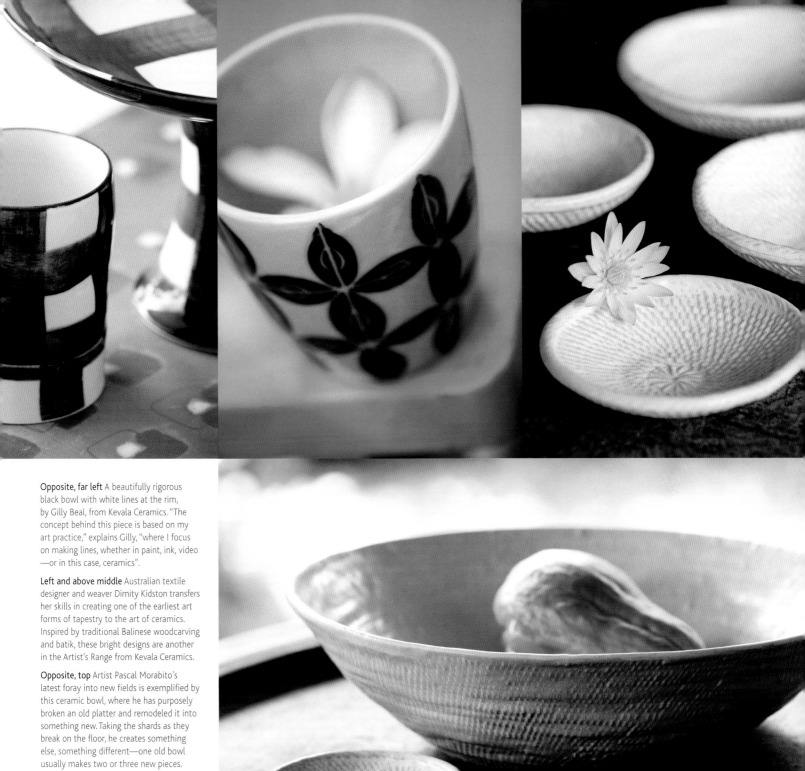

Opposite, far left A beautifully rigorous black bowl with white lines at the rim, by Gilly Beal, from Kevala Ceramics. "The concept behind this piece is based on my art practice," explains Gilly, "where I focus on making lines, whether in paint, ink, video —or in this case, ceramics".

Left and above middle Australian textile designer and weaver Dimity Kidston transfers her skills in creating one of the earliest art forms of tapestry to the art of ceramics. Inspired by traditional Balinese woodcarving and batik, these bright designs are another in the Artist's Range from Kevala Ceramics.

Opposite, top Artist Pascal Morabito's latest foray into new fields is exemplified by this ceramic bowl, where he has purposely broken an old platter and remodeled it into something new. Taking the shards as they break on the floor, he creates something else, something different—one old bowl usually makes two or three new pieces.

Above All the work from Gaya Design fuses Western and Eastern elements, and the ceramics section is no different. A collection comprising trays, candleholders and plates takes the black-and-white *poleng* pattern and reinterprets it in a contemporary manner.

Opposite (in foreground) and previous page, right Taking their inspiration from the craftsmanship inherent in traditional Bali Aga baskets that take months to make and feature a fine, even weave, artist Gilly Beal has created a series of ceramic pieces for Kevala Ceramics. Individually made by hand, they pay homage to the beauty of the baskets.

Left Candlesticks with a cracked glaze in turquoise from Gaya Ceramics for Italian company Gervasoni.

Below left This deep blue ceramic box from Gaya Ceramic and Design is based on the *keben* boxes that are made locally from hand-hammered aluminum sheets. The word means "container" in Balinese, and, as is apt, the local people use them to present offerings at the temple. These ceramic versions are beautifully executed by hand also.

Below Gaya Ceramics specializes in unique *raku* plates and high-concept stoneware sculptures, but also individualized product lines for private customers. Here, the bathrooms at trendy store Word of Mouth sport beautiful blue-and-white ceramic sinks made specifically to order.

Right and below right More Dimity Kidston pieces (bowls, mugs and plates) from the Artists' Range at Kevala Ceramics. Dimity uses a *sgraffito* technique to carve on the clay—the result is eclectic and engaging.

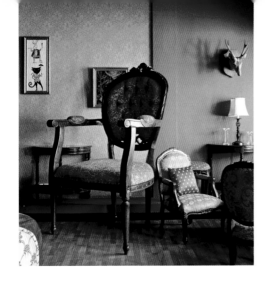

CUSTOM-CRAFTED FURNITURE

Bali has long been home to wood carvers and carpenters, for the most part supplying temple and home compounds with statues, carved panels and furniture, mainly in teak. Now, this traditional market has been joined by a number of new players—cabinetmakers, furniture designers, interior concept designers, all making anything and everything for the home. From entire kitchens to individual custom-crafted pieces, they supply for export also.

Whether your taste runs to Scandinavian purist, opulent oriental or faux Louis XVI style, you'll be able to find a bespoke furniture producer without difficulty. There's no shortage of high-quality craftsmen, both Balinese and from overseas.

Take Detlav Hauth of Casa Moderno for example: After stints at many of Europe's design houses, Detlav relocated to Bali eight years ago, setting up a company that produces high-end cabinetry for the German market. He found the Balinese had the skills he needed, Bali could provide the materials, and he used his German technical know-how to produce "pure and elegant" furniture. Now, he also undertakes space planning and interior projects—for both residential and commercial clients—in Bali itself.

He is by no means alone. There are literally scores of such studios on the island, catering to both very specific briefs and more open-ended ones. Stephane Sensey, responsible for much of the furniture at Villa Asli, specializes in producing vintage French-style furniture. Think chairs with delicately flared legs, pony skin upholstery and highly polished wood. Or Jacques Hugen of H+R Creation who produced much of the furniture to designs commissioned by the owners of Villa Issi. His clients had a clear idea of the types of furniture pieces they wanted for their new home, having studied and collected photos of Italian furniture over the years. They simply changed dimensions or added features to designs by Poliform and Minotti, and presented their requirements to H+R. There was a bit of to-ing and fro-ing, but eventually they ended up with their vision realized—bespoke pieces for the living and dining room in exactly the right size, materials and colors.

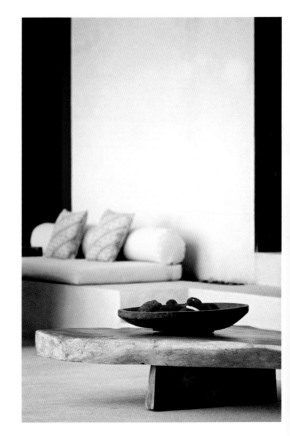

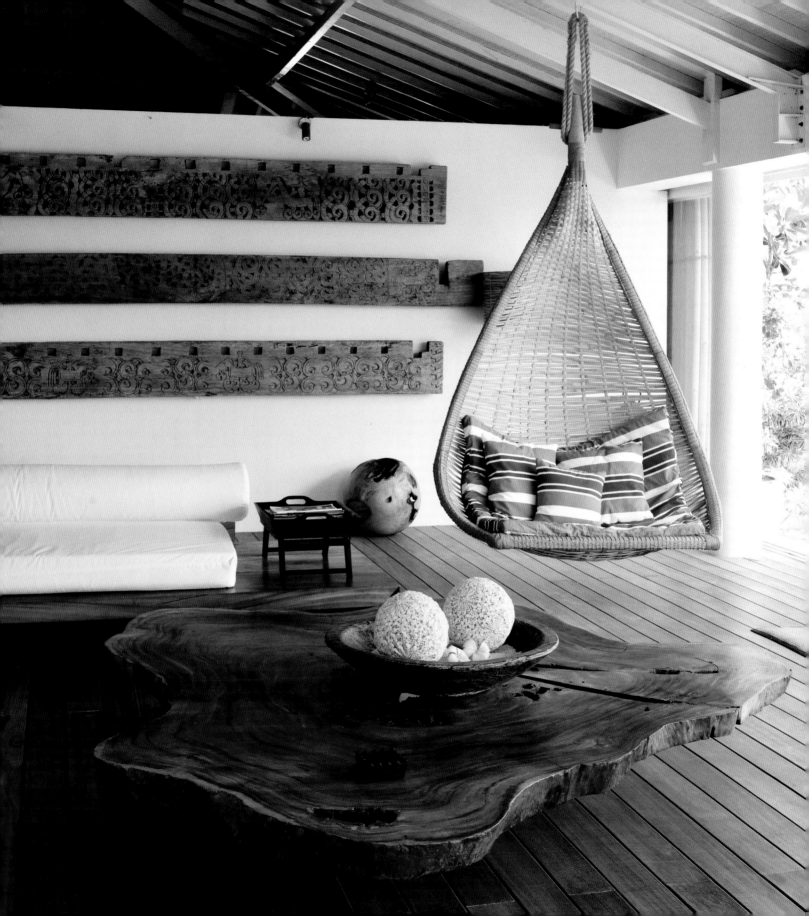

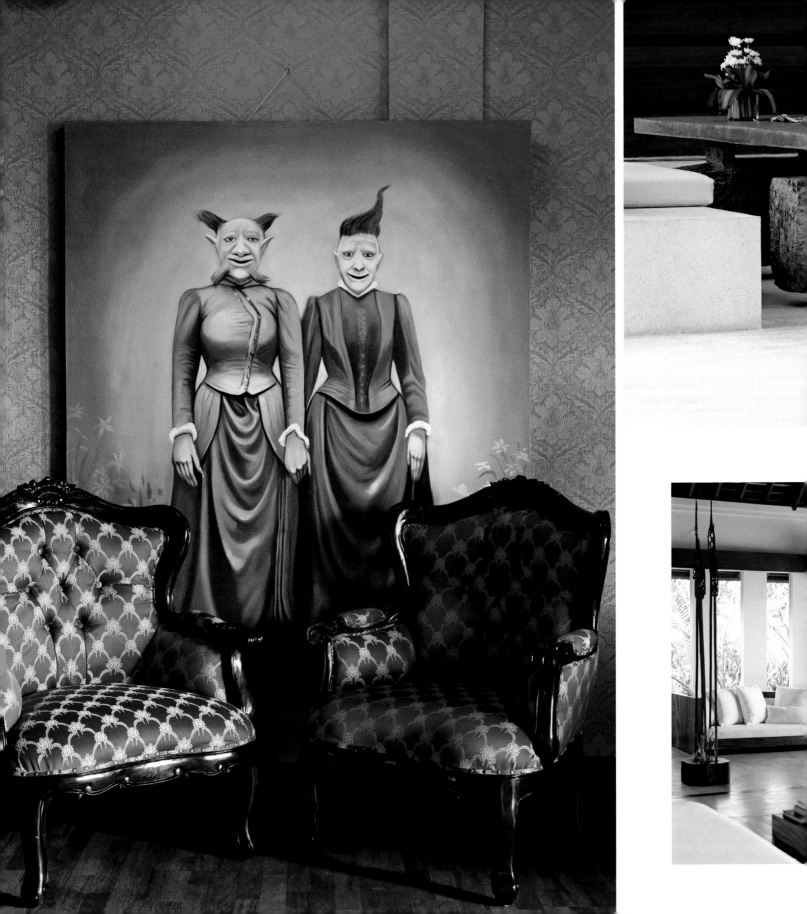

Left A rustic-chic table sits between two white benches. Designed by Komong, the base comprises two large roughly-cut chunks of mahogany, while the top is a piece of *merbau*.

Below left All the larger pieces of furniture at Ketapang Villa were crafted in a workshop in Java to designs specified by owner, Olivier Meens. This sleek, low sofa and trunk lamp were a case in point. After manufacture, Meens shipped them to Bali on a specially commissioned boat.

Below right Made in Bali dining table and chairs were commissioned by London-based Josette Plismy from Gong for Villa Tantangan. The owners are fans of George Nakashima and his influence can be seen in the natural-grained wood lamp, on right.

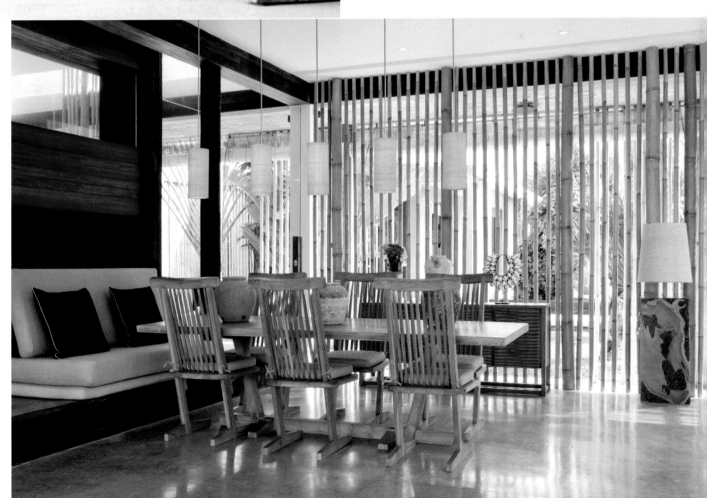

Above A jeweler and perfumer by profession, Pascal Morabito is also an artist (although he claims not to be). He designed this swing sofa, table and bench, then had it made by a Balinese craftsman. The lime-washed look is very à la mode and works especially well in an outdoor setting.

Left This custom-crafted low-level coffee table is made to a design by Renato Guillermo de Pola from an antique primitive wood column sourced in Borneo. The log was cut lengthways, then used in two pieces as the base for the glass-topped table.

Above right A primitive wooden bench in front of a rock wall in the home of Ross Peat. Ross is a tireless inventor of one-off art pieces that utilise materials from the natural world.

Right Custom crafted low sofas from designs by Gong.

Opposite, right Jacques Hugen of H+R Creation believes that longevity is one of the hallmarks of good design. He wants to make "the antiques of the future", as exemplified here in these furniture pieces specially commissioned with exact dimensions and styles by the owners of Villa Issi.

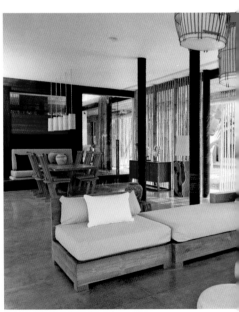

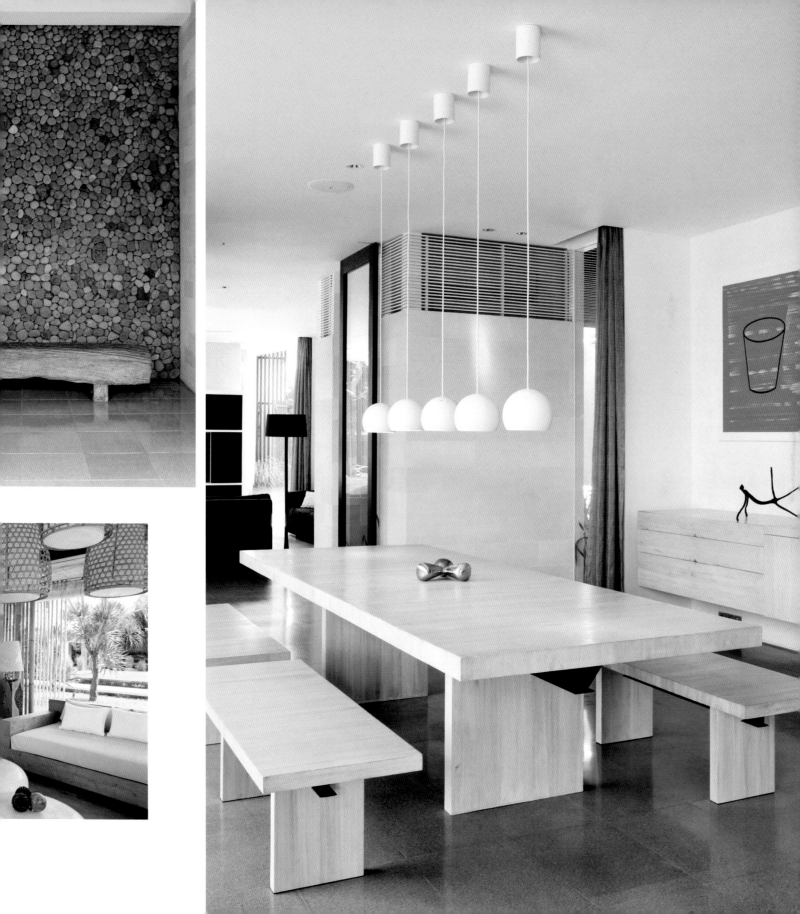

ETHNIC ACCENTS

In the same way that temple statues, carved stone figurines and terracotta pots are used in the garden as a form of outdoor decoration, wooden and stone statues find their way into living rooms and verandahs as interior accents. There's no shortage of such statues in Bali, because the Indonesian archipelago is peopled with innumerable gods and goddesses, as well as guardian and animal deities, and manifold mythical beasts and birds.

Other "folk" elements include basket wares, local fabrics such as batiks and ikats, and old agricultural implements. When combined with modern plinths or streamlined contemporary furniture, they add an exotic touch to a Western-style home. Used as focal points or as flanking forms at an entranceway, they are also extremely effective.

Another popular form of ethnic ornamentation is the use of carved bas-reliefs, old doors and temple panels. Often used as decorative panels, or converted into tabletops, bar counters and the like, they help to keep an interior authentic. They also add that sometimes overlooked factor—texture.

Pascal Morabito is probably the most inveterate collector of ethnic statuary in this book (with people queuing up at his home on a daily basis to try to sell him things!), but the fine collections of Made Wijaya and the owner of Villa Asli shouldn't be overlooked either. In all three of their homes, the statuary adds drama and visual interest, not to mention a marvelous sense of place.

Opposite, left Sometimes the color or texture of an object is more important than the actual item itself. This is a modern-made mask which has been distressed to look old; its attraction lies in its strong orange color.

Opposite, right A copy of a Toraja figure found, most likely, on a door.

Left A collection of totems, votive statues and roof decoration sits before an abstract expressionist painting of the Sayan valley by Jonathan Collard (1994) at the atelier home of Made Wijaya. The statue in foreground is of Saraswati.

Above A collection of Timorese carved and decorated toddy flasks in bone with wooden stoppers..

Far left Stone totems in the collection of Pascal Morabito are amassed in large groups around his extensive property.

Left Intricate carving on the front of a *kudus* house from Central Java.

Left below A cowrie shell bib necklace from east Indonesia is mounted on a steel support for display purposes.

Opposite, clockwise from top left A collection of ceramics from Villa Asli; a classical East Balinese door carved in the 1950s; a goat skull decoration; set into a wall in one of the rooms at Villa Bebek is an exquisite late 19th-century Bali Aga door—this detail shows a primitive *padma* rosette.

Clockwise from top left A detail from a *hsun-ok*, a lacquer container from Burma that is used for offerings to the Buddha or the monastery. This one sits on the coffee table at Ross Peat's home. A row of Burmese monk statues at Villa Asli. Gracing a '60s style balustrade at the Villa Bebek is a line of stone statues from east Indonesia (Timor and Sumba). A detail of a carved Toraja artefact.

Right Ed Poole's design for Starfish Bloo combines the rusticity of giant lobster pot booths, fish trap-style pendant lights and *bakau* poles lashed to the ceiling with high technology in the form of resin-covered columns lit from within.

Far right In FIRE's private dining room, minimalist temple grey walls and a timber ceiling constructed to represent a bonfire arrangement act as the backdrop to fiery red table settings and chairs.

ISLAND INTERPRETATIONS

As Balinese architect Yoka Sara tries to distil some essence of Bali into his contemporary architecture, so does interior designer Ed Poole in his interiors for the hospitality industry. Such reinterpretation can easily be recreated (on a humbler scale) in home interiors, thereby anchoring the space firmly in its locale. Just because a thing doesn't outwardly look Balinese, doesn't mean that it doesn't have a strong connection to the island.

The two restaurants at the über-cool W Retreat & Spa in Bali are a case in point. Designed by Singapore-based Poole Associates in 2010–2011, they pick up on certain Balinese customs and crafts, then incorporate them into a new design narrative.

Using a black, white, yellow and red palette, FIRE's interior is based on the ancient Balinese *kecak* dance, where 150 or more men dressed in white-and-black *poleng* cloth enact a trance ritual often around a fire. In the restaurant, the *poleng* cloth is re-envisioned in a long marble counter that surrounds an open kitchen, while a fireball chandelier with ruby red blown glass tendrils fading to amber at the tips takes center stage. The ceiling takes on a radial pattern of timber slats with a burnt finish, while black terrazzo, textured Java Gold stone, and ochre-colored textiles serve to unite the various areas.

Starfish Bloo, the second restaurant that looks out over the Indian ocean, takes its inspiration from closer to home—from the beach in fact. As its name suggests, blue is the predominant color: turquoise resin columns in an abstracted starfish shape rise to the ceiling, blue neoprene starfish pillows add a touch of humor, and recycled slump glass table tops glow with a blue hue. Six huge lobster trap "booths" reach up to the ceiling, while weather-beaten timbers and tanks of undulating kelp complete the seaside theme.

Using motifs from close to home gives spaces an identity that is both respectful to the locale and visually stimulating. They also end up being a great talking point to boot.

BALI BY DESIGN

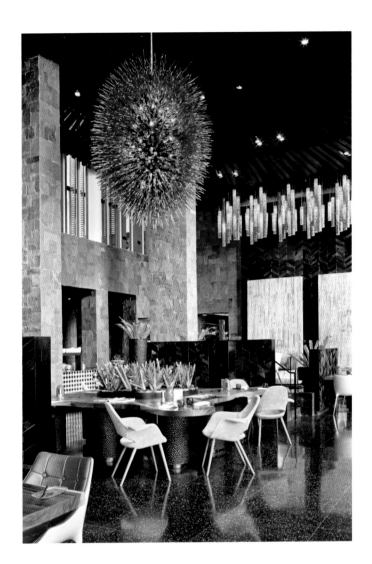

Far left The traditional Balinese black, white and grey *poleng* pattern, representing the struggle between good and evil, is rendered in the bar counter.

Left Stretch limo-style sofas, whose backs reach up the wall to pendant lights high above, face robust wooden tables at either side of the restaurant. Their ochre-toned upholstery in crushed velour echoes the fiery color scheme elsewhere.

Above The central chandelier, custom-crafted in the Czech Republic, derives its color from 24-carat gold melted into the glass mix; it hangs above an arrangement of heliconia that resemble flames.

THE IMPORTANCE OF LIGHTING

Lighting is one of the most powerful elements of interior design—and should never be overlooked. In Bali, numerous lighting designers are producing a variety of lamps for both indoor and outdoor spaces that bring richness and depth to any living space. We showcase some of their designs on these pages.

Even though there are no energy-saving regulations in Bali, many homeowners are keen to reduce consumption, not least because the electricity supply can be erratic. Recent developments in the industry have focused on how energy saving solutions can be incorporated into homes, so we showcase examples of LED lighting, new energy-efficient bulbs, low voltage tungsten halogen bulbs, revolutionary dimmers, and a host of up lights, down lights and niche lights. A superior lighting designer will use any number of these combinations to produce the right atmosphere.

On these pages, you'll find some illuminating examples of individual lamps and rooms that are imaginatively lit. Layering lighting—using different types of lights—can achieve interest and flexibility of mood, while stand-alone examples are good for bringing focus on a particular area. Whether we're looking at a giant pendant installation over a huge dining table, an elaborate chandelier, or the blue glow of a cluster of glass-and-resin balls, is immaterial: they all throw light on a craft that is often overlooked.

Left Integrating art with life, Gaya Design produces high-concept stoneware sculptures, such as these handmade lights that allow small pockets of light to sparkle from inside long thin pendant poles.

Right Seminyak's Café Bali, with its whitewashed wood, mismatched furniture, eclectic collection of mirrors and relaxed vibe, is noteworthy for an extraordinary collection of creative lights designed by local resident Robert Nollet. The lights range from pendant ball-and-chain creations, to cute overturned baskets painted white, and a red antler chandelier over the bar. This huge pendant central cluster brings focus to the whitewashed beams of the *joglo*-roofed structure.

Far right The slim hanging lamps behind this stunning chandelier at FIRE restaurant at the W Retreat & Spa take their design inspiration from the traditional Balinese black, white and grey *poleng* pattern that represents the struggle between good and evil.

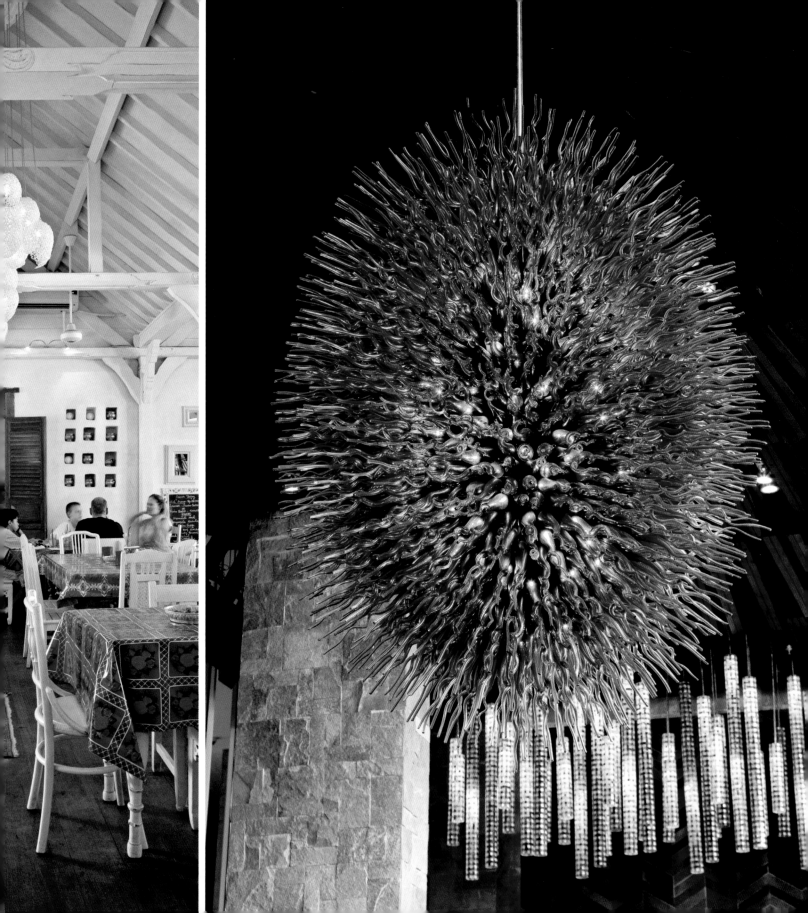

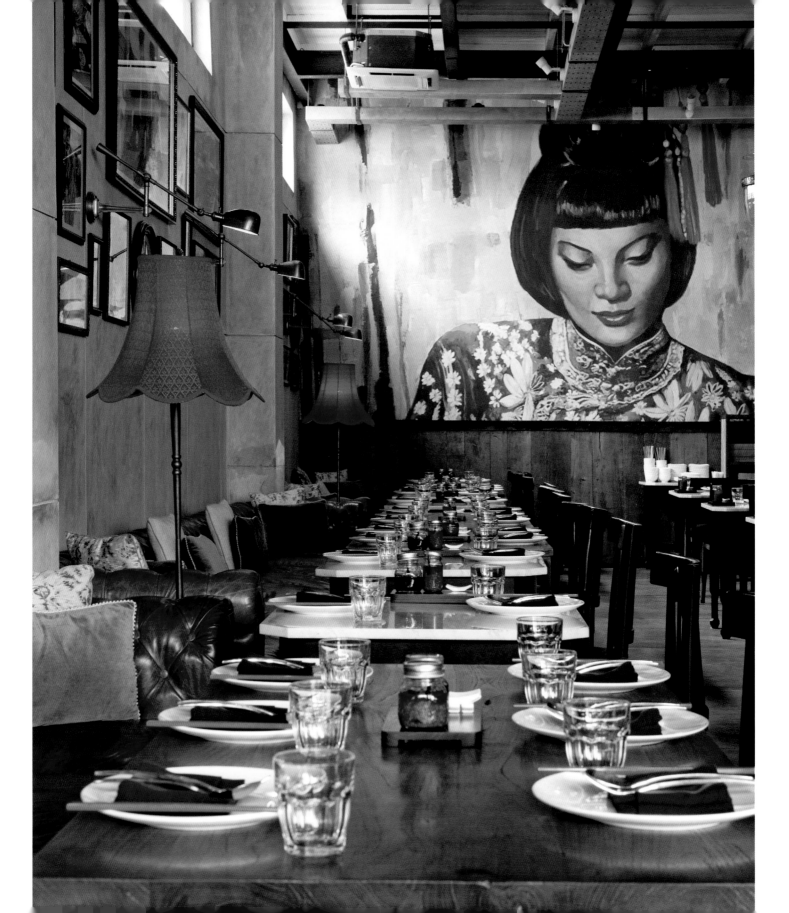

Opposite Mama San, a trendy Seminyak restaurant, utilised retro-deco wall lights and lush lamps with red shades to light the boho-chic interior.

Above The interiors of Sarong restaurant took their cue from a massive 8 m painting by Danish master Per Hillo; taking the bronze, silver and lush tones from his work, interior designer Liv Clausen set about creating a boudoir-style restaurant that touches the senses in many ways. Take the lighting for example: working with local manufacturers, Alabaster Lighting, Clausen went for a wow factor in the chandeliers (think honey-colored saucers hiding the bulbs, jewel toned crystals, pendant beads) and ambient lighting elsewhere to highlight the bronze tones of the drapes and the dark wood of the rafters. A self-professed dimmer queen, Clausen says you can never underestimate the importance of lighting in any interior.

Above right Retro light switches at the tranquil Villa Wahyu

Right Well known internationally and in Bali, the Wijaya Classics range of outdoor lights features primitive and modern styles that celebrate Balinese artistry and craftsmanship, as well as the indigenous materials of south east Asia. n far right, the handcrafted lamp, designed with metal artist Pintor Sirait, features a hand-carved *palimanan* mount and urn, and a fiberglass and metallic body with abstract patterning. It has a robust elegance that works well with an Asian aesthetic.

Above and far right The brainchild of ex-Super Potato designer Nobuyuki Narabayashi (Nara-san), Desain9 is a Bali-based company that specializes in interior and product design. Their lamps featured here—the Bali Moji lamp featuring old Balinese scripts above and the Recycled Wood lamp on far right—are inspired by a desire for reinvention. Nara-san likes to work with recycled and re-used materials, fashioning them into new, contemporary forms.

Middle Gaya Design make ceramic products such as these pendant lights, but may also be called upon to find creative, tailored solutions for all interior decoration needs.

MODERN FURNITURE

Until fairly recently, it was difficult if not impossible to acquire modern furniture from Europe in Bali. The verandah and open living room was the domain of locally produced pieces—bamboo sofas, Chinese day beds, planter's chairs, wicker-and-cane loungers, the low-slung hammock.

In time, these came to be replaced with some sharper models produced on the island by a new breed of artist/artisans, mainly Italian and French in origin. They became well known for producing unique collections that utilized organic materials such as bone and shell, together with resin, metals and coconut wood. These well-crafted pieces are still popular today.

The next wave came in the form of faux rattans and resin or polyurethane wicker weaves, along with aluminum models with porotex mesh backs and seats. These work extremely well with Sunbrella fabric cushions, both outside and in. Exuding tropicality, they are also hardwearing and weather resistant—a boon in Bali.

Today, we are seeing yet another trend: the import of top European names at such stores as Mario Gierotto's simplekoncepstore. Gierotto scours the trade shows in Italy to bring out lightweight, durable and on-trend designs that blend the disciplines of technology and art. Closer to home, he also stocks some pieces from Accupunto, a father and son design duo who formulated and patented a contoured seating system based on the ancient practice of acupressure. For homegrown alternatives, check out Word of Mouth's quirky pieces: despite its designers' insistence that they are inspired by Bali, on initial inspection their work seems more city-centric than rice field romantic.

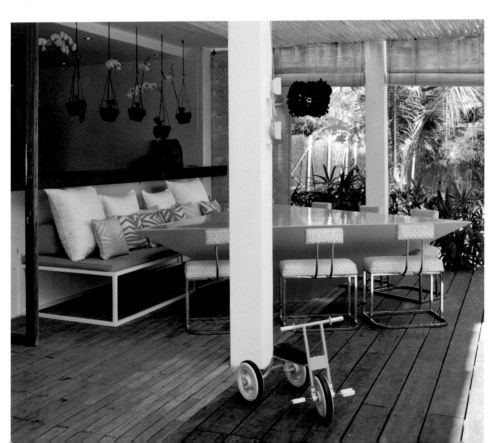

Above A pocket of post-modernity in Seminyak, the Word of Mouth café, shop and bar is an adult playground of artefacts, furniture, fashions and fun. Architect Valentina Audrito and her husband Abhishake Kumbhat are the duo behind the concept: they're clearly enjoying themselves far too much if the colorful, on-trend pieces they produce are anything to go by.

Opposite, far left Word of Mouth graphic printed fabrics and Le Triangle table—both in bright primary colors.

Left A few examples of Kartell designs that combine sophisticated forms with advanced plastic processing in color-injected polycarbonate: Mr Impossible chair by Philippe Starck and Eugeni Quillet; Take Lamp by Ferruccio Laviani in various chromatic tones; and a collection of La Bohème stools. The latter are designed by Starck to designs that reflect classic Greek vase styles. All are available at simplekoncepstore.

Above Today, contemporary furniture designers and manufacturers continue to evolve design. The home of Mario Gierotto showcases some of his store's own design pieces, as well as well known names from Europe.

Left Pretty circular low-level Dulang tables available at Valentina Audrito and Abhishake Kumbhat's Word of Mouth homewares store.

Right One of seven designs in Valentina's first furniture line Le Uova de Leon or Leon's Eggs, Turn me On is a rotating lamp. Other pieces, also inspired by the egg as an ideal shape, are no less quirky; the Three Minute Boil seat is similar, but with a cushion beneath the lid.

Far right top Don't break my Eggs is another in the Egg Line from Word of Mouth.

Far right bottom Made from fiberglass, polyurethane and water resistant fabric, the Shipwreck lounger adds a touch of modernist cool to an ironwood deck.

Right Combining the unrefined texture of recycled teak timbers with a ceramic tabletop, this counter from funky homewares store, Carga, is a great example of the textural appeal of wood re-use.

Far right Nara-san of Desain9 designed all interior elements at a restaurant in Seminyak called The Junction, including the beautifully smooth furniture that has been left unpolished, yet thoughtfully labeled with brass signage. The flooring is also a dream, with recycled timber, slightly rough in texture, contrasting with terrazzo tiles. One of Nara-san's primary aims in his work is to focus on regional design—taking traditional techniques and materials and fusing them with modern methods—thereby reinventing them in contemporary ways.

RECYCLED WOOD

In their quest for sustainability, many homeowners, architects and designers are using recycled wood products in both architecture and interiors. It's encouraging to see well-crafted timber decks, floors, door and window frames, furniture and cabinetry all made from Borneo ironwood (*ulin*) that has been retrieved from Kalimantan, Sumbawa and elsewhere in the Indonesian archipelago.

Much of Indonesia's nautical history has been tied to wood, with wharves, jetties, boardwalks, break waters and marine warehouses, not to mention boats themselves, all made from tropical hardwoods. As the government rebuilds these ancient structures in cement or brick, the wood is discarded, indeed often abandoned. Now, enterprising individuals are snapping up the timber planks—and exporting them to other parts of the world, including Bali.

The bench in Mario Gierotto's home that sits adjacent his swimming pool was constructed by Wijaya Ketut of WK Concept from timber salvaged from an old fishing boat that had been abandoned on the Sumbawa coast. Ketut likes the fact that many of the planks retain their coats of sun-bleached green, blue and yellow paint, and tends to leave the boards as they were found, just drying them in kilns before he crafts them into something new. The fact that each individual plank tells a story gives extra beauty and character to the pieces.

Other sources of recycled wood include whole homes (often Dutch colonial buildings), carved panels from a variety of structures, railway sleepers and telegraph poles. Mostly made from *ulin*, a wood that grows and regenerates extremely slowly, and teak, they are disassembled, shipped and made into something new by talented craftsmen in Bali.

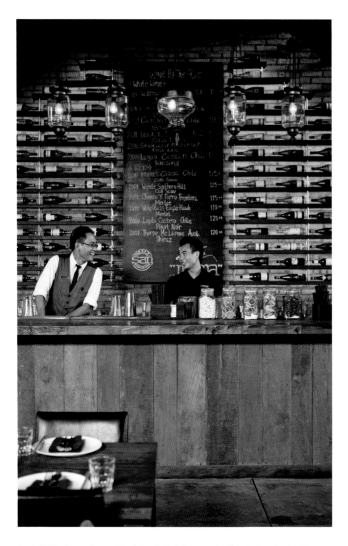

Far Left The bar at Potato Head Beach Club (see overleaf) is designed using ideas from the owners' personal collection of vintage mid-century furniture. The bar front is clad in recycled timbers salvaged from a traditional boat.

Left Nobuyuki Narabayashi or Nara-san of Desain9 had the inspired idea of using only recycled teak and *ulin* in his revamp of trendy Seminyak restaurant, The Junction. Here, the ceiling, outside walls and interior furniture are all made from reclaimed wood, sanded and whitewashed in various shades of pale. Inside spaces are delineated by large partitions containing hundreds of glass jars full of "everything Bali"—from spices and foodstuffs to stones, shells and sand. Even the tall column lamp is made from recycled wood. "My idea is to express today's Bali, not Balinese traditional style, using objects that have been thrown away or left over," he explains. "When you look at something that has a history behind it, it seems to have a lot more substance."

Above Recycled wood was used on the bar counter and tabletops at Mama San.

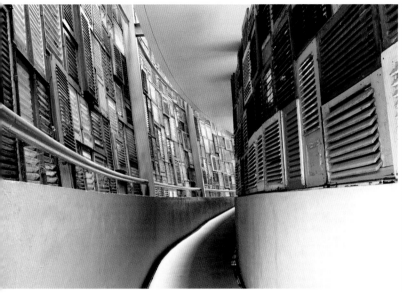

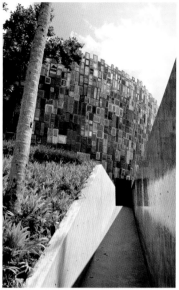

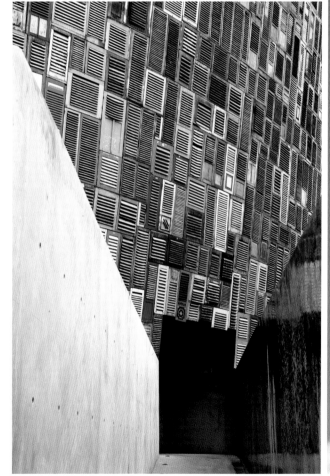

Above and Opposite The brainchild of bar/bistro impresarios and inveterate collectors, Ronald Akili and Jason Gunawan, Potato Head Beach Club sports a surreal, yet sophisticated, design. The work of acclaimed architect Andra Matin (who also designed the duo's Potato Head Jakarta and Ark Jakarta), it is a modern take on no less a structure than the Coliseum.

The beach club's overriding design statement is a towering elliptical façade crafted from a collection of over 10,000 mismatched pastel-hued shutters. Hunted out from all across the Indonesian archipelago, they cocoon the semi indoor-outdoor interior with a curving sinuosity. Part talking point, part practical shield, they pave the way for an amphitheatre-like space that includes a bar, lounge, three different restaurants, open-air lawn with swimming pool, and pool bar.

Fronting the beach, the space is semi divided into different areas that flow one to the next. Start at the bar clad in recycled timbers salvaged from a traditional boat, then make your way over to a lounge furnished with the owners' collection of 1950s and 1960s' tables and chairs. If you're peckish, the upstairs restaurant sports scenic views; if you want to lounge, poolside beckons.

Whatever your preference, you can't fail to be bemused, exhilarated and/or excited by a building that is so unashamedly individual. All credit goes to owners and architect alike for sticking to a palette of simple robust materials, such as cement, stone and recycled wood. The latter takes the form of the shutters, boat timbers and vintage mid-century modern furniture, amongst others.

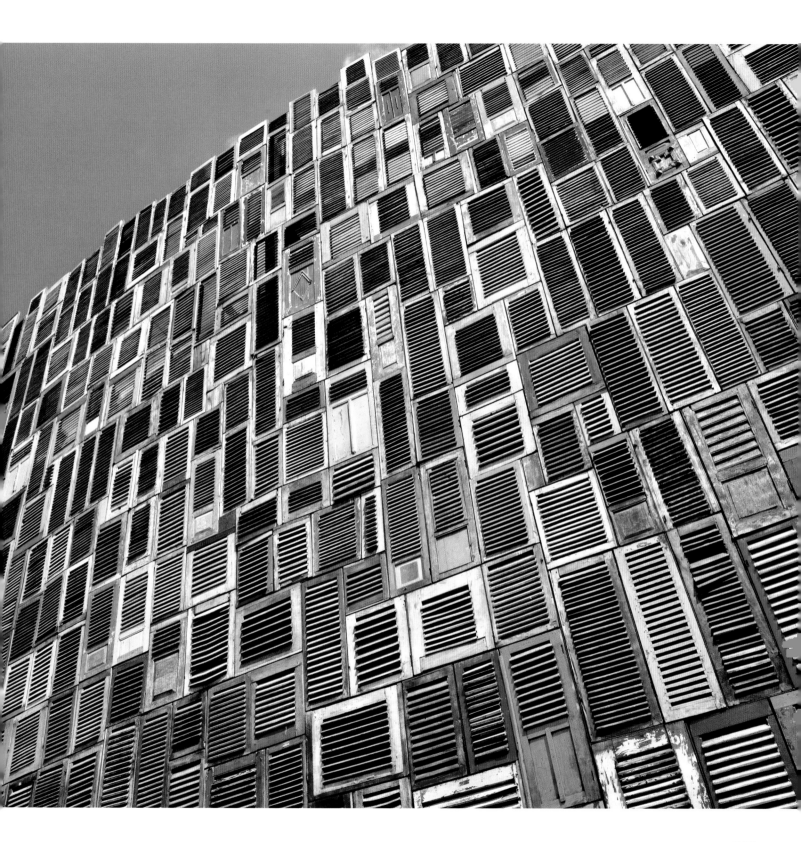

Credits

Architects, interior designers and landscape designers:

ar + d pte ltd (Ali Reda)
http://www.arplusd.net

andramatin (Andra Matin)
andra168@cbn.net.id

Area Designs (Cheong Yew Kuan)
http://www.areadesigns.com/

Liv Clausen Interiors
liv.c@cox.net

Desain9 (Nobuyuki Narabayashi)
http://www.desain9.com/

Ross Franklin Architecture
http://www.rossfranklinarchitecture.com/

GM Architects
(Gianni Francione & Mauro Garavoglia)
gmarch@indo.net.id

Gfab Architects (Gary Fell)
http://www.gfabarchitects.com/

Gong (Josette Plismy)
http://www.gong.co.uk/

ibal designs (Charles Orchard))
http://www.ibaldesigns.com/

i-LAB architecture
http://www.ilabarchitecture.com/

Bruce Johnson Garden Design
bstanfordj@gmail.com

KplusK Associates (Johnny & Paul Kember)
http://www.kplusk.net

Stuart Membery
http://www.stuartmemberyhome.com/

PT NuQu Living Design
(Reginald Worthington)
http://www.nuqu.biz/

Glenn Parker Architecture & Interiors
gpai@indosat.net.id

Budi Pradono Architects
http://www.budipradono.com/

Renato Guillermo de Pola
http://www.renatoguillermodepola.com/

Poole Associates
http://www.pooleassociates.com/

Seriously Designed (Ross J M Peat)
http://www.seriouslydesigned.com/

Wahl Architects (David Wahl)
http://www.wahlarchitects.com/

PT Wijaya Tribwana International
(Made Wijaya)
http://www.ptwijaya.com/

Word of Mouth (Valentina Audrito &
Abhishake Kumbhat)
http://www.wordofmouthbali.com/

Yoka Sara International
http://www.yokasara.com/

Zapp Design (Reynaldo Maldonado)
http://www.zapp-design.com/

Designers/Manufacturers/Shops:

Accupunto
http://www.accupunto.com/

Alabaster Lighting
http://www.alabasterlighting-bali.com/

Belindo
http://www.belindo-lifestyleflooring.com/

PT Built Dutch
http://www.b-dutch.com/

Casa Moderno (Detlev Hauth)
http://www.casamoderno.com/

Deweer Interiors (Johan Meyers)
http://www.deweer-interiors.com

DeLighting
http://www.de-lighting.com/

Gaya Ceramic and Design
http://www.gayaceramic.com/

H+R Creative
http://www.hugeandrich.com

Hishem
http://www.hishem.com/

Ibuku
http://www.ibuku.com/

Indi-vie
info@indivie.com

JP Kitchens
johanmeyers@gmail.com

Jenggala
http://www.jenggala-bali.com/

Kevala Ceramics
http://www.kevalaceramics.com/

Lightcom
http://design.lightcom.asia/

Métis Gallery
http://www.metisbali.com/

Pascal Morabito
http://www.pascalmorabito.com/

NuQu Living Design
http://www.nuqu.biz/

Old Java
http://www.oldjava.com/

Pesamuan Studio
http://www.ceramic-bali.com/

Platform18/27
http://www.platform1827.com/

Saparua
http://www.saparuafurniture.com/

Saya Gallery
http://www.sayagallery.com/

Stephane Sensey
http://www.stephanesensey.com/

simplekonsepstore
http://www.simplekonsepstore.com/

WK Concept
http://www.wkconcept.baliklik.com/